PAINTING

Realistic Landscapes

with DOROTHY DENT

Dorothy Dent

NORTH LIGHT BOOKS

CINCINNATI, OH
www.artistsnetwork.com

Dorothy Dent began teaching decorative painting classes in 1972, eventually growing her home studio into the nationally known Painter's Corner, Inc. shop and studio in Republic, Missouri. Dorothy began self-publishing painting instruction books in 1980 and has published 26 titles since then. Her painting series, *The Joy of Country Painting*, appeared on PBS, and two companion books were published by Bob Ross, Inc. Her work has appeared in all the decorative painting magazines, including *Decorative Artist's Workbook*. Dorothy continues to teach not only in her shop but all over the United States, Canada, Japan, Argentina and Australia. Her schedule and art can be seen on her web site www.ddent.com.

Other fine North Light Books are available from your local bookstore, art supply store or direct from the publisher.

06 05 04 03 02 5 4 3 2 1

Library of Congress Cataloging-in-Publication Data

Dent, Dorothy
Painting realistic landscapes with Dorothy Dent / Dorothy Dent.
 p. cm.
Includes index.
ISBN 1-58180-157-2 (alk. paper)
1. Landscape painting--Technique. 2. Dent, Dorothy. I. Title.

ND1342.D479 2002
751.45'436--dc21 2002016504

Editor: Christine Doyle
Production Coordinator: Kristen D. Heller
Designer: Joanna Detz
Layout Artist: Kathy Gardner
Photographer: Christine Polomsky

TO CONVERT	TO	MULTIPLY BY
Inches	Centimeters	2.54
Centimeters	Inches	0.4
Feet	Centimeters	30.5
Centimeters	Feet	0.03
Yards	Meters	0.9
Meters	Yards	1.1
Sq. Inches	Sq. Centimeters	6.45
Sq. Centimeters	Sq. Inches	0.16
Sq. Feet	Sq. Meters	0.09
Sq. Meters	Sq. Feet	10.8
Sq. Yards	Sq. Meters	0.8
Sq. Meters	Sq. Yards	1.2
Pounds	Kilograms	0.45
Kilograms	Pounds	2.2
Ounces	Grams	28.4
Grams	Ounces	0.04

Dedication

This book is dedicated to the memory of my mother, Christie McCafferty. She was a very creative person who grew gourds and designed them into fish, pigs, turtles, chickens and flowers many years before the popularity of gourds became what it is now. She made dolls and dressed them with handmade clothing. She taught me to make roses out of icing for special cakes, how to cook and sew, and how to can vegetables from our garden. She never had any painting lessons, but she painted, so I was not a stranger to oil paints around the house. If not for that, perhaps I would never have picked up a brush. Thanks, Mom, for everything.

Acknowledgments

Thank you to the editors and staff at North Light Books who have been so encouraging, helpful and easy to work with. Thanks to Greg Albert, whom I first discussed the book with, and to Kathy Kipp, who brought it into being.

Thank you to my staff at Painter's Corner who have been with me for so many years. Without their help I would not be able to do all the things I do, including having the time to put this book together.

Thank you to my husband, D. A. Garner, who is ever supportive of all I do.

Last but not least, thank you to the students who have supported me by attending my workshops and buying my teaching materials over the years. Without you I would certainly be in another line of work.

D. Dent

table of contents

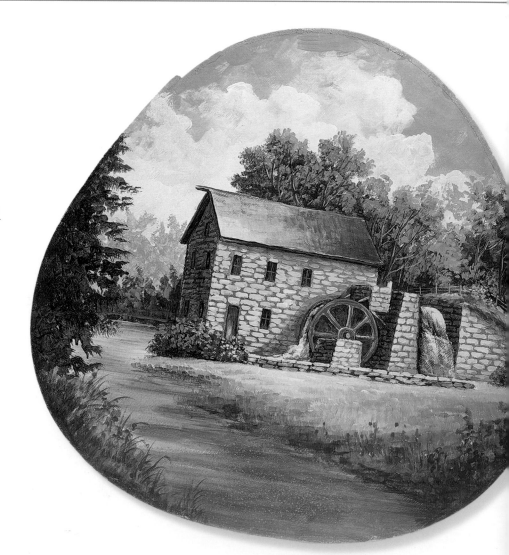

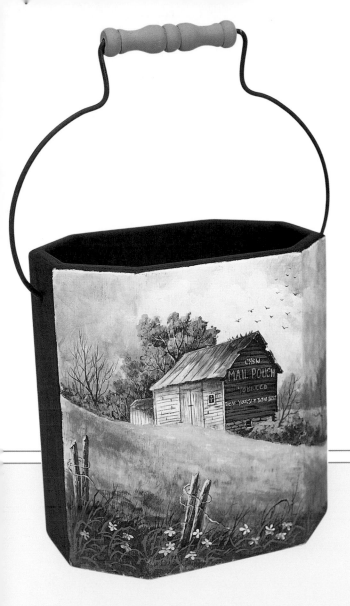

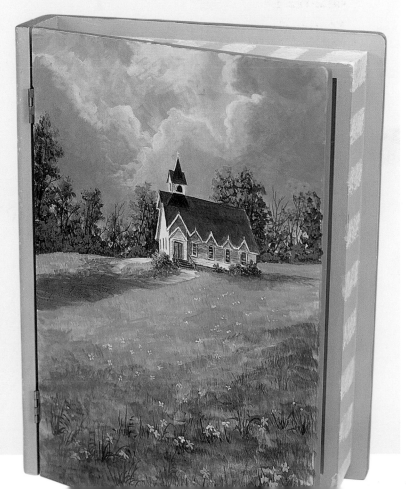

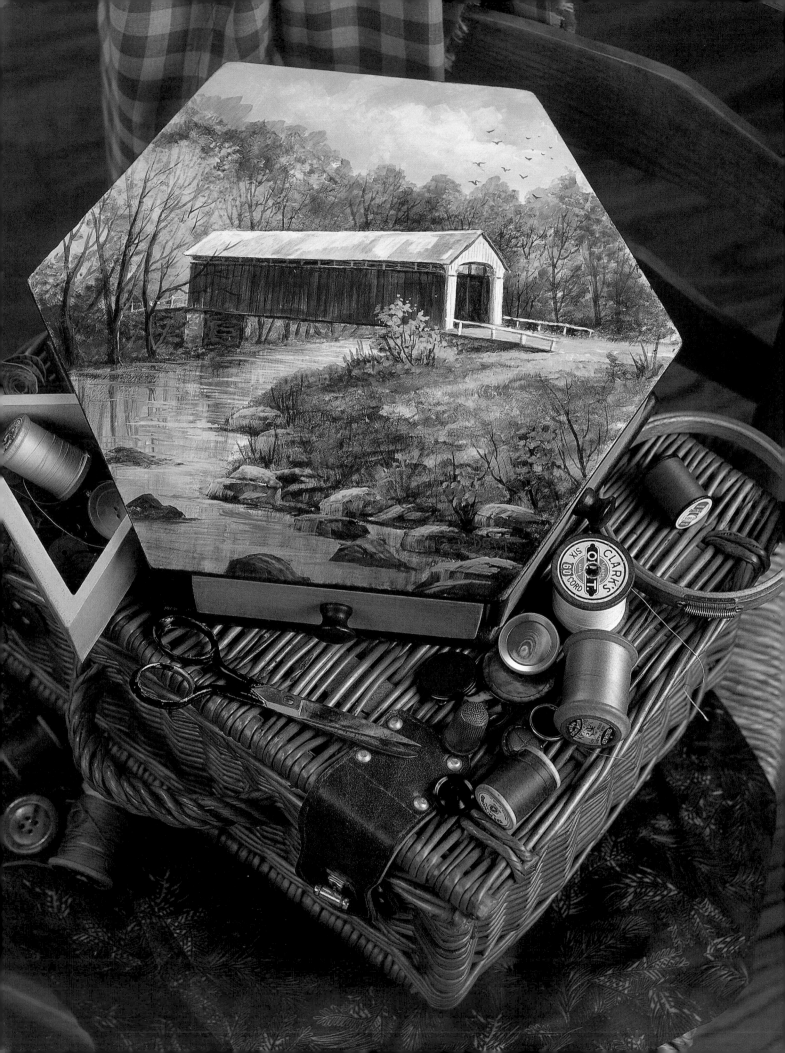

introduction

For as long as I can remember, I have loved paintings. To transform a flat blank surface into a "window" where you could see form and beauty could be nothing short of magic. The mystery was figuring out how it happens. Where do the colors go to make a painting look real? In order to learn this, I took advantage of as many art classes as I could, and eventually began to teach what I had learned—first in my home, then in my own studio. It is my hope that with this book you will feel as if you are in the classroom, looking over my shoulder as I lead you through one painting after another, explaining each step as I go.

The patterns are here for you to transfer to your surface, so you can get right into the painting. Each step is described in detail with a color photo, so your painting will progress easily. You will find that by replicating an instructor's painting you are learning where colors go and learning one way to approach the subject matter. The Old Masters taught their apprentices by having them copy their work, so copying is not a new thing—it's a tool of learning. There are those who wish to go on and design their own paintings, and this is great. However, spending some time copying from a book such as this can only be helpful as you are learning at least one way a painting can be done. For those of you wishing to do your own designs, perhaps you can use this book to "jump start" your own paintings.

Just like any worthwhile endeavor, painting takes practice. No one thinks that taking a six-week course of piano lessons will enable them to play as well as the teacher. If everything we tried were easy, it would be boring. And painting is never boring. There is always something new to learn, a new technique to try, something different to paint, another approach to consider. A person is limited only by fear of trying something new or, worse yet, fear of failure. No time spent painting is ever wasted. Whether the piece turns out to be a "masterpiece" or one you may want to hide in the closet, you will learn something each time you pick up a brush. And the best way to learn anything is by doing. It is important and necessary to read instructions on painting, but it is when you actually pick up the brushes to do the work that the learning process really begins. That is also when the fun begins. The joy is in the doing.

Painting is good for the soul. From time to time we all need to become so engrossed in something that all our cares and worries fly away. At that time there is nothing left in the world but you, the brush, your paints, and the painting you are totally lost in.

It is my hope that you will paint along with me in this book and find excitement and joy in learning my approach to acrylics. Remember that no two people paint exactly alike, and your paintings need not be a mirror image of mine to be good. The important thing is to enjoy the process of creating something you are proud of and to bring a bit of that painting "magic" into your own world.

Dorothy Dent

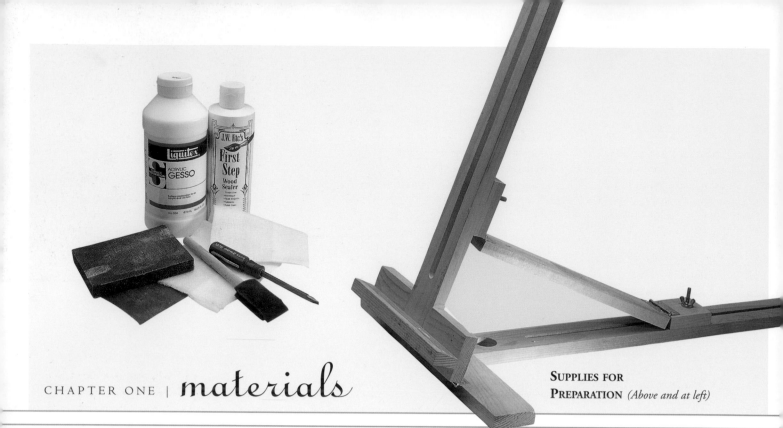

CHAPTER ONE | *materials*

BASIC SUPPLIES

These are the basic supplies you will need to complete the projects in this book. The specific supplies used for each project will be listed before the instructions for that project.

Supplies for Preparation

- Fine, medium and coarse sandpaper

- Tack cloth

- Wood sealer

- Gesso or acrylics for basecoating

- 1-inch (25mm) foam brush

- Tiny screwdriver for removing and replacing hinges

- Table easel for holding canvases and some wood items if desired

Supplies for Transferring Patterns

- Graphite or transfer paper (black and white)

- Stylus or pen or pencil

- Tracing paper

- Scotch brand tape or masking tape

Supplies for Painting

- Paper towels (the more absorbent ones are best)

- Container for water

- Palette paper

- DecoArt Americana Acrylics (see each project for needed colors)

- Brushes (see list on page 9 for those used in this book)

Supplies for Finishing Up

- Antiquing medium (optional for Covered Bridge box)

- Varnishes designed for wood and canvas

- Masking tape (used for making stripes on certain pieces)

- Glue (to attach pegs on Country Christmas board and drawer knobs on Covered Bridge box)

- Sea sponge (for design on outside of some boxes, or you may use a wadded-up paper towel)

BRUSHES

Good brushes are absolutely necessary. You are spending time and money on your projects. Don't make your fun time frustrating by trying to paint with old, worn-out brushes. The brushes I selected are these:

- no. 1 liner Royal Synthetic series 595

- no. 2 liner Royal Synthetic series 595

- no. 8 round Royal Synthetic series 250

- no. 4 filbert Royal Synthetic series 170

- no. 8 flat Royal Synthetic series 150

- ½-inch (12mm) flat Royal Synthetic series 700

- ¾-inch (19mm) flat Royal Synthetic series 700

Brush Care

One of your most expensive investments will be for good brushes. Just as a carpenter would not go to work with a broken hammer and bent nails and expect to do a good job, neither should you begin to paint with cheap brushes that will not hold an edge or worn-out brushes that should have been thrown away long ago. If you take care of your brushes, they will serve you long and well. If you are careless, you will be replacing brushes constantly. All brushes will wear out in time, but treating them kindly will certainly prolong their usefulness.

As you paint, avoid working paint up into the ferrule. If you do get some up that far, stop and clean the brush right away, then reload it. Letting paint dry in the ferrule is one of the most damaging things you can do to

SUPPLIES FOR TRANSFERRING PATTERNS

your brushes. The dried paint will hold the bristles apart, and the brush will never return to a chisel edge again unless the dried paint is removed. And once it is in there and dry, it is very hard to get out. At the end of the painting day, wash your brushes with a good soap or brush cleaning product. Wash the hairs gently—don't scrub

them to the point you are breaking the bristles backwards. Dry them gently in the direction of the bristles, not by scrubbing them roughly on a towel.

Store your brushes carefully in a brush caddy. Don't toss them into a box to roll around jamming their bristles into other objects in the box.

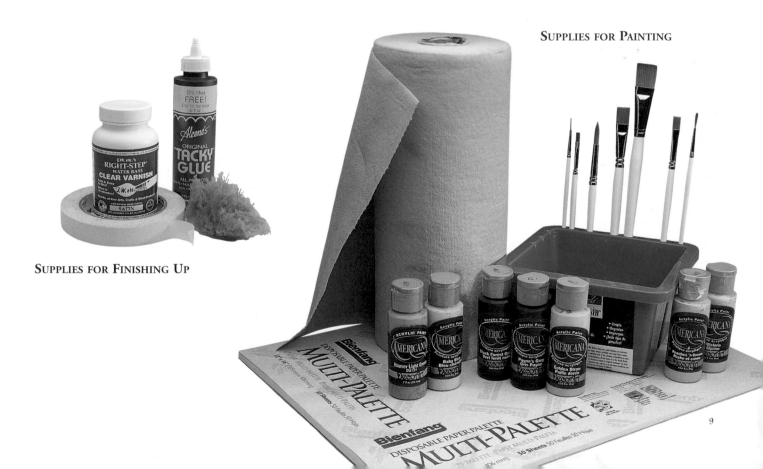

SUPPLIES FOR FINISHING UP

SUPPLIES FOR PAINTING

PAINTS

The colors for each piece are listed at the beginning of the project. I chose DecoArt Americana Acrylics because the colors are bright and beautiful, and most shops carry the paints. Although bottled paints, which are developed for the decorative painting market, are not as thick or opaque as tube (professional) acrylics, Americana paints cover quite well. I find them easy to work with.

PALETTE PAPER

Be sure you have a palette pad made for acrylics. The surface will have a waxy, shiny look. If you are working at home and run out of palette paper, you can use a piece of waxed paper or freezer paper. Tape it to the table to keep it from sliding around. Place a damp paper towel on one end of the palette to place your squirts of paint on (see page 13).

WATER CONTAINER

A brush tub found in most art stores is best, as it has grids at the bottom to help remove the paint from your brushes. Most tubs have two or three sections so you can have "dirty water" and "clean water." If you have no brush tub, any container for water will do. Change the water from time to time as it gets too dirty.

PAPER TOWELS

Buy the most absorbent towels you can find. Shop Towels from Wal-Mart are excellent. Of course, any towel will do in a pinch, but the softer ones are the best.

PAINTING SURFACES

The designs in this book can be painted on many surfaces and can be enlarged or reduced as well. A good copy machine will make them any size you want. Think creatively as to what you can paint on. You know you can paint on anything that doesn't move!

Wood

Most of the wood designed for the art market is quite smooth and requires little sanding. Some wood may require more. You do want a smooth surface to work on and wood that has been sealed nicely. Don't skimp on the preparation of your surface as it will cost you time in the long run and will result in a poorer quality piece.

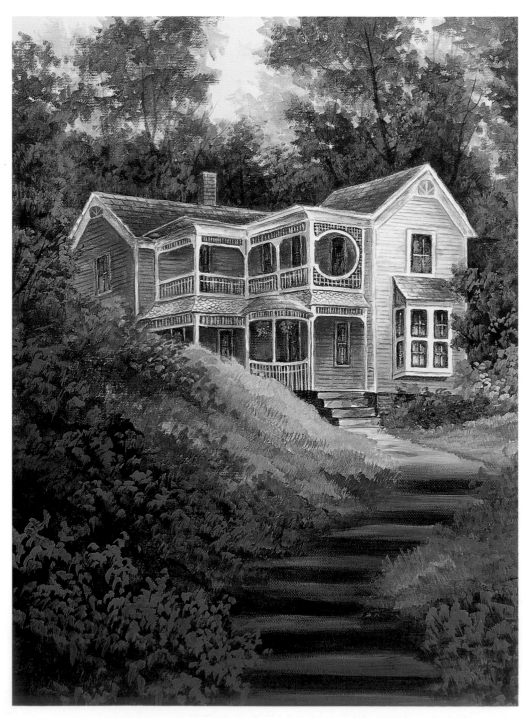

terms and techniques

Basecoat

This is the first coat of paint applied to the surface. You will be working other colors on top of the basecoat. The basecoat needs to be dry before you proceed with other colors.

Brush mix

Paints are picked up and mixed with the brush only. Work on the end of the bristles and avoid forcing paint up into the ferrule of the brush. In this way, the colors are loosely mixed together and can have a more natural look. For instance, if you are mixing Light Buttermilk + Deep Midnight Blue, simply pick up a bit of each color and brush back and forth a few times on the palette to loosely mix the paint. As you begin to paint, you will see if the color is close to what you are looking for. If not, adjust the color by adding more of whatever seems to be missing. If it is too dark, add more Light Buttermilk; if too light, add more Deep Midnight Blue.

As you work through this book you will note sample brush mixes near the mixes mentioned in the text. These will help you to determine the approximate mix in that area. The mixes shown are the most commonly used mixes, but there are other mixes as well. For all mixes, the paint is picked up as a loose mix of at least two colors. The color mixes can vary a bit, so it is not essential that your mix be exactly like mine. The color value, how light or dark the color, is more important than the exact color. The color mixes shown will help you to see the color value used as well as the color of the mix.

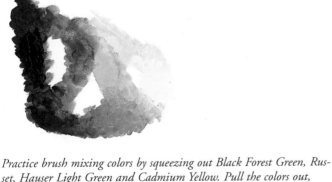

Practice brush mixing colors by squeezing out Black Forest Green, Russet, Hauser Light Green and Cadmium Yellow. Pull the colors out, and blend into the next color adjacent to it. You will get a very dark value by mixing Black Forest Green + Russet. By adding Hauser Light Green to the Black Forest Green you will get medium values of green. This mix can be dulled with a touch of the Russet. Adding more Cadmium Yellow to Hauser Light Green will give you a lighter, brighter green. Experiment by mixing colors together rather than depending on ready-mixed colors in the bottles.

Use the color mixes at left to paint a practice bush. Begin with the darkest values, building up to the light. Work for clusters of foliage, with the light values facing the light source.

Chisel edge

The sharp edge of your brush. An old worn-out brush will lose its chisel edge and become worthless to paint with unless you are scrubbing in color. The chisel edge of a brush will wear off after a great deal of use. The brush will then need to be replaced.

Direction of light

In each painting you need to be aware of which way the light is coming from. The sun cannot shine from two directions at once. Only one side of the objects in the painting will be light. The other side will be in shadow. Be consistent with the light source throughout the painting.

Easel

A table easel is great to paint on if you are working on canvas or even some wood items. It will hold your surface up in front of you so you can more easily see if you are keeping lines straight. You can also step back and easily see the way the project is looking from a distance.

Ferrule

The metal part of the brush that holds the bristles.

Foam brush

Small sponge brush on a stick. They are inexpensive and great for basecoating large areas on wood projects and for applying gesso to canvas. They can be washed with soap and water and used again, or they can be discarded after use.

Gesso

An acrylic-based white paint used to prepare surfaces for painting. It can be used under either oil or acrylic paint. Stretched canvases are already primed with gesso when you purchase them; however, the addition of two or three more smooth coats is very helpful when working with acrylic paints. The additional gesso will seal the textured surface of the canvas, making a smoother surface to work on.

Glaze

A thin layer of transparent paint brushed on over a dry layer of paint to change the color. It is sometimes referred to as a "wash." For instance, shadows can be glazed in on a building rather than trying to paint the shadow color in as part of the basecoat. In this book the paint is thinned with water, but glazing can also be done with painting mediums mixed into the paint.

Graphite paper

A specially treated paper to transfer the designs to the painting surface. It works like carbon paper, only it is not greasy. It comes in various colors, but black and white are most commonly used. It is also called transfer paper. You will slip graphite paper beneath your pattern and trace the design using your stylus.

Hard edge

A hard or straight line between two colors. Because acrylics dry quickly, it is a good idea to brush out edges of paint in large areas such as sky while the paint is still wet and before any hard lines dry where you don't want them to be.

Medium

A painting medium is a product that can be added to the acrylic paints to slow down the drying. I have used only water as my medium in these projects. I like for the paint to dry quickly so I can paint on top of what I have just done. Since most mediums slow the drying, I find I must wait longer to continue to work or the basecoats will tend to lift off with additional applications of paint.

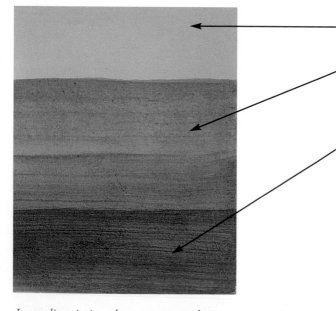

BASECOAT OF
BABY BLUE

BASECOAT OF
BABY BLUE +
ONE GLAZE OF
PAYNE'S GREY

BASECOAT OF
BABY BLUE +
TWO GLAZES OF
PAYNE'S GREY

In acrylic painting, glazes are great tools to use to adjust color over basecoats. You can apply as many glazes as you want to an area; just be sure each coat is dry before adding another on top of it.

Palette pad

A disposable pad of waxed paper made for either acrylic or oil. Lay a piece of wet paper towel at one end of the pad on which to squeeze out the paint. The moist towel will keep the paint from drying out too fast. Do your brush mixing on the dry surface. Some people prefer a wet palette that is designed with a wet sponge beneath the entire surface of the palette paper.

Side loading the brush

Loading the brush so that the paint is strong on one edge of the brush and fades away to transparent at the other edge of the brush. See instructions for side loading below.

Slip-slap

Crisscross, overlapping strokes that go in all directions.

Stylus

A wooden tool similar to a pencil with a ball shaped metal tip.

Placing the acrylic paints on a wet paper towel keeps the paints from filming over. It also leaves space on the palette for brush mixing.

It is useful for transferring patterns without marking on the pattern. You may use a pen or pencil if you don't mind marking on your pattern.

Tack cloth

A specially treated cloth used to pick up dust from wood after sanding. Available in craft or lumberyard stores.

Tracing paper

Thin paper you can see through for tracing the designs out of the book.

Transferring the design

Done by slipping a piece of graphite paper beneath the design that has been traced onto tracing paper. Mark over the design with the stylus.

SIDE LOADING THE BRUSH

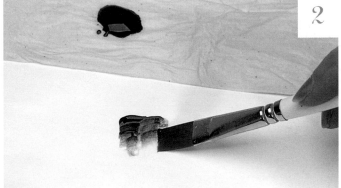

1 Side load a brush by dipping one corner of a damp brush into the paint.

2 Stroke it a few times on the palette to distribute the paint along the bristles. Use the corner of the brush with the heavier paint to lay in shadows on buildings.

Value

The value of a color refers to how light or dark it is. For instance you can have light blue, medium blue and dark blue. All can be described as blue, but they are different values of blue. Lighter values of colors look more distant and give a feeling of depth or perspective to the scene. Darker values or brighter colors look closer to you. Understanding color value, and where to put it in your painting, is important to give it a realistic look. In each project in this book, you will find formulas for the values that need to be mixed and complete step-by-step instructions for placing them in your paintings.

Varnish

The final protective coat on your wood or canvas. There are many available varnishes in both spray and brush-on varieties. Choose a non-yellowing water-based varnish for use over acrylic paints.

Wash

See *Glaze* on page 12.

VALUES AND GLAZES

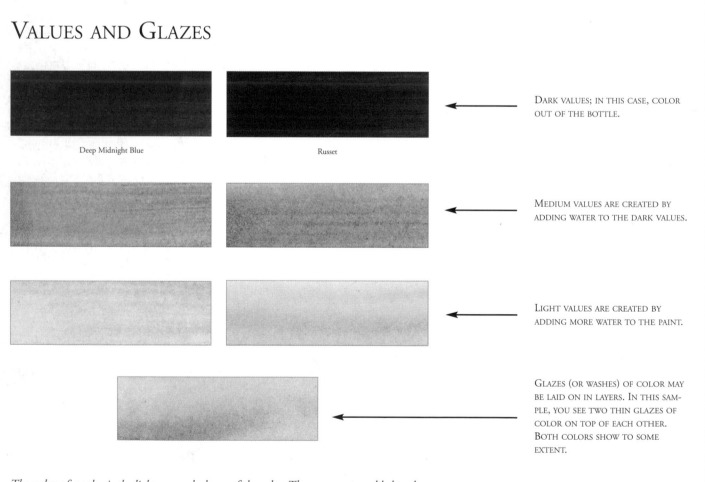

Deep Midnight Blue

Russet

DARK VALUES; IN THIS CASE, COLOR OUT OF THE BOTTLE.

MEDIUM VALUES ARE CREATED BY ADDING WATER TO THE DARK VALUES.

LIGHT VALUES ARE CREATED BY ADDING MORE WATER TO THE PAINT.

GLAZES (OR WASHES) OF COLOR MAY BE LAID ON IN LAYERS. IN THIS SAMPLE, YOU SEE TWO THIN GLAZES OF COLOR ON TOP OF EACH OTHER. BOTH COLORS SHOW TO SOME EXTENT.

The value of a color is the lightness or darkness of the color. The more water added to the paint, the lighter the value. For a thin glaze or wash of color, add more water to the paint to create a transparent look.

PAINTING GRASS

This is an example of beginning with light values and working medium and dark values in as separate steps. Note that it is usually necessary to pick up a little of the previously applied paint in the brush as you work in the next value.

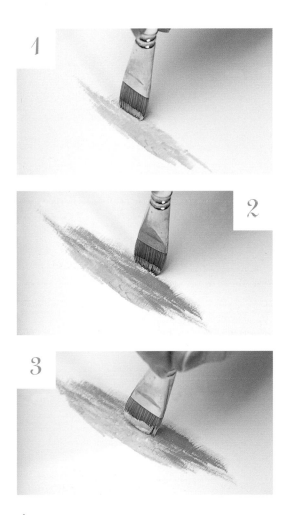

1 Paint grass with short downward strokes. Work with the flat of the brush, beginning with the light values.

2 Pick up medium values, working over the edges of the light. Work the light into the medium and a little medium into the light to soften the edges where the colors meet.

3 Additional light may be added on top of the basecoats and darker values worked into shaded areas.

MY TECHNIQUE: OILS VS. ACRYLICS

I am basically an oil painter. When the decorative painting industry first began, virtually all teachers and students were working in oils. As new acrylic paints were developed and promoted to decorative painters, many of the teachers began using that medium. Now, most of the artists in the decorative painting market use acrylics. There are still some of us who continue to work mostly or completely in oils. Several years ago, I began working in acrylics in addition to oils as a response to the many requests from acrylic painters who wanted to paint my designs.

The difference between oils and acrylics is mainly the drying time. Oils dry slowly, giving artists time to blend and push the paint around to get the effect they are looking for. Acrylics dry very quickly with little time to blend, so they must be approached differently. One must view the quicker drying time as an advantage, not a disadvantage. The advantage is that you can place layers on top of the basecoats to achieve the shading and highlights, and you can do it very quickly.

In large areas such as skies, water and buildings, the light or medium values need to be laid on first. Darker values are then glazed on top of the basecoats to build up the shaded areas. Additional highlights can be added on top of the basecoats where needed. So, you are mostly working light to dark, rather than dark to light, as you would do in oils. However, I do a few things, such as trees, bushes and rocks, dark to light, just as I would do with oil paints.

Another advantage of working in acrylics is that you can quickly paint over anything you would like to change. The basecoats are almost instantly dry, so if you don't like what you have done, simply paint over it to correct it. No need to scrape off paint or wait hours for it to dry to make corrections. You can also add glazes of colors in many layers to create beautiful tints and hues, shadows and highlights. To add glazing with oils, the basecoat needs to dry, so adding glazing with oils is a time-consuming process.

If you are already an acrylic painter, you will have no problem working with the paints. If you are an oil painter wanting to try acrylics for the first time, just follow the steps carefully, and you will get the hang of this great medium. Just don't try to make it behave like oil, because it won't. Acrylic painting is fast and fun. Give it a try, I think you will enjoy it.

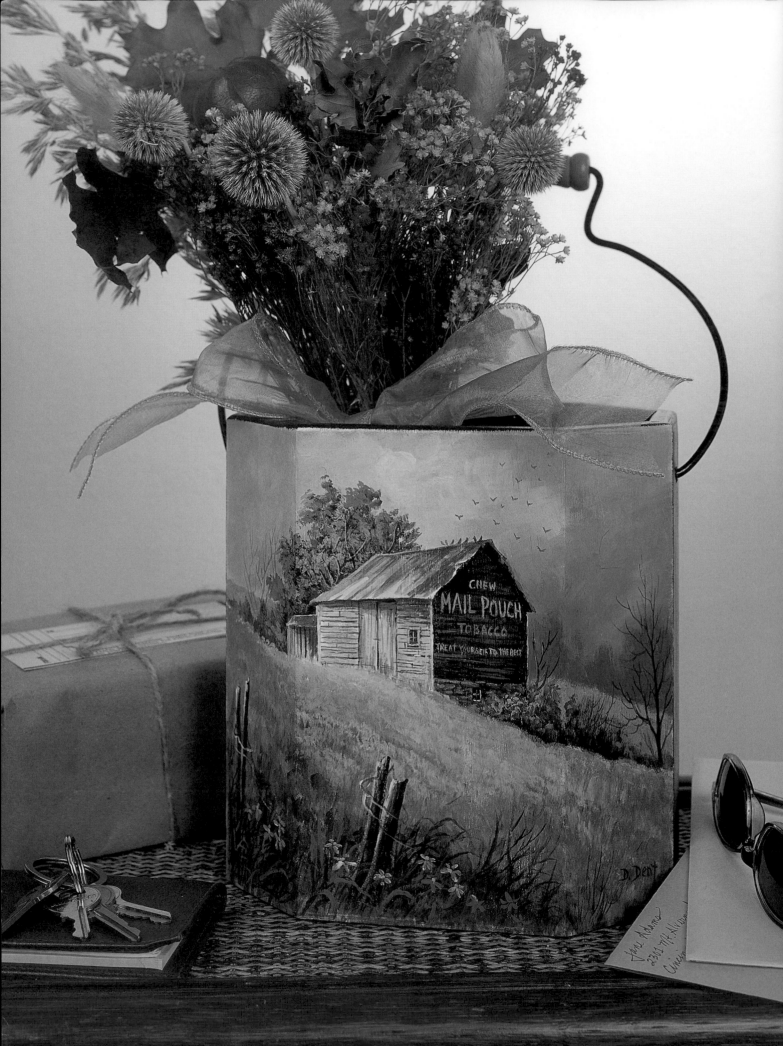

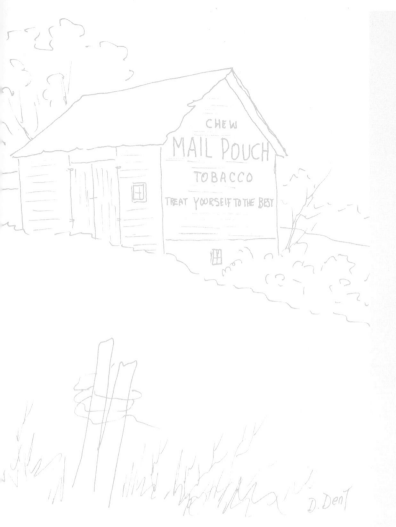

Mail Pouch Tobacco Barn

As I am a person who loves old barns and advertising signs painted on them, I get excited when I run across a Mail Pouch Tobacco barn. I have read that years ago they were scattered all over the United States. Most of those that are now left are found in the eastern part of the country. But, like so many of our old barns, mills and covered bridges, most have given way to progress and have been torn down. This old barn was in West Virginia, along the side of the road and just waiting for my camera.

In this project you will learn to paint a simple sky and building; learn the techniques of painting trees, bushes and grass; and have the option of painting as much detail as you would like to put in. You will also see how to change colors and values with glazes of thin, transparent paint.

MATERIALS

DecoArt Americana Paints

Baby Blue	Deep Midnight Blue	Dusty Rose	Golden Straw	Lamp Black
Light Buttermilk	Mink Tan	Payne's Grey	Primary Red (Napthol Crimson)	Russet
Soft Peach	Violet Haze			

Royal Synthetic Brushes

no. 1 liner series 595, no. 2 liner series 595, no. 8 flat series 150, ½-inch (12mm) flat series 700

Additional Supplies

fine sandpaper, tack cloth, 1-inch (25mm) foam brush, stylus, black graphite paper, white graphite paper

Surface

Wooden bucket from Sechtem's Wood Products

*This pattern may
be hand-traced or
photocopied for
personal use only.
It appears here at
full size.*

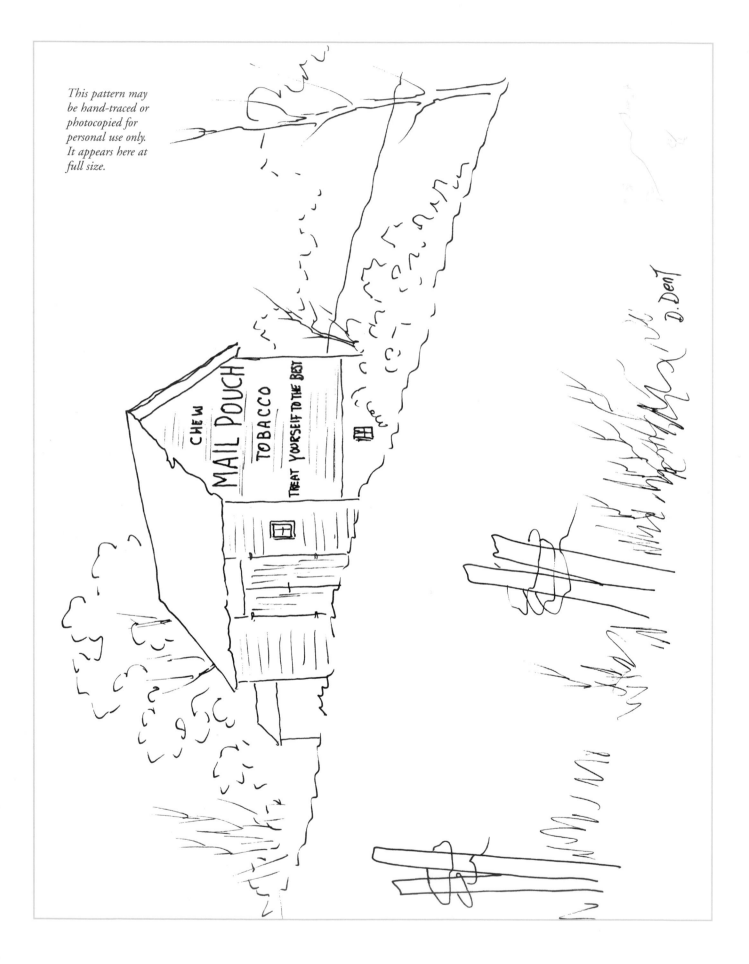

CHEW
MAIL POUCH
TOBACCO
TREAT YOURSELF TO THE BEST

D. DenT

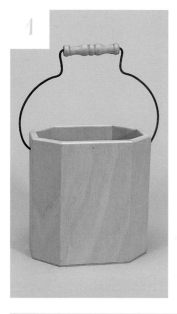

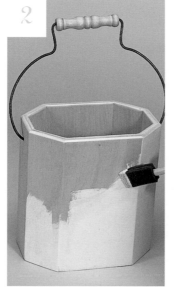

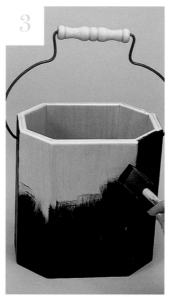

1 Sand the surface to smooth the wood. Use a tack cloth to wipe off any residue.

2 Using the 1-inch (25mm) foam brush, basecoat the front and two side panels of the bucket with Light Buttermilk. Paint two coats for full coverage.

3 Basecoat the rest of the bucket with two coats of Lamp Black using the foam brush. Paint the edges and the inside of the bucket as well as the metal handle. Using the ½-inch (12mm) flat, paint the wooden part of the handle with Mink Tan.

4 Tape the pattern to the box with a piece or two of tape toward the top of the pattern so that the pattern will not slip while tracing. Make sure the sides of the barn are parallel to the sides of the box. Slip black transfer paper under the pattern, and trace the pattern with the stylus. Do not trace the lettering on the barn or the bare trees at this time.

5 Check to make sure all needed lines are transferred. Now you are ready to paint.

Sky

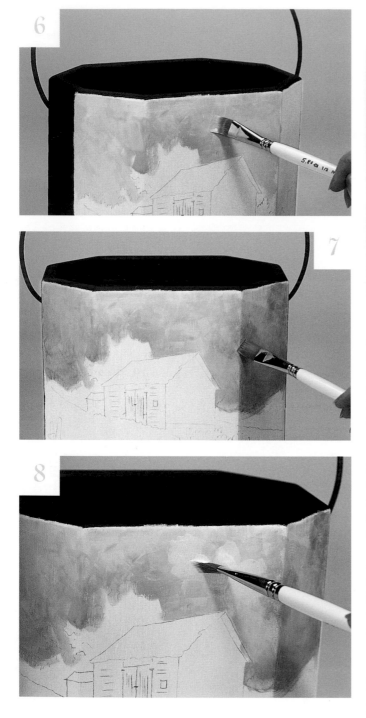

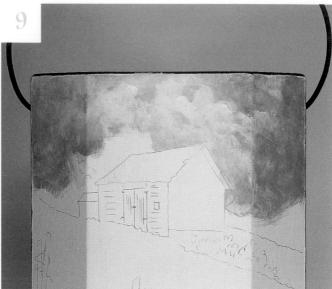

6 Begin with the sky. Brush mix Baby Blue + Light Buttermilk approximately 1:1 with the ½-inch (12mm) flat. Give the sky a basecoat, continuing to loosely brush mix as you go so that you get some variation of color. Paint your brushstrokes in various directions as this adds interest and variety to the sky and helps create a cloudy look. Bring the sky color down into the tops of the trees a bit so that the sky shows through the groups of foliage.

7 When the sky is completely dry, make a wash of Violet Haze. Brush this over the sky, especially at each side. Keep the mix wet and thin so you can see some of the blue through it. You want no hard edges of color. Again, paint the brushstrokes in different directions, and keep them fairly short. If this mix becomes too solid, brush a little of the blue mix over it here and there.

8 After cleaning the brush, pick up a little Light Buttermilk. Beginning at the top of a cloud, brush in irregular and uneven edges, blending the bottom of the cloud into the blue. Keep the paint a bit wet for this blending, which is actually a thin wash of color put over the dry basecoat.

9 Continue to work in more clouds until you are satisfied with the result. Add heavier Light Buttermilk to make the clouds brighter. Thinning the paint more will make soft, blue-white filmy clouds. Remember, with acrylics you can paint over anything you don't like and try again.

Baby Blue + Light Buttermilk

Baby Blue + Light Buttermilk with Violet Haze glaze

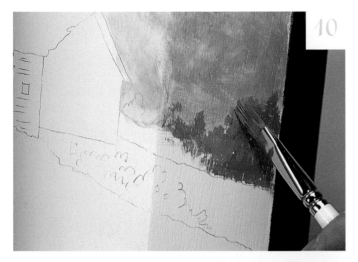

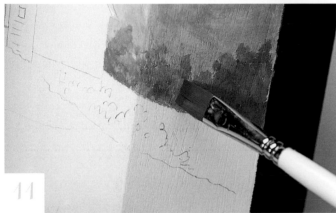

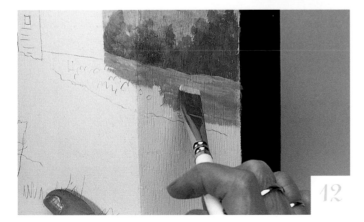

10 Brush mix Violet Haze + a tiny touch of Lamp Black. Using the bottom corner of the 1/2-inch (12mm) flat, begin the trees with this mix, adding a bit of Light Buttermilk from time to time to lighten the value. The trees are quite distant, so keep even the darker values fairly light to create that distance. Since foliage has light and dark values, vary the values by patting a little lighter value over a darker one, working in small groupings of foliage.

11 With a very thin touch of Primary Red, wash a soft pink glow over the trees here and there. The color is strong, so keep it thin and light.

12 Fill in the distant field with Dusty Rose using the flat of the 1/2-inch (12mm) flat brush and short patting-down strokes. For variation in the grass colors, add touches of Light Buttermilk to the Dusty Rose. Paint a little of this color on the small field to the left of the barn also. If the tracing lines still show, simply add a bit more paint over the lines.

13 Toward the bottom of the field on the right, add a very thin glaze of Deep Midnight Blue. Pull down with little short strokes to create a hazy, shadowy look. The blue will help give distance to the field. If you get too much or if it looks too solid, simply pat in a bit more Dusty Rose to soften the blue.

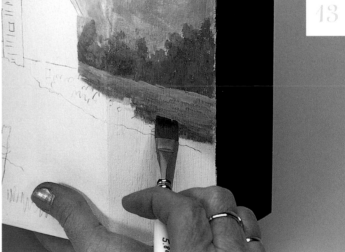

Violet Haze + Lamp Black +
Light Buttermilk

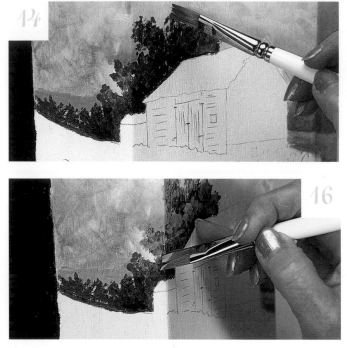

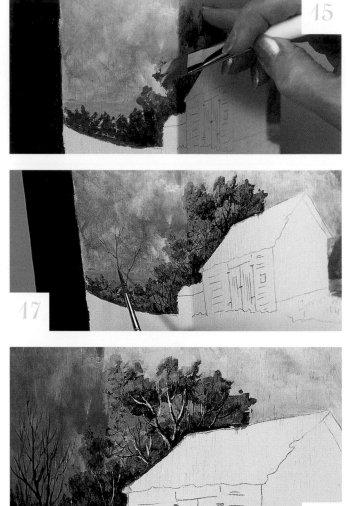

14 Using the bottom corner of the ½-inch (12mm) flat, pat in the dark basecoat on the trees behind the barn. Begin with a mix of Lamp Black + Primary Red mixed to a black-purple. As with all brush mixes, the colors will vary a bit as you go. Use the same general stroke that you used for the distant trees. Paint a bit past the tracing line to give a loose, irregular look to the treetops—the tracing lines are only a suggestion of how tall to paint the trees. Paint the bushes to the left also.

15 To make this foliage look distant, paint groups of foliage with lighter values toward the outside of the group, medium values toward the center or middle of the groups, and leave some of the darker basecoat still showing at the base of each group. To do this load only one flat side of the ½-inch (12mm) flat with Golden Straw. Turn the brush so that the paint is on top of the brush. Tap with the corner of the brush, pushing the paint off the top of the bristles to build up the heavier and brighter foliage at the top and sides of the clusters. Tap a lot of overlapping foliage to build up a fairly large grouping of leaves, thus building the shape of the cluster.

Lamp Black + Primary Red

16 Toward the center of the cluster, lift up on the pressure of the brush and pick up a little of the basecoat color to create the middle-value foliage. Allow a little of the dark basecoat to show through toward the bottom of the clusters to give depth to the tree. Go over the lighter foliage two or three times to build up more highlights. You may also pat in more dark values over the light if too much of the dark has been lost. When finished, you want to see light, medium and dark values in the leaves.

17 Add trunks and limbs to the trees with the no. 1 liner using a mix of Lamp Black + Primary Red thinned with water. Work on the tip of the liner to thread branches in and out of the foliage. Refer to the pattern for the bare tree to the left of the barn, but paint a tree unique to your piece. Add more water to the mix for lighter-value limbs; add less water for darker limbs.

18 Highlight some limbs with Light Buttermilk, adding the highlight to the left of the branch (not directly on the branch).

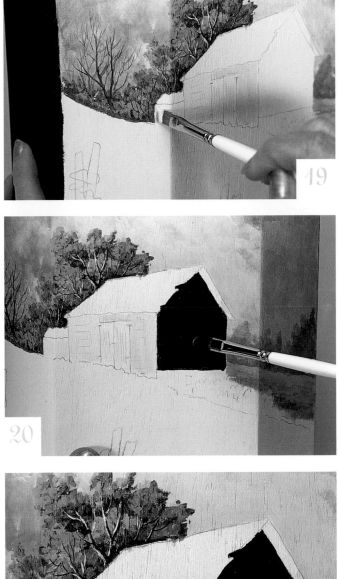

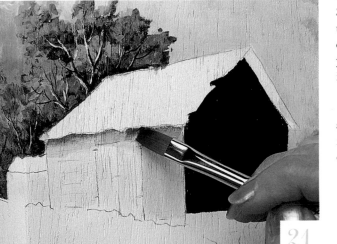

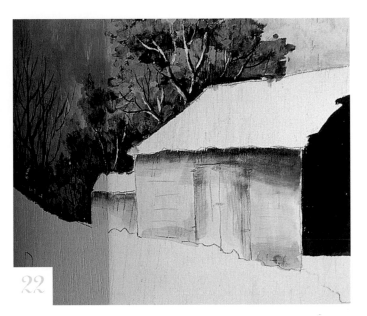

19 Clean up any stray foliage that has gotten onto the barn with a bit of Light Buttermilk on the brush. Then paint the front of the barn with a brush mix of Light Buttermilk + a touch of Soft Peach on the no. 8 flat.

20 Using the no. 8 flat, basecoat the gable end of the barn with Lamp Black. You will probably need two coats for full coverage.

21 Next, shade beneath the roof edges on the left side. To do this, dip the no. 8 flat brush in water and blot it slightly. Side load the brush by tipping the right corner of the brush in Payne's Grey. Stroke the flat of the brush on the palette a few times to distribute the paint down through the damp bristles. With the Payne's Grey corner beneath the roof edge, stroke the brush across the barn. If you do not get it dark enough the first time, let it dry and go over it again.

22 Side load the brush in the same way, and add Payne's Grey shading under the roof of the rear portion of the building and to the right of that wall. Paint a very thin Violet Haze wash at the bottom of the wall on each side of the door and to the inside of the door.

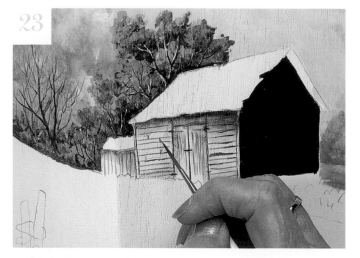

23 Using the no. 1 liner, brush mix Payne's Grey + Primary Red with enough water to make a very thin line. Paint the horizontal board lines on the light wall. Add an occasional vertical line to indicate the end of a board length. Keep the paint very wet, and stay on the tip of the brush. Some lines can be slightly darker and wider to indicate larger cracks between the boards. Don't worry if the lines are not perfectly straight. It is an old barn, and a few crooked boards only create character! Add the hinges and latch on the door, and a crack line around the door. Create corner boards at each corner of the wall by stroking in a thin line just to the inside of each corner. Add more Light Buttermilk to the corner board if needed. Paint vertical lines on the smaller building.

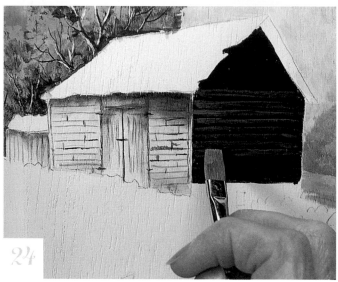

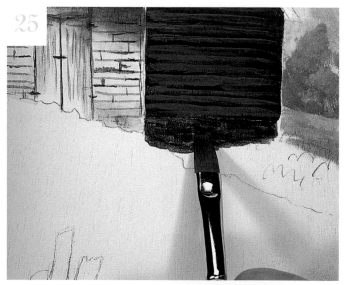

24 Using the side of the no. 8 flat brush, streak Violet Haze on the dark wall of the barn. Make the boards about the same width as the ones on the left and leave space between the boards for the black basecoat to show through. Add a little more Lamp Black here and there to open up larger cracks or missing boards.

25 With the no. 8 flat, base in the foundation with two coats of Russet + Payne's Grey. Paint out the small window; you will add it in later.

26 With the no. 2 liner brush and a little Mink Tan, stroke in the stones on the foundation. Vary the size and shape a bit, and stagger them so they are not stacked directly on top of each other.

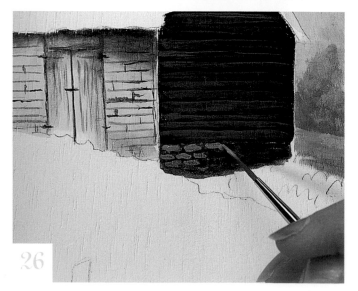

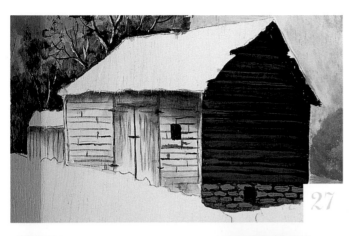

27 Paint the windows using the no. 2 liner and Lamp Black. Paint in the overhang of the roof on the upper right side, making it a bit ragged to suggest broken shingles.

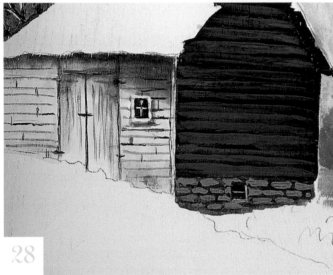

28 Paint the panes and frame on the left window with Light Buttermilk using the no. 2 liner. Add a thin shadow of Payne's Grey around the outside of the frame to pull it away from the wall. Deepen this shadow a bit more under the bottom of the frame. On the foundation window, paint a thin line of Light Buttermilk down the right side and across the bottom. Add one horizontal line through the center.

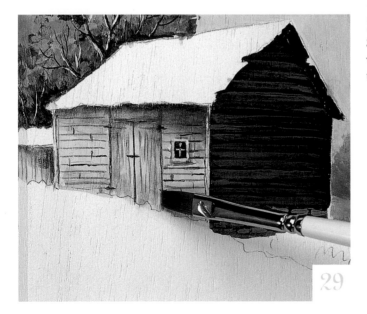

29 Be sure the left wall is dry, then add a thin wash of Golden Straw across the front wall of the buildings using the no. 8 flat. This will add a warm glow of light to this area. Add a few hints of very thin Russet here and there on the wall also.

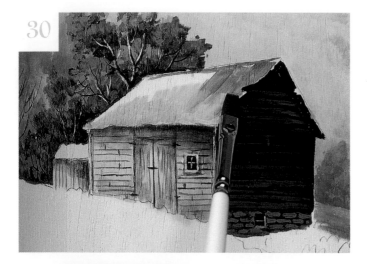

30 With the no. 8 flat, paint a thin wash of Golden Straw on the light, bottom part of the roof. Next, load the brush with thinned Russet, and begin to pull long strokes down into the Golden Straw area. Don't cover up all the Golden Straw—let the Russet thin out to a light wash as it overlaps the Golden Straw.

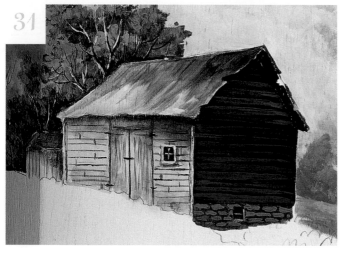

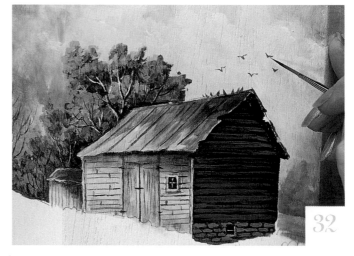

31 To create a rusty look to the roof, let some of the Russet be a little darker and some a little lighter (by adding more water). Add a few strokes of thin Payne's Grey or Deep Midnight Blue. Paint the small roof to the left with the same general colors. Add a line of Russet above the overhang to the right of the gable end.

32 Load the no. 2 liner with thin Payne's Grey, and draw in vertical lines on the barn roof to indicate sheets of tin.

Pick up a bit of Light Buttermilk and highlight the edges of the small roof to the left, cleaning up the edges and creating more contrast.

Load the brush tip again with Payne's Grey and paint the tiny birds on the roof with two strokes. Make a slightly slanted stroke for their backs and a slightly rounded stroke to fill in the breast—the rest you can leave to your imagination. Paint the flying birds with little flying Vs.

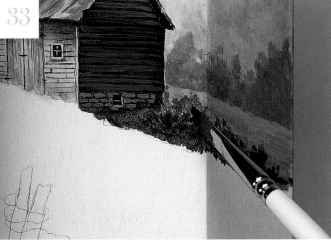

33 Paint the bushes on the right side of the barn with a basecoat of Payne's Grey + Russet. Use the bottom corner of the brush for a loose irregular look at the top of the bushes.

34 Add light values to the bushes with Golden Straw, loading the paint on the top corner of the brush, and tapping in clusters of foliage.

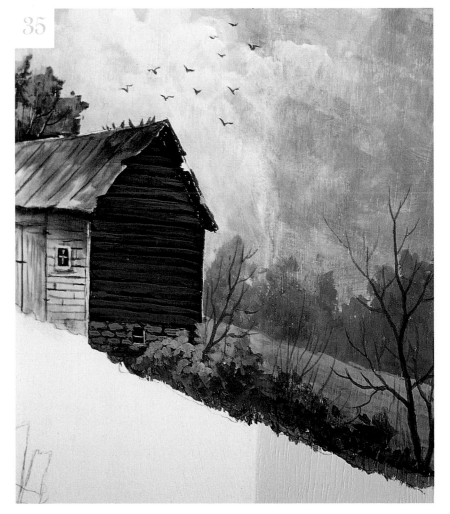

35 Add a little Russet + Primary Red in the same manner for the rusty red foliage. Load the no. 2 liner with thinned Payne's Grey + Russet and paint the bare trees.

Russet + Primary Red

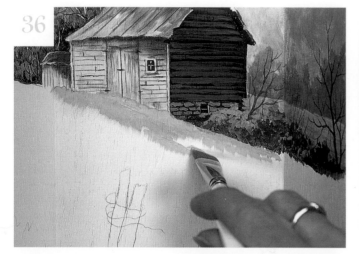

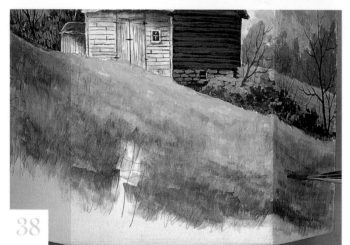

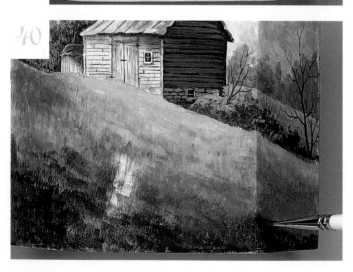

36 Begin the grass at the top, picking up Golden Straw on the ½-inch (12mm) flat and painting with short downward strokes that overlap each other. Follow the contours of the hill as you work, creating the look of grass.

37 Continue the same short strokes on the hill, working down to the bottom of the posts.

38 At the bottom of the hill, pick up a little thinned Mink Tan + Russet and continue the downward strokes, overlapping some of the Golden Straw grass. This will add additional color and texture to the grass. For the best effect, work on the tips of the bristles, standing the brush straight out from the surface.

39 Add a little thinned Violet Haze over some of the lower areas of the grass for hints of cool violet.

40 Deepen the shading under the posts and at the bottom of the bucket with Payne's Grey + Russet. Continue using the same short downward strokes.

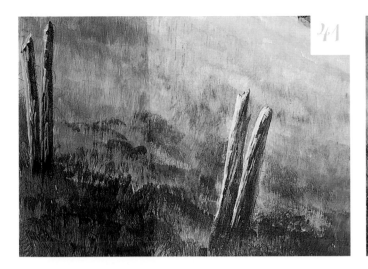

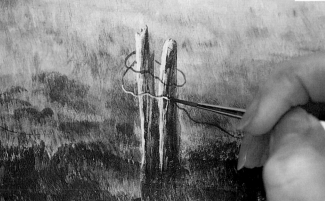

41 Using the no. 8 flat, paint the posts with two coats of a mix of Payne's Grey + Russet. To add light highlights, load one side of the brush with Light Buttermilk and hold the brush so the paint is facing left. Stroke down the left side of the post, beginning just to the outside edge of the dark basecoat. Work on the chisel edge of the brush. Add a few choppy downward strokes on the post to create rough texture. Avoid losing too much of the dark basecoat.

42 Load the no. 1 liner with thinned Payne's Grey, and paint the wire. Add a thin line of Light Buttermilk next to the Payne's Grey to highlight the wire.

Weeds

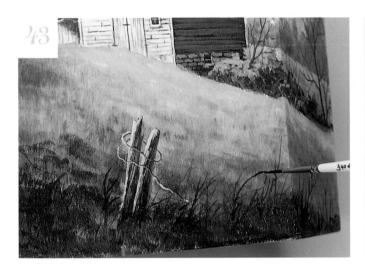

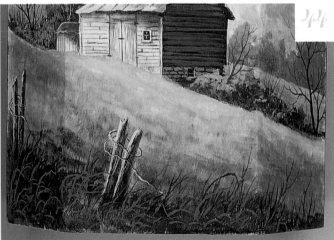

43 Paint the tall weeds and grasses with thinned Payne's Grey + Russet using the no. 1 liner. Hold the brush toward the end, and flick loosely up rather than drawing the grass up with a heavy hand. Work for a loose uneven look.

44 Load the no. 2 liner with thinned Violet Haze and add more grass blades in the dark areas.

Flowers

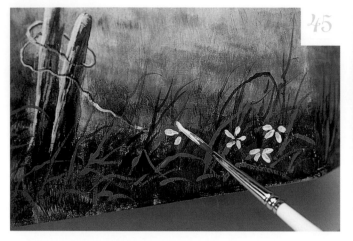

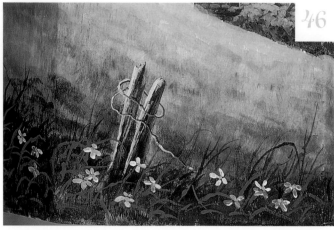

45 With Light Buttermilk and the tip of the no.1 liner, create the small flowers. Set the liner down at an angle, and pull a short stroke toward the center of the flower for each petal

46 Mix a touch of Violet Haze into the Light Buttermilk, and paint a few more flowers or petals on some of the lighter flowers to indicate shading. Touch a dot of Golden Straw in the center of each.

Lettering

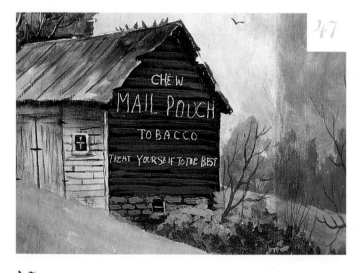

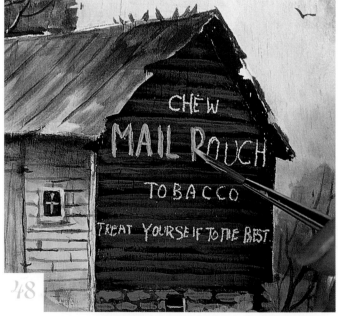

47 To add the lettering, carefully place the pattern over the painted design. Tape it to the surface, and slip a small piece of white graphite paper underneath. Trace the lettering with the stylus.

48 Paint "Mail Pouch Tobacco" with Golden Straw on the no. 1 liner.

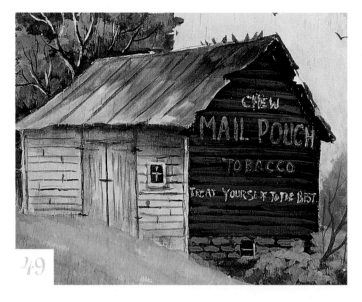

49 Use the same brush to paint the rest with Light Buttermilk. If the lettering isn't perfect, that's OK. It will just look more rustic and weathered. If you feel you must do a little correcting, simply touch up around the edges of the letters with Payne's Grey.

Wash a little thinned Payne's Grey and/or Payne's Grey + Russet over the lettering to add shading, as it is on the shadowed side of the barn.

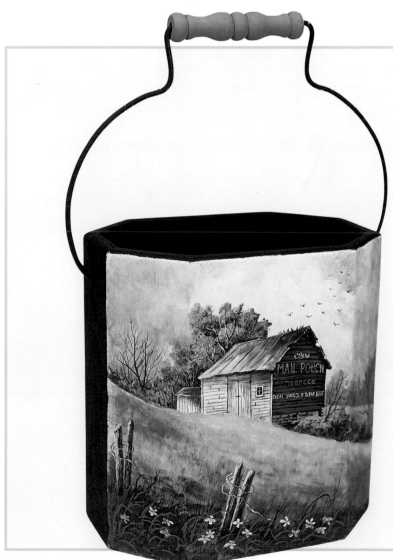

Apply two coats of varnish to finish the bucket. This piece will look great anywhere in your home. Try filling it with dried flowers for an extra touch of beauty.

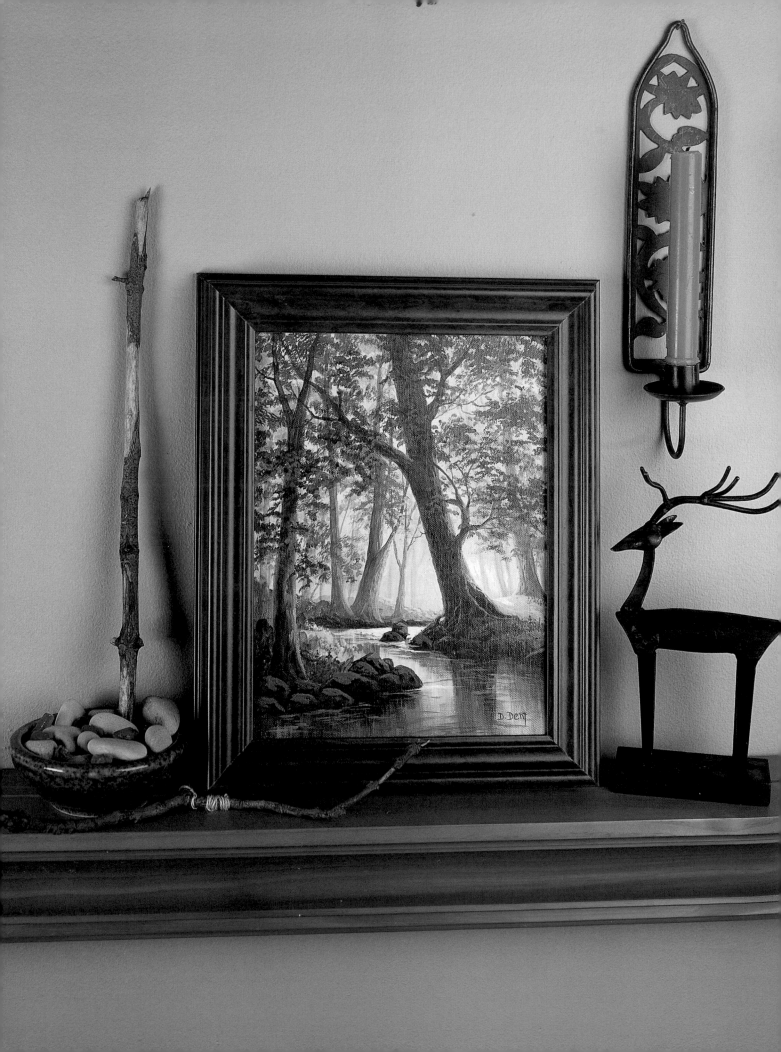

Forest Glow

Most of us love paintings with trees and water. They are peaceful and serene and make us wish for a stroll along the bank, just watching the water flow by.

In this painting you are introduced to large foreground trees. Tree trunks are round, so you will learn to highlight and shade the edges to take away the sharpness that causes them to look flat when based in. You will learn to paint still water and how to add reflections and top water movement lines that give the water shine. This painting will introduce you to rocks as well. They are not at all hard to paint, as they are basically tops and sides. You will soon be adding rocks to all your paintings.

MATERIALS

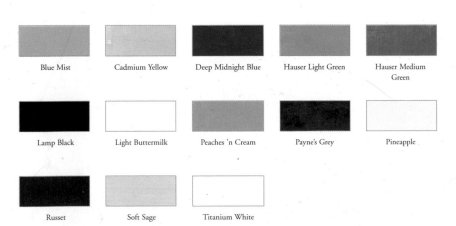

DecoArt Americana Paints

Blue Mist	Cadmium Yellow	Deep Midnight Blue	Hauser Light Green	Hauser Medium Green
Lamp Black	Light Buttermilk	Peaches 'n Cream	Payne's Grey	Pineapple
Russet	Soft Sage	Titanium White		

Royal Synthetic Brushes
no. 2 liner series 595, no. 8 flat series 150, ½-inch (12mm) flat series 700

Additional Supplies
white gesso, 1-inch (25mm) foam brush, black graphite paper, stylus

Surface
9 x 12-inch (23cm x 30cm) canvas from any craft or art supply store

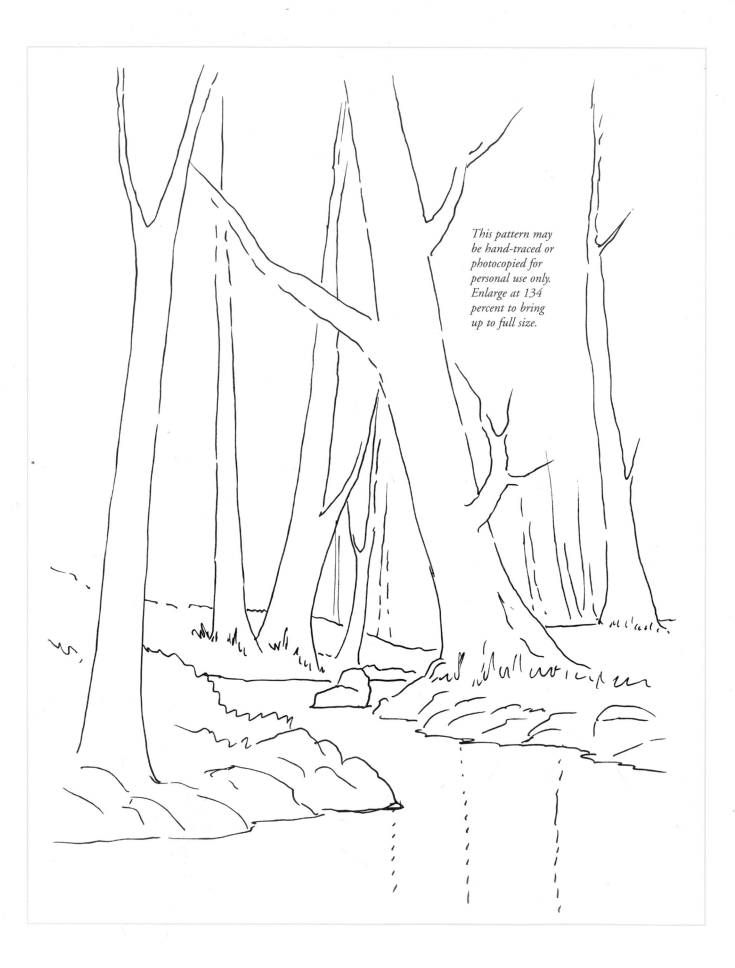

*This pattern may
be hand-traced or
photocopied for
personal use only.
Enlarge at 134
percent to bring
up to full size.*

1 Using the 1-inch (25mm) foam brush, cover the canvas with two or three coats of gesso. When dry, transfer the pattern onto the canvas with black graphite paper and the stylus.

Using the ½-inch (12mm) flat, paint the sky on both sides of the big tree with Pineapple. You can paint out some of the smaller tree trunks, but go around the large trunk.

2 Loosely brush mix Pineapple + Peaches 'n Cream. Work toward the top of the canvas with strokes going in various directions. Where this mix touches the Pineapple in the center, pick up a little more Pineapple on the brush to blend the colors together without leaving a hard line. Stop before going all the way to the top.

3 With a clean brush, pick up Soft Sage and a little water to thin the paint. Begin at the top of the canvas with loose brush-strokes going in different directions. Brush over the edges of the Pineapple and Peaches 'n Cream with the thinned paint. You do not want to see any hard or straight lines where colors come together.

4 Still using the ½-inch (12mm) flat, add a strong highlight just to the right of the big tree with Titanium White. Pat the paint in a bit thickly. Don't blend it too much, but soften the edges a little. Add just a little Titanium White to the left of the tree trunk.

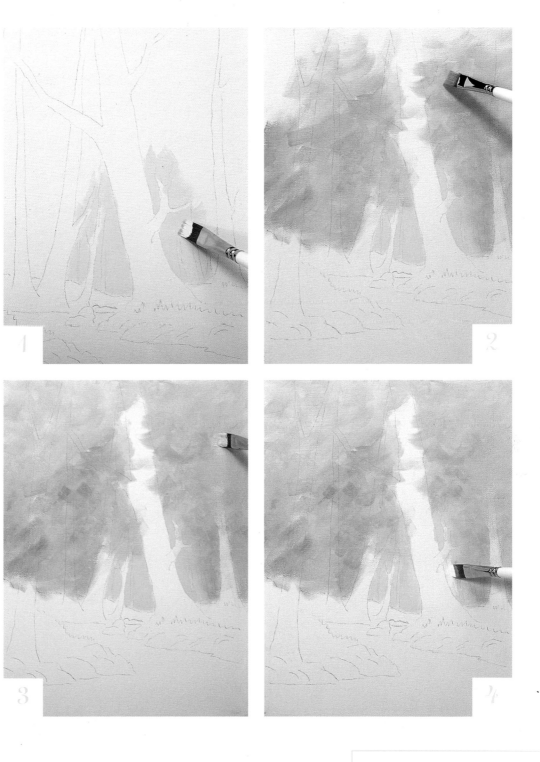

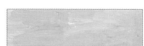

Pineapple + Peaches 'n Cream

Distant Trees

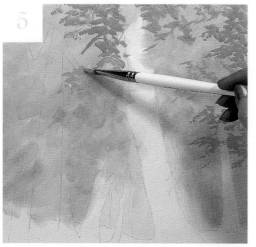

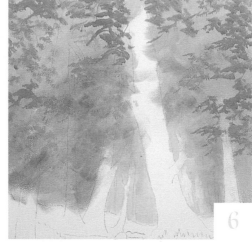

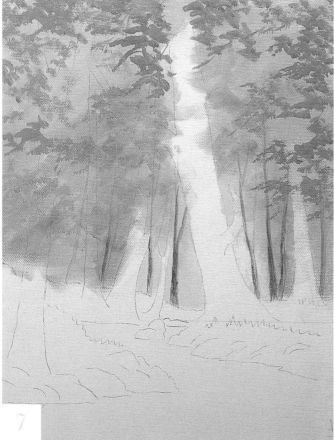

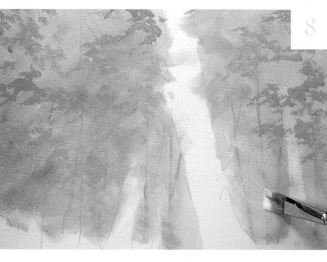

Soft Sage + Blue Mist

5 Begin tapping in the most distant leaves on the trees using a mix of Soft Sage + Blue Mist. Tap with the corner of the no. 8 flat, holding the handle to the side as you see here.

6 Vary the leaves in color (by brush mixing the two colors in different proportions) and value (by thinning the paint with water). You will later cover up many of them with darker foliage, but a few lighter leaves should show from behind the dark ones to add depth.

7 Using the same mix used in the leaves and the same brush, add some distant tree trunks and limbs with the chisel edge of the brush. Keep the paint very wet for a light value. Add a touch of Russet to the mix to add a nice hint of brown tones now and then. Add smaller branches with the no. 2 liner, working with very wet paint.

8 If your trees are too dark to look distant, set them back farther by brushing a glaze of Titanium White + Peaches 'n Cream and/or Titanium White + Pineapple. Work with several thin layers of the glaze, rather than one heavy layer, to build up hazy distance.

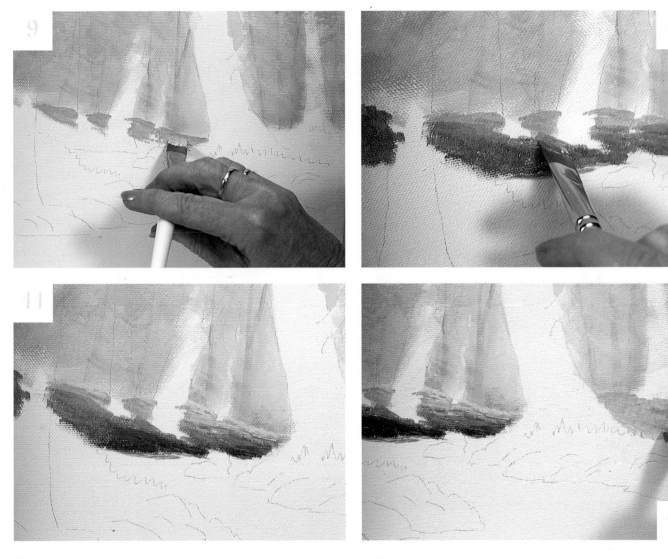

9 Paint the most distant grassy bank next using the no. 8 flat and a mix of Pineapple + Hauser Light Green. Work with short downward strokes and the flat of the brush.

10 Continue down to the bottom of the bank, picking up darker values of Hauser Light Green + Russet. Work around the tree trunks and down to the edge of the water. Soften where the light and dark values meet by picking up a bit more Hauser Light Green + Pineapple and patting out any harsh lines.

11 Add strong highlights to the top of the bank with additional Pineapple patted on top of the basecoats. Add a darker value at the bank line with Payne's Grey + Hauser Medium Green. To eliminate any harsh lines, soften the top of this bank with more Hauser Medium Green.

12 Brush mix Pineapple + Hauser Light Green, and pat in the far right bank. Shade the bank with pats of Hauser Medium Green to the right and bottom.

Pineapple + Hauser Light Green

Tree Trunks

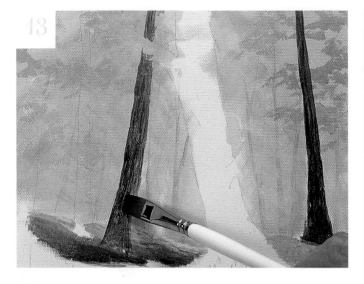

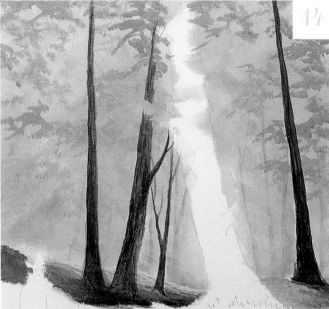

13 Base in the tree trunks with Russet + Payne's Grey, working on the chisel edge of the 1/2-inch (12mm) flat. Vary the colors a little, showing more Payne's Grey on some trunks and more Russet on others.

14 Basecoat the small trees in the distance using the no. 2 liner and the same mix. Add water to thin the mix to help the paint flow off the brush and to make lighter values for distance.

15 The light source in this project is coming from the center of the canvas, so the light sides of the trees face the middle of the canvas. To highlight these edges of the trees, load one flat side of the no. 8 flat with Peaches 'n Cream. Hold the brush vertically with the paint facing the middle of the canvas. Begin just beyond the edge of the basecoat and stroke in the highlights with short choppy strokes. Blend the highlight into the dark basecoat by picking up a little Russet on the brush with the highlight color. Work this slightly darker value over into the tree a little way. Don't stop the highlights in a straight line. Add a little Pineapple to strengthen the lightest highlighted area.

16 Add touches of Blue Mist to the shadow side of the tree. Use the same technique with a small amount of paint on the chisel edge of the brush. This will soften the outside edge, giving the tree a rounded look. Avoid bringing the Blue Mist too far into the dark part of the trunk.

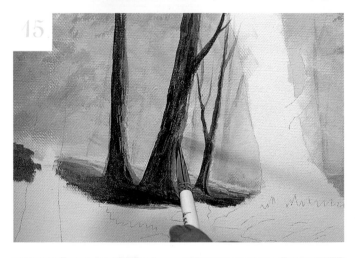

Russet + Payne's Grey

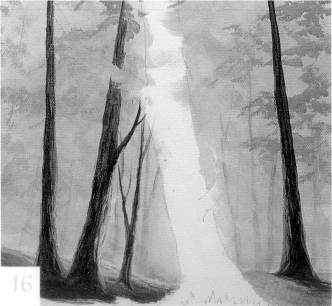

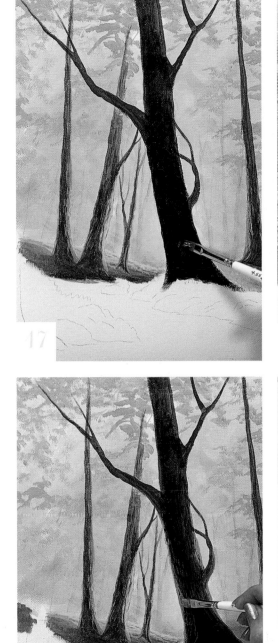

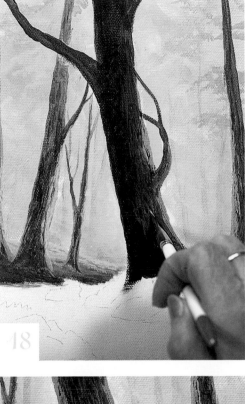

17 Base in the large tree with Payne's Grey + Russet on the no. 8 flat. This tree will be very dark, so basecoat with two or three layers of paint to prevent the white background from showing through. Base in the main branches also.

18 Highlight the right side of the tree with Peaches 'n Cream, loading the paint on one flat side of the brush, as before. The paint should be facing right as you chop the highlights onto the trunk. Fade out the strokes as you work toward the center of the tree by picking up Russet with the Peaches 'n Cream. Build up the impression of bark that fades into shadow toward the middle of the tree.

19 Load Blue Mist on one flat side of the brush, and hold the brush so the paint is facing left. Tap short downward strokes on the left side of the tree to add a cool highlight to the shadow side. Pick up a little Russet with the Blue Mist as you come into the tree a little.

20 With Lamp Black on the no. 8 flat brush, base in the area just beneath the tree, the bank and all the rocks along the edge of the water.

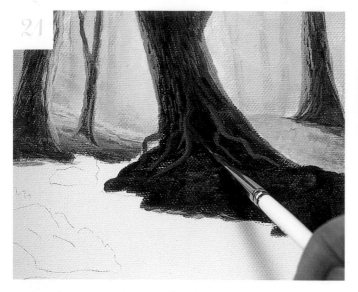

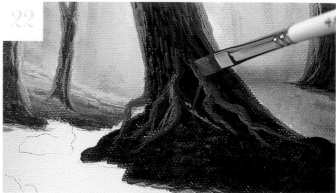

Russet + Blue Mist

21 Brush mix Russet + Blue Mist on one flat side of the no. 8 flat brush. With the paint on the top of the brush, paint in the roots of the tree with the bottom corner of the brush. The tops of the roots should look like they are coming from the tree. You may need to pat in a little dark mix of the tree basecoat to set the roots into the tree nicely.

22 Pat a little Blue Mist on the backside of the roots for cool highlights. Pat a little light green on a few for a mossy look using mixes of Hauser Light Green + Pineapple and Hauser Medium Green + Hauser Light Green.

Bank and Water

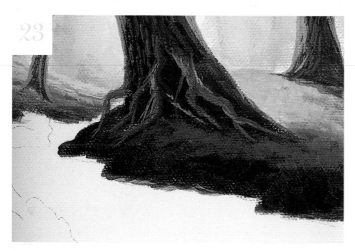

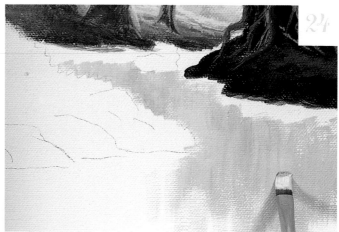

23 Pat a little grass around the roots with Hauser Medium Green + Russet on the no. 8 flat, avoiding the rocks.

24 Working with the no. 8 flat, base in the center of the water with Pineapple, picking up a little Peaches 'n Cream now and then. Use fairly long downward strokes.

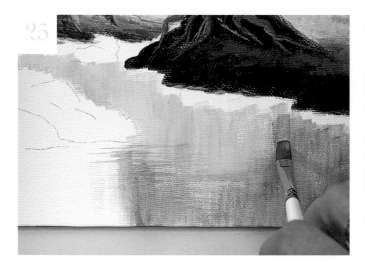

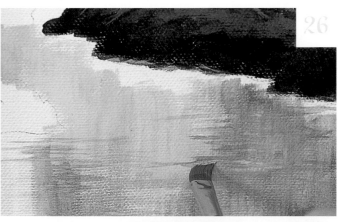

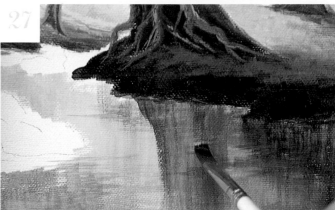

25 Brush mix Hauser Medium Green + Blue Mist, and thin with water. Brush long downward strokes in the darker areas of the water, overlapping the Pineapple and brushing over the edges of it with very thin paint. Brush in some horizontal strokes with the flat of the brush, blending the light and dark together. Add a few horizontal strokes with the chisel edge of the brush to create lines on top of the water.

26 Pick up more thinned Pineapple if needed to help in the blending. Add the horizontal lines with the chisel edge of the brush to pull some of the dark into the light and some of the light into the dark.

27 Paint several thin layers of the green mix (from step 25) on the water to build up color, letting it dry between coats. For the darkest shading in the water, brush mix Russet + Payne's Grey + touches of Lamp Black and thin with water. Brush in downward strokes where the darkest reflections are, then quickly brush in a few horizontal strokes before the paint dries. Use the same mix for the reflections of the big tree. Again, brush downward, then quickly brush lightly across to distort the downward lines.

28 Continue building up the colors in the water with more thin layers of color, brushing downward with the flat of the brush first, then quickly across while the paint is still wet. Add a touch of the dark mix (from step 27) underneath the distant banks, but keep this area lighter for distance. As you add layers of lights and darks you will see the water having depth and shine.

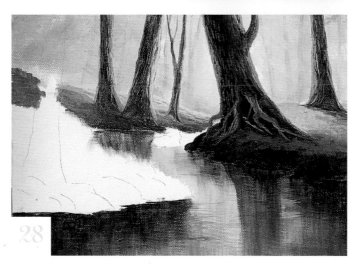

Hauser Medium Green + Blue Mist

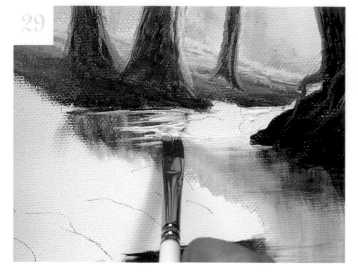

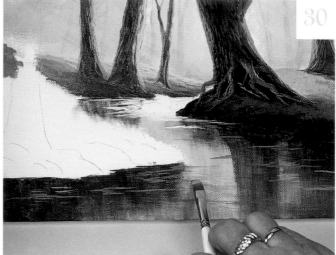

29 With Light Buttermilk on the no. 8 flat, add the light water around the distant bend and rock. Move the brush horizontally, on the chisel edge, to get the feeling of ripples moving on the surface of the water.

30 Pick up Hauser Light Green + a touch of Blue Mist. Paint short, horizontal movement lines in the water to give the water depth and dimension.

Left-Hand Bank

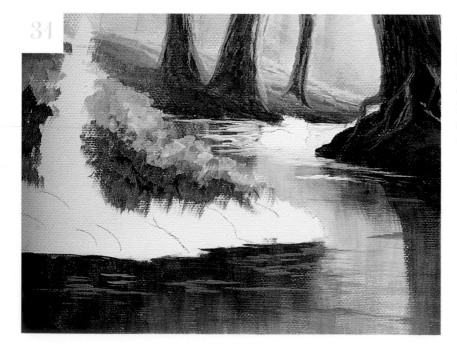

31 Using the ½-inch (12mm) flat, brush mix Hauser Light Green + Pineapple, and tap in the light grass. Hold the brush perpendicular to the surface. Pick up a little Hauser Medium Green for variation. As you move down the grass, toward the bank, pick up a little Payne's Grey. Keep the strokes short and pull downward. Work around the tree and down to the rocks.

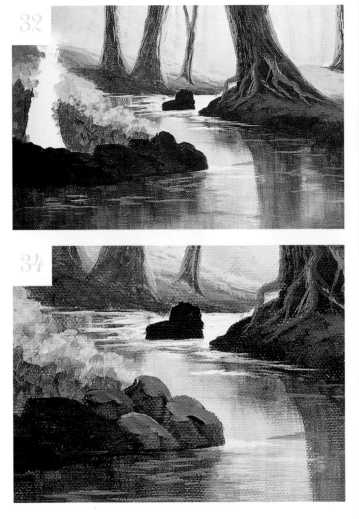

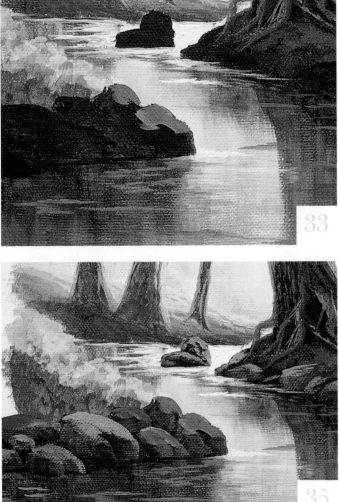

32 With the no. 8 flat, fill in the rocks with Lamp Black.

33 Begin to shape the rocks by first establishing the top of the rock. Mix Russet + Peaches 'n Cream, and brush in an irregular shape to define the top surface of the rock. Work for different shapes to each one.

34 Indicate the side of each rock with a small amount of Russet + Blue Mist. The sides should be darker than the top for contrast. Use a light touch with only a little paint.

35 Continue painting tops and sides of the rocks, working for contrast in color values to show the shapes. Too much light color on the sides will cause you to lose the shape. If this happens, simply add a thin glaze of a dark color to the side to bring the contrast back.

Russet + Peaches 'n Cream

Remaining Tree and Foliage

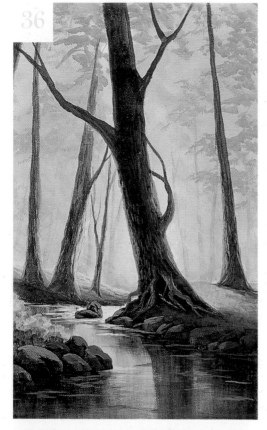

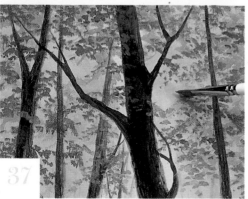

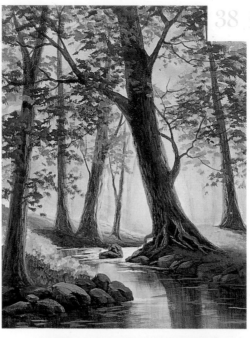

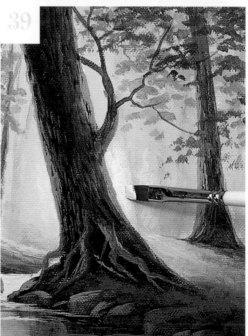

36 Base in the remaining tree or trees with a mix of Russet + Payne's Grey slightly thinned. Highlight on the right with Peaches 'n Cream + Pineapple. Shade on the left with Blue Mist.

37 Use the corner of the ½-inch (12mm) flat to tap in the foliage, holding the handle of the brush to the side rather than down. Begin with Hauser Light Green, adding touches of Hauser Medium Green. For the lightest leaves toward the center, add a touch of Cadmium Yellow to the Hauser Light Green. Work for loose groupings of foliage.

38 Add some darker foliage with a mix of Deep Midnight Blue + Hauser Medium Green. Tap this foliage in with the same corner of the brush, again working for groupings of leaves. For variety, add a little Hauser Light Green, tapping over the dark mix in a few places. Add a few more branches with thinned Payne's Grey + Russet using the no. 2 liner. Use wetter paint to fade some of the branches into the background.

39 Re-establish the strong light on the right of the big tree by patting Titanium White on rather thickly with the no. 8 flat. Also add a little on the left side and a bit in between the distant trees on the right. Touch a bit on the top of the grassy bank on the right as well. This will give the light areas an extra glow.

Cadmium Yellow + Hauser Light Green

Deep Midnight Blue + Hauser Medium Green

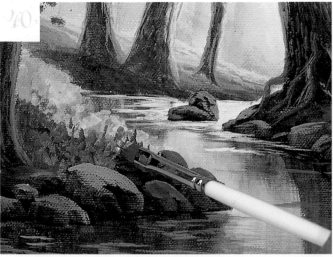

40 Add the flowers with a mix of Deep Midnight Blue + Titanium White. Tap them in with the bottom edge of the no. 8 flat. Work for a loose, natural look.

Deep Midnight Blue + Titanium White

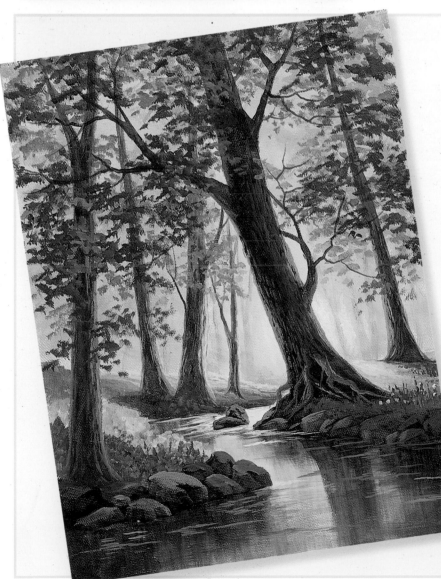

Tap flowers onto the right and left banks to finish the painting. Protect your painting with two coats of varnish.

PROJECT THREE

Rosewood Cottage

English cottages have been so popular the last few years that I couldn't resist putting one in this book. It is painted from a photograph I took while in England a few years ago. I added the lit windows, a few more flowers and the sunset sky.

There are many things to learn in this painting. You will be layering on thin washes of paint to add color to the sky and shading on the building. You will learn how to paint a stone wall on the cottage, as well as how to create the look of a thatched roof. Learn an easy way to paint pine trees in this scene so you will be able to paint them again in other paintings. Everyone loves light streaming from brightly lit windows. See how easy it is to achieve.

MATERIALS

DecoArt Americana Paints

| Antique Rose | Baby Blue | Black Forest Green | Light Buttermilk | Payne's Grey |
| Peaches 'n Cream | Pineapple | Russet | Violet Haze | Wisteria |

Royal Synthetic Brushes
no. 1 liner series 595, no. 2 liner series 595, no. 4 filbert series 170, no. 2 flat series 150, ½-inch (12mm) flat series 700, ¾-inch (19mm) flat series 700

Additional Supplies
white gesso, 1-inch (25mm) foam brush, fine sandpaper, tack cloth, black graphite or Saral transfer paper, stylus

Surface
Wooden tray from Viking Woodcraft, Inc.

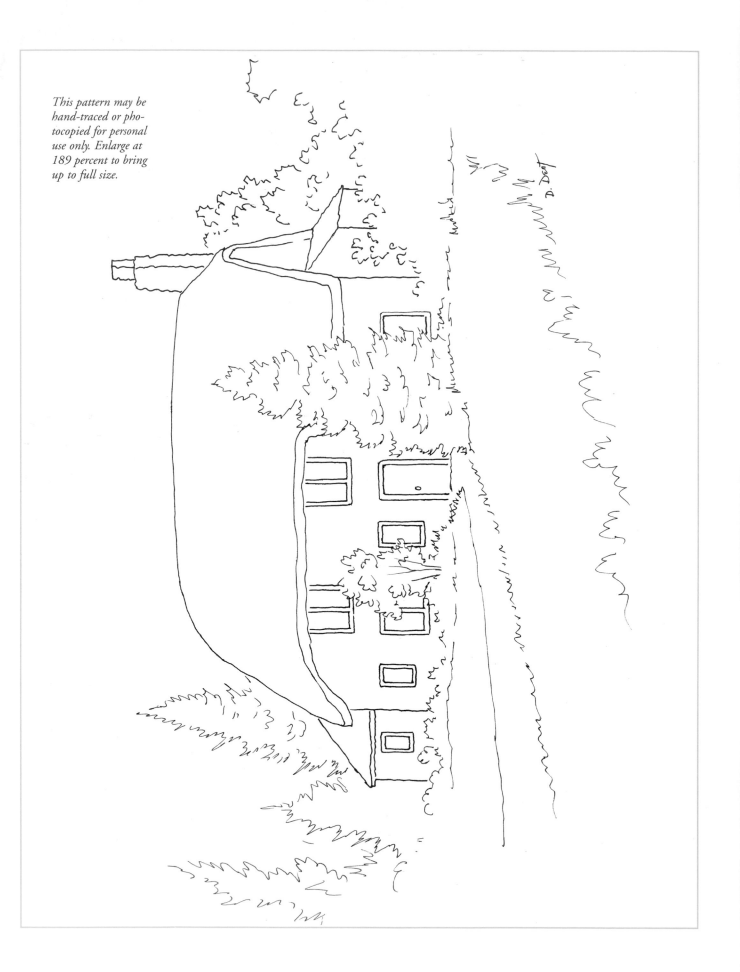

This pattern may be hand-traced or photocopied for personal use only. Enlarge at 189 percent to bring up to full size.

1 After sanding the raw wood and wiping with a tack cloth, basecoat the bottom of the tray with two coats of white gesso using the 1-inch (25mm) foam brush. With the same brush, base the sides with two coats of Black Forest Green. Brush Wisteria on the edges of the rim. Transfer the pattern using black graphite and the stylus.

2 Using the ½-inch (12mm) flat, basecoat the entire sky with Wisteria, adding more water as you brush toward the bottom of the sky to create a lighter value.

3 When the basecoat is dry, brush a thin glaze of Antique Rose over the sky with the ½-inch (12mm) flat. Brush horizontally, glazing in more at the bottom than at the top.

4 With thinned Violet Haze on the bottom corner of the ½-inch (12mm) flat, tap in the most distant foliage. Tap some in above the tree pattern line, adding touches of thinned Baby Blue in the distance also.

Trees

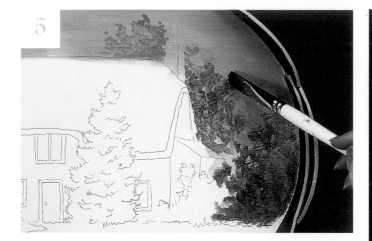

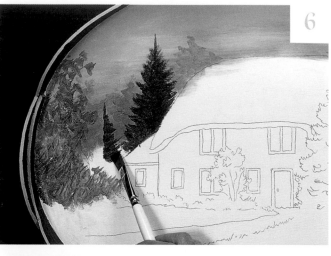

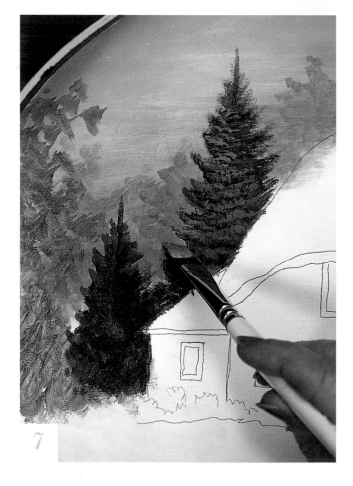

Black Forest Green + Russet

Black Forest Green + Wisteria

5 Using the ³⁄₄-inch (19mm) flat, brush mix Black Forest Green + Russet, adding a little water to thin the mix. Using the bottom corner of the brush, tap in the darker bushes on both sides of the house. Vary the color, sometimes using more Black Forest Green, sometimes more Russet. Work for the varied values of foliage. Deepen the color toward the bottom using more paint and less water.

6 Paint the pine trees with the ¹⁄₂-inch (12mm) flat loaded with Black Forest Green + Russet, mixed to a dark green. Paint a center placement line in for a tree. Pat in the branches with the side of the brush, making a full Christmas-tree shaped tree. You may need two coats for a nice dark value.

7 Highlight the trees with Black Forest Green + Wisteria, mixed approximately 1:1. Occasionally add touches of Violet Haze in the shadows. Tap more highlights on the left and center of the trees. If you get more than you want, tap in more of the dark basecoat.

8 Using the no. 1 liner, paint the very distant trunks and branches with thinned Violet Haze. Add a bit of Payne's Grey to the Violet Haze for those trees closer to you.

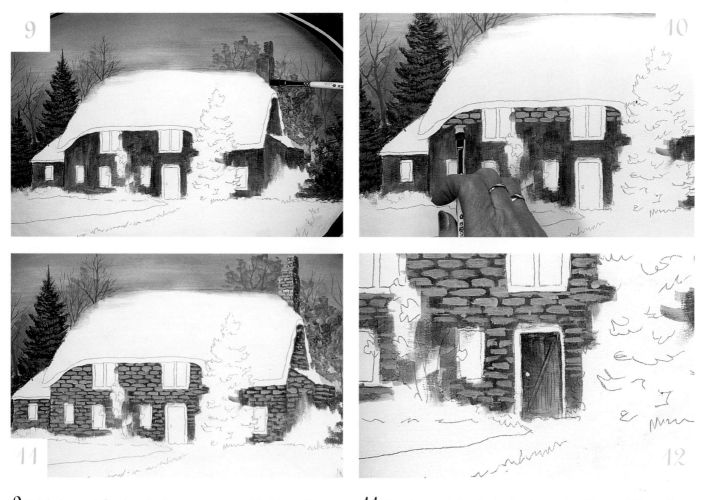

9 With the no. 8 flat, base in the cottage walls with thinned Russet. It doesn't have to be smooth—this will become the dark value seen between the stones as mortar. Base in the chimney at the same time.

10 With the no. 8 flat, paint the bricks on the wall with Light Buttermilk + Peaches 'n Cream. Paint one row at a time, staggering the bricks in the rows so that they are laid just as real bricks are.

11 Use the no. 2 flat for the bricks on the chimney. When all the bricks are finished, they should look similar to this.

12 Basecoat the door with thinned Russet using the no. 8 flat. Pull vertical strokes allowing the paint to be a little streaky, as this will help it to look like wood grain. Shade the door with thinned Payne's Grey, shading it a bit darker to the left. With the no. 2 liner, suggest some board lines and trim lines with thinned Payne's Grey + Russet. Highlight the door with a few streaks of Peaches 'n Cream. Add a dot of Pineapple for the doorknob.

Light Buttermilk + Peaches 'n Cream Payne's Grey + Russet

Windows

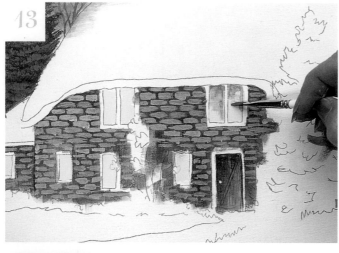

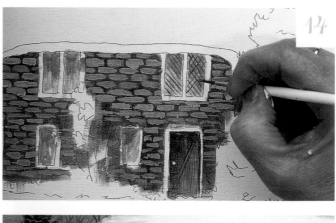

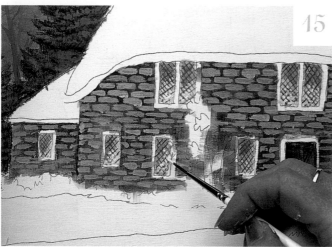

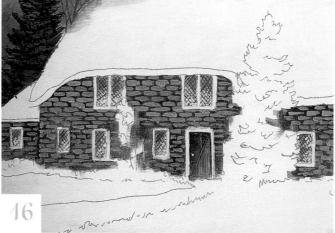

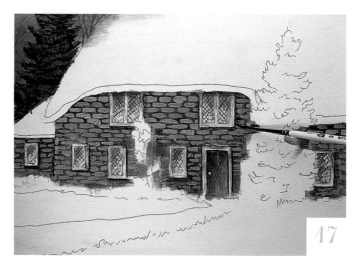

13 Basecoat the windows with Pineapple using the no. 4 filbert. Add an orange-pink mix of Pineapple + Antique Rose in the tops of the windows, thinning the paint slightly with water. Don't lose all the Pineapple basecoat.

14 With a little thinned Violet Haze on the no. 1 liner, add the diamond-shaped windowpanes.

15 For a final highlight in the windows, load the no. 2 liner with Pineapple, and dab it into the panes that you want to be the brightest. Don't worry if a little gets on the pane lines as that will make the light look like it is glowing.

16 Basecoat the window and door frames with Light Buttermilk + Pineapple using the no. 2 liner.

17 Shade around the frames with thinned Payne's Grey + Russet. This will help to straighten up any crooked frames. Deepen the shading at the tops of the windows that are under the overhang of the roof. Add more shading underneath the bottom of the windows too. If you have lost some of the light on the frames, re-establish it with additional touches of Pineapple and/or Peaches 'n Cream.

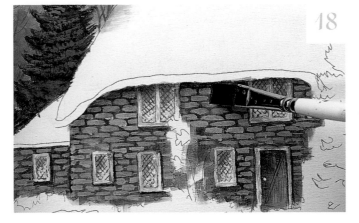

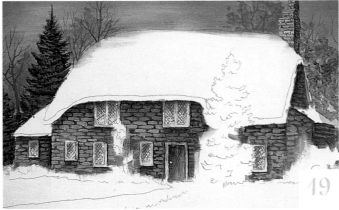

18 Using the ½-inch (12mm) flat, load the corner of the brush with thinned Payne's Grey. Stroke the brush a time or two on the palette to distribute the paint along the bristles. With the brush held so the Payne's Grey is under the edge of the roof, brush in the shading at the top of the wall as shown.

19 Continue to thinly layer in the Payne's Grey to create shadows under the roof edges and other places where needed. It is better to have several thin layers to create darker shading than one heavier layer. The center of the wall should be lighter, so avoid putting shadows here. Paint the far right wall with additional shading all the way up to the chimney.

Roof

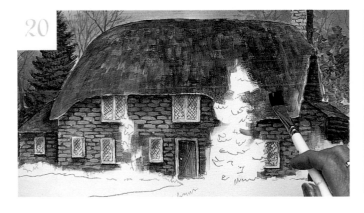

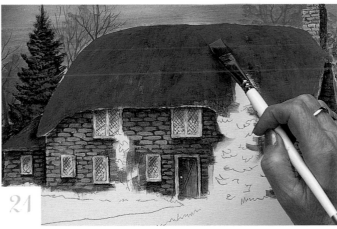

20 Paint the roof with slightly thinned Payne's Grey using the ½-inch (12mm) flat. Pat in the whole roof with short downward strokes. A slightly mottled look will give an impression of thatch, so don't try to make it smooth.

21 Go over the roof again with Violet Haze + a touch of Payne's Grey, keeping the paint thin and continuing with short downward strokes. Vary the color, using more Violet Haze in some areas and more Payne's Grey in others

Violet Haze + Payne's Grey

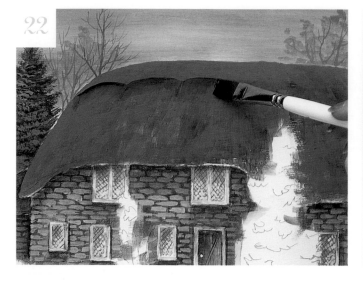

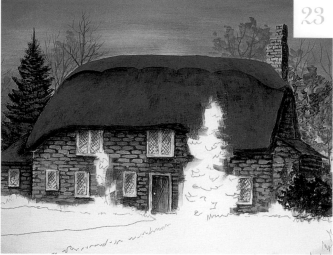

22 Paint the scallops on the roof to define the cap over the peak of the roof. Dip the ½-inch (12mm) flat in water and blot slightly. Dip one corner in Payne's Grey and stroke a couple of times on the palette to distribute the paint along the bristles. With the Payne's Grey corner up and the brush held flat, stroke in the scallops.

23 Do the same for the edging at the bottom of the roof, but hold the brush so that the Payne's Grey edge is at the bottom. Also add a Payne's Grey edge at the right side of the roof. Use a slightly smaller brush for that edge, if you like.

Foreground Trees

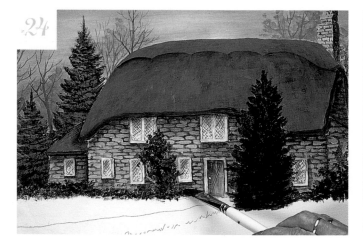

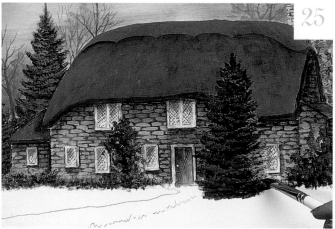

24 Base in the foliage in front of the cottage with a dark mix of Russet + Black Forest Green. Tap in the bushes with the bottom corner of the ½-inch (12mm) flat. Paint the pine tree as described in step 6.

25 Highlight the bushes with Black Forest Green + Wisteria, adding touches of Violet Haze. Leave some of the dark basecoat to create depth. On the pine tree add more Black Forest Green + Wisteria on the right and more Violet Haze on the left. Dab a little Pineapple on the foliage closest to the windows to give the effect of light hitting the branches.

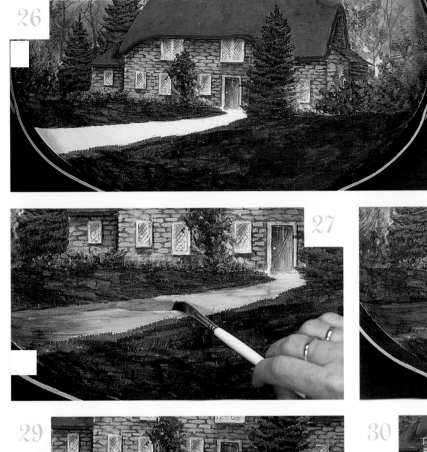

26 Using the ¾-inch (19mm) flat, basecoat all of the grass with slightly thinned Black Forest Green + Russet. Loosely mix the paint, but work in a bit more green than Russet. Use short downward strokes that follow the slope of the ground.

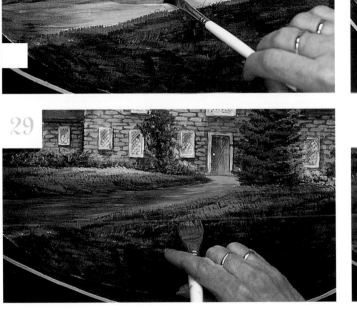

27 With the no. 8 flat and thinned Russet, brush in the path with horizontal strokes. The path should look streaky. Work for a slightly darker value to the left side.

28 Add a little Peaches 'n Cream by the door, fading it down into the Russet. With the ½-inch (12mm) flat, add a thin glaze of Payne's Grey to the left to deepen the shading. Continue brushing back and forth with horizontal strokes.

29 Highlight the grass under the lit windows with a lot of Pineapple on the top of the ¾-inch (19mm) flat. Paint with short downward strokes to create a bit of texture. As you move away from the windows, pick up a little Black Forest Green with the dirty brush for a middle value between the highlight and the basecoat. On the right side, highlight the grass with Pineapple + Black Forest Green, adding touches of Payne's Grey to the mix. Use the same downward strokes, fading the color out over the dark basecoat.

30 As you work into the middle ground, pick up some Violet Haze on the top of the brush and use the same downward strokes. Add some Violet Haze to the far left also. If you get too much, go back and stroke in some Black Forest Green + Russet.

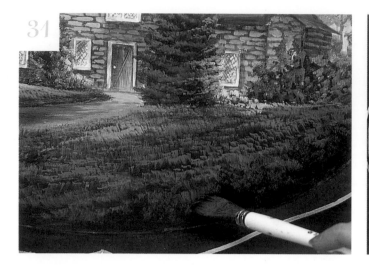

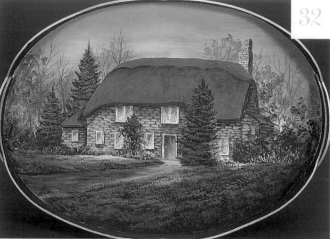

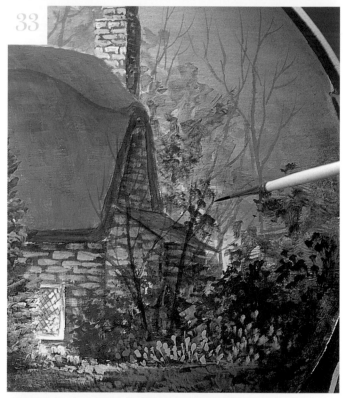

31 With the ¾-inch (19mm) flat, tap in the very bottom bushes with Black Forest Green + Russet + Payne's Grey mixed to a dark value. Tap them in along the bottom of the tray, and up the right side. Pick up Antique Rose on the top corner of the brush and tap in the red flowers. Occasionally give the brush a downward flick to set the flowers into the bushes a bit.

32 Add more flowers around the building using variations of Antique Rose, Baby Blue, Violet Haze, and Antique Rose + Russet. Add touches of Peaches 'n Cream on the rose bush by the door and to some of the flowers on the left. Use the no. 2 liner with the paint loaded quite heavily to add some of the small flowers. With Baby Blue on the tip of the liner, flick in some ground flowers around the bushes. When adding flowers in this way, think of groupings of color and work for a balanced look.

33 With the no. 2 liner and thinned Payne's Grey, add the small tree trunks and limbs in front of the cottage. Work for both lighter and darker values by varying the amount of water mixed with the paint. The lighter trees will look more distant.

34 With the bottom corner of the no. 8 flat, paint the smoke with thinned Light Buttermilk + a touch of Pineapple. Begin the smoke at the top of the tray and make circular strokes down toward the chimney. Use very thin paint for a light, wispy effect.

Light Buttermilk + Pineapple

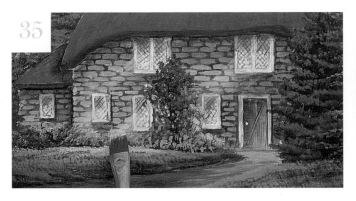

35 Paint the light rays streaming from the windows with thinned Light Buttermilk + Pineapple on the ½-inch (12mm) flat. Set the brush in the window and pull out, putting very little pressure on the brush. Keep the paint very thin, and repeat the stroke if needed to brighten the light. Allow the paint to dry between strokes for best results

36 Add the trim on the box by loading the no. 2 liner with Violet Haze. Pull comma strokes around the edge of the rim, spacing them out in a freehand manner.

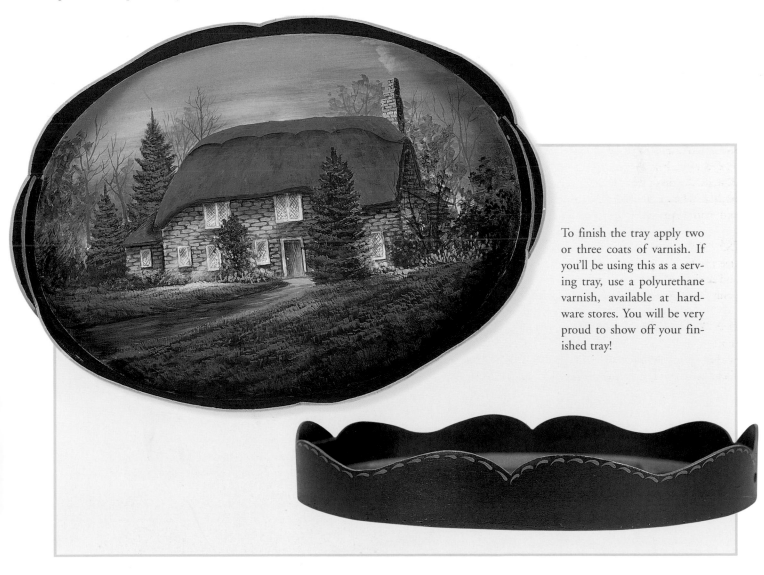

To finish the tray apply two or three coats of varnish. If you'll be using this as a serving tray, use a polyurethane varnish, available at hardware stores. You will be very proud to show off your finished tray!

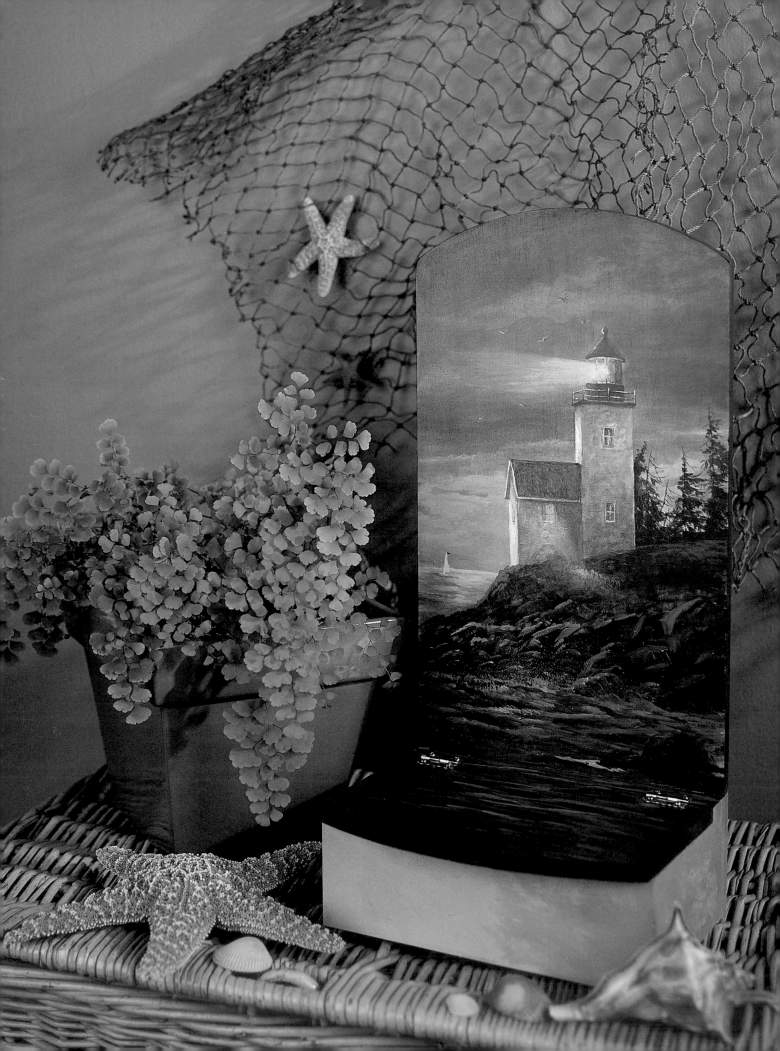

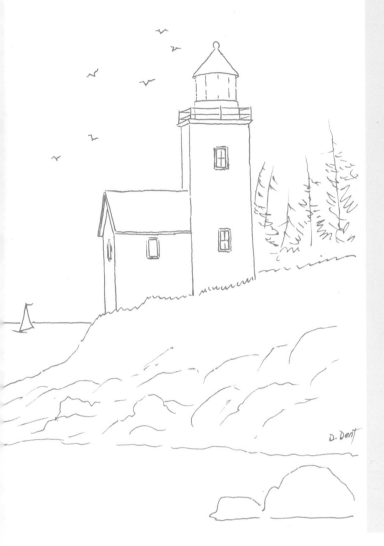

Harbor Lights

I love lighthouses, and so do many of you. They are so popular now that one sees them in everything from fine art paintings and sculptures to refrigerator magnets. The shores of Maine boast many lighthouses, and I took many photos while teaching in that area. I used my "artistic license" to simplify one of them to create this design.

There are many lessons in this small painting. You will learn to paint a sunset sky by working with several layers of color. You will learn a technique for painting a building that looks like rock or stone, but not as detailed. You will learn how to paint the beam of light, which is similar to the light rays in Rosewood Cottage, and you will have more practice on rocks. Of course the ocean needs to look like it is moving and splashing, so you will see that the direction of your brushstrokes is all important.

MATERIALS

DecoArt Americana Paints

Baby Blue	Black Forest Green	Deep Midnight Blue	Green Mist	Light Buttermilk
Payne's Grey	Peaches 'n Cream	Pineapple	Primary Red (Napthol Crimson)	Russet
Titanium White	Violet Haze			

Royal Synthetic Brushes
no. 1 liner series 595, no. 2 liner series 595, no. 8 round series 250, no. 8 flat series 150, ½-inch (12mm) flat series 700

Additional Supplies
fine sandpaper, tack cloth, 1-inch (25mm) foam brush, stylus, black graphite paper

Surface
Wall box from Sechtem's Wood Products

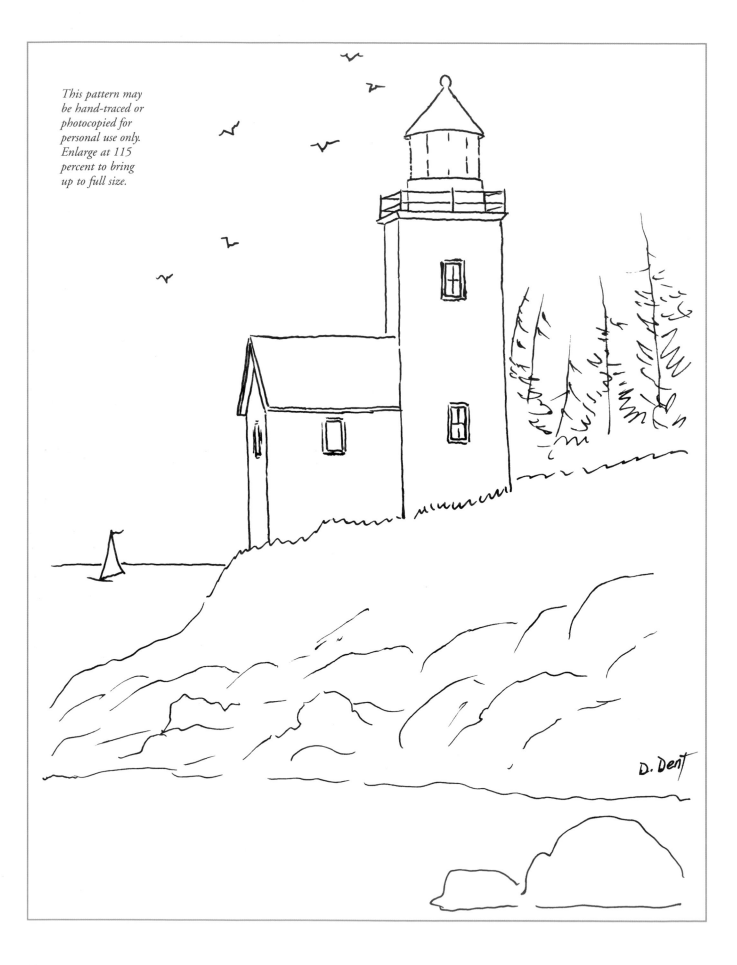

This pattern may be hand-traced or photocopied for personal use only. Enlarge at 115 percent to bring up to full size.

D. Dent

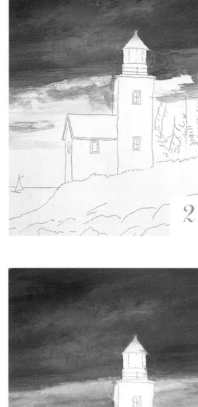

1 After sanding the wood and wiping with a tack cloth, basecoat the surface with two coats of Light Buttermilk using the 1-inch (25mm) foam brush. Base in the edges with Deep Midnight Blue. Transfer the pattern to the surface using black graphite paper and the stylus.

2 With the ½-inch (12mm) flat, brush mix Deep Midnight Blue + a little Light Buttermilk and paint the sky. Vary the colors a bit, making the sky darker to the top with more Deep Midnight Blue, and a little lighter to the bottom with more Light Buttermilk. Since there will be more clouds added to this basecoat, you do not need to make the sky smooth. Add a little Baby Blue under and overlapping the dark basecoat in a few places at each side. By varying the colors you can begin suggesting clouds. Leave unpainted the areas that will be peach. Work carefully around the lighthouse. Keep the brush moving in a generally horizontal direction to suggest wind flow.

3 With the same brush, mix Peaches 'n Cream + Light Buttermilk + a touch of Pineapple. Brush in the light areas, working on the side of the brush and overlapping the blues. Vary the combination of the mixes (Peaches 'n Cream + Light Buttermilk and Pineapple + Light Buttermilk) to give your sunset sky the lovely variations of color. Apply several layers of these mixes to soften the edges where the light values overlap the dark. Add a bit more Baby Blue at the edges to help set the colors together.

4 Continue layering and working color on top of color until you are satisfied with the sky.

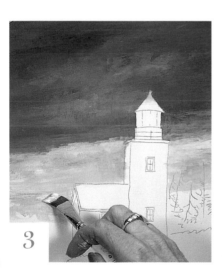

Deep Midnight Blue + Light Buttermilk

Peaches 'n Cream + Light Buttermilk + Pineapple

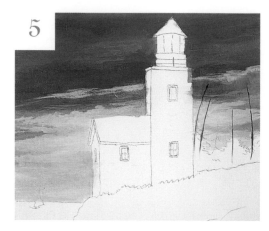

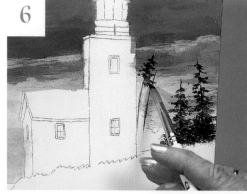

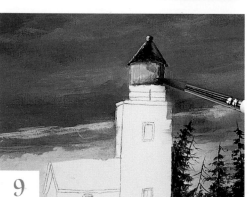

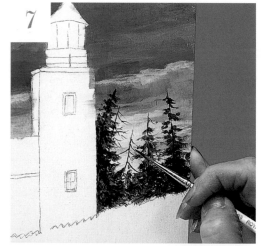

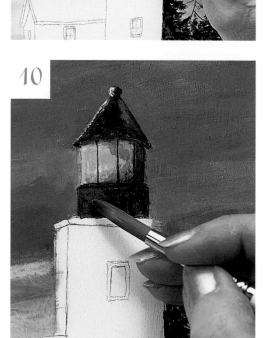

5 With a mix of Black Forest Green + Payne's Grey on the no. 8 round, paint a placement line for the center of each pine tree.

6 With the tip of the brush and the same dark mix, tap in little branches working from the centerline out. Paint the branches shorter at the top and gradually longer at the bottom.

7 Using the no. 1 liner and thinned Payne's Grey, flick in a few bare branches.

8 With the no. 8 round, fill in the cap of the lighthouse with a dark mix of Payne's Grey + Deep Midnight Blue. Highlight on the left with Light Buttermilk using the no. 2 liner. Touch a little Violet Haze on the right side for a cool reflected light. Soften the edge where the basecoat and the Violet Haze meet by adding a bit of thinned Deep Midnight Blue between the colors.

9 Basecoat the entire light area with Peaches 'n Cream using the no. 8 round. Be sure to maintain the slight curve at the bottom of the cap. Shade this area by brushing in a little thinned Russet on the right side and at the bottom. When dry, deepen the shading with a little thinned Payne's Grey.

10 With the no. 8 round, base in the dark section beneath the light with Payne's Grey. Note that the top edge curves up just slightly in the center. Paint out the fence at this point. With the no. 1 liner, paint the Payne's Grey vertical bars in the light.

Payne's Grey + Deep Midnight Blue

Black Forest Green + Payne's Grey

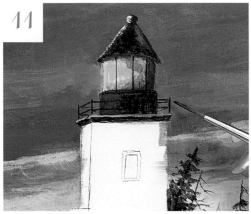

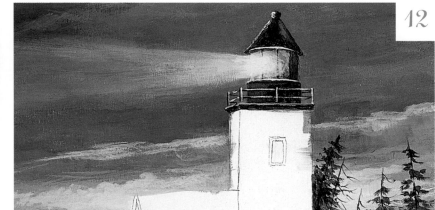

11 With the no. 8 round, paint in the base of the platform with Payne's Grey. Switch to the no. 1 liner and highlight the top of the platform with Baby Blue. With thinned Payne's Grey on the liner, paint the little posts back in. Paint all the vertical posts, then paint the horizontal railings. Don't forget the hints of railings on the backside of the light.

12 With the bottom corner of the no. 8 flat, tap Pineapple in the center of the light where the brightest part of the light would be. With thinned Pineapple and the flat of the brush, pull the paint from the center into the sky. Keep the paint very thin, and brush back and forth as needed to soften the glow of light. Several coats are better than one heavy coat; allow it to dry between coats. Build up more color as needed directly in the light. Add the light reflecting on the bottom of the cap, the base of the light, the posts and railings with a thin line of Light Buttermilk applied with the tip of the no. 1 liner. Add a bit of Pineapple over the Light Buttermilk where the light is the brightest.

Walls

13 When painting the wall, consider the Light Buttermilk basecoat as the light value. With the no. 8 flat, add texture and the look of stones by patting in thinned Deep Midnight Blue, adding a little Violet Haze now and then. Pat on the flat side of the brush and overlap the strokes. Keep the strokes loose and pick up touches of Light Buttermilk now and then for additional highlight. Work for contrast between the colors in the sky and the colors on the lighthouse.

14 Highlight the left-hand walls with Light Buttermilk, adding a touch of Pineapple. If needed, add a bit more Peaches 'n Cream to the sky to create a higher contrast between the sky and the wall. Additional shading of thinned Payne's Grey may be added for deeper shading under the eaves of the smaller building and to the right of that building's front wall.

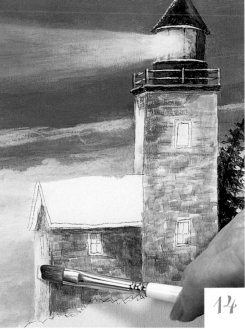

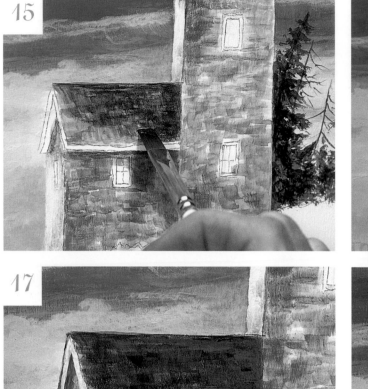

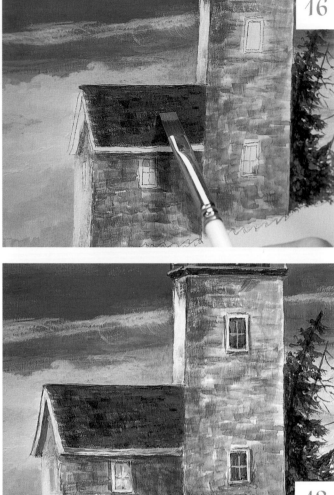

Payne's Grey + Light Buttermilk Peaches 'n Cream + Pineapple

15 With the no. 8 flat, paint the roof by following the slope as you stroke in thinned Russet. Use short downward strokes that overlap to create the feeling of shingles. Add hints of thinned Payne's Grey for shading, continuing with the short downward strokes.

16 Thin Violet Haze with water and stroke a little over the roof to lighten the darks. Continue to use short downward strokes.

17 Load the no. 2 liner with a medium value mix of Payne's Grey + Light Buttermilk. Paint in the narrow area under the overhang of the roof on the upper left side. Add more Light Buttermilk to strengthen the light walls if needed for contrast. With Light Buttermilk on the liner, paint in the fascia board. On the long side of the roof, shade the fascia board with a little Violet Haze. Paint a very thin line of Russet at the top of the diagonal fascia board on the far left side—this will separate the roof line from the sky.

18 Basecoat the inside of the two dark windows with Payne's Grey + a touch of Light Buttermilk using the no. 2 liner. Paint the frames with Light Buttermilk, then shade around the outside of the frames with thinned Payne's Grey. Base the lighted window with Peaches 'n Cream + Pineapple. Add the frame the same as the others. Paint the far left-hand window with the same light colors—it is too small to need a frame.

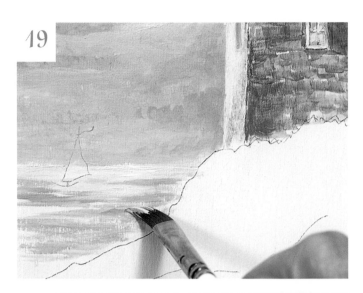

19 With the no. 8 flat, mix Peaches 'n Cream + Light Buttermilk, and begin to paint the distant water with horizontal strokes using the chisel edge of the brush. To create a choppy look, vary the colors a bit by sometimes picking up more Light Buttermilk and sometimes more Peaches 'n Cream.

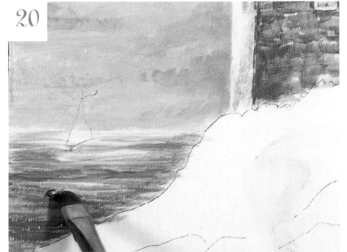

20 Work a little blue into the water with a mix of Light Buttermilk + Deep Midnight Blue. Continue to use choppy horizontal strokes, and overlap some of the peach.

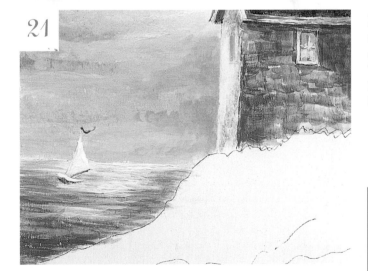

21 With the clean brush, pick up Light Buttermilk and highlight the top of the water, then paint a loose zigzag line down the middle of the water for extra shine. Load the no. 2 liner with Titanium White and base in the sail and hull of the boat. Add a little Light Buttermilk + Deep Midnight Blue to the bottom of the sail and the bottom of the hull. Add a touch of Primary Red for the flag.

| Peaches 'n Cream + Light Buttermilk | Light Buttermilk + Deep Midnight Blue |

Grass

22 Basecoat the grass with a brush mix of Black Forest Green + Russet, using the ½-inch (12mm) flat. With the paint on the top of the bristles, use short downward strokes and follow the slope of the ground as you go.

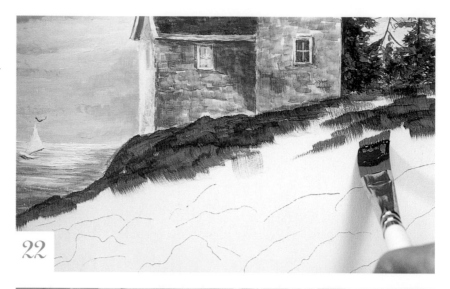

23 Work the grass down to the rocks. Highlight the top and left part of the grass with Pineapple + Green Mist. Let the highlight fade out as you move down to the middle of the grass. In the upper right, under the pine trees, tap in a bit of Deep Midnight Blue + Light Buttermilk with only a small amount of paint on the brush.

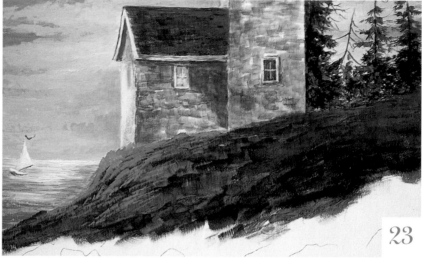

24 Add the light rays with thinned Pineapple, using the no. 8 flat. Set the brush flat on the window, then pull the light out at a bit of an angle. Where it hits the ground, add Pineapple + Green Mist for a light spot on the grass.

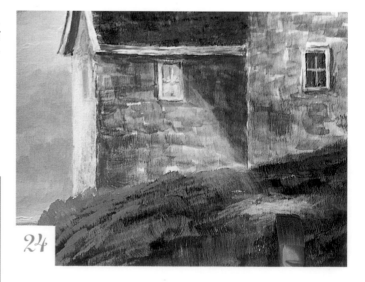

Black Forest Green + Russet

Pineapple + Green Mist

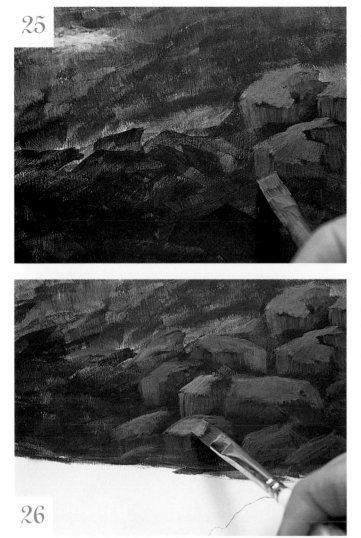

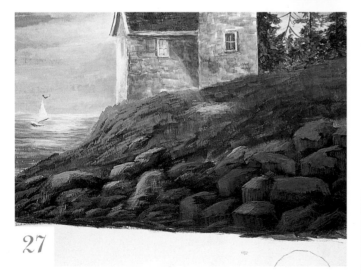

25 Brush mix a dark mix of Payne's Grey + Russet using the ½-inch (12mm) flat. Basecoat the rocks with two or three layers of this mix for a very dark basecoat.

With the no. 8 flat, brush mix Deep Midnight Blue + Light Buttermilk for a light blue-gray. When shaping the rocks, work on one rock at a time. Stroke in the top of the rock first. The top should be lighter than the sides, but still allow a little of the dark basecoat color to show. Shape the sides next using less paint on the brush for a darker value. Allow some of the dark to show as holes in the rocks and as shaded area between rocks. Begin another rock by again stroking in the top of the rock, then suggest the sides.

26 Continue to paint one rock at a time, varying their shapes and sizes. If you lose too much of the dark values on the sides, you will lose the shape of the rock. Add more darks back in as needed with Payne's Grey + Russet. Add touches of Light Buttermilk + Russet for a highlight on top of a few rocks.

27 When the rocks are all in, add a little Peaches 'n Cream to highlight a few of the rock tops to the left and top of the pile.

| Payne's Grey + Russet | Light Buttermilk + Russet |

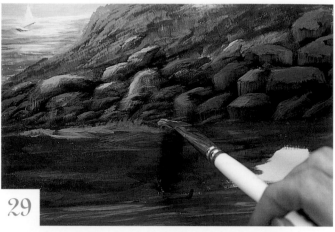

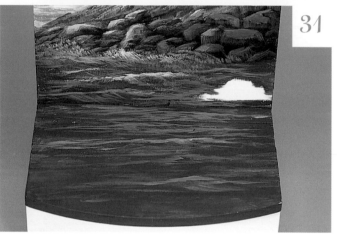

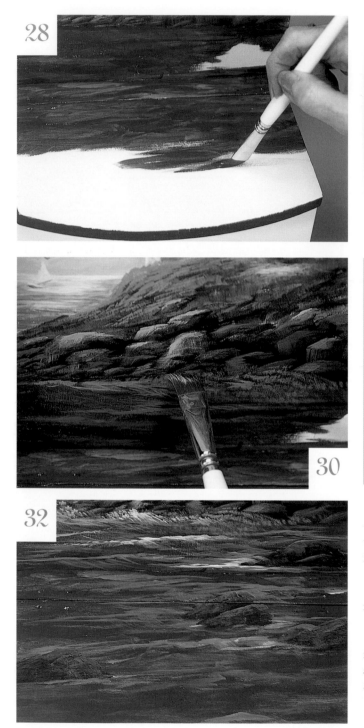

28 Base in the water with Deep Midnight Blue, occasionally picking up a bit of Black Forest Green. Use the ½-inch (12mm) flat and back-and-forth, horizontal strokes. Paint around the rocks in the water. Don't worry about achieving solid coverage—a bit of background or lighter color helps to give the appearance of foam and motion.

29 Highlight the water with a brush mix of Deep Midnight Blue + Light Buttermilk, adding Violet Haze every now and then. Push the highlights against the rocks with just a bit of paint on the ½-inch (12mm) flat brush.

30 Let the bristles of the brush separate to get the light sprays of foam.

31 Continue to paint more highlights with the ½-inch (12mm) flat, painting the strokes horizontally to show movement. Pull a few strokes down at an angle from the top of a wave to show a swell. Some of the final highlights may be just Light Buttermilk.

32 Base in the rocks in the water with Payne's Grey + Russet, shaping the rock with this dark mix on the ½-inch (12mm) flat. Add tops and sides with the no. 8 flat, using the same colors and procedures as on the previous rocks. Brush in movement lines around the rocks with Light Buttermilk to set them into the water.

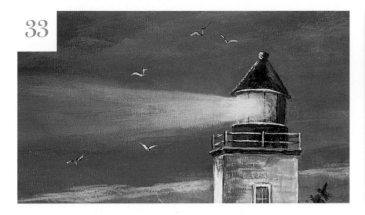

33 With Payne's Grey on the no. 1 liner, paint flying Vs in the sky for the birds. Highlight them with touches of Light Buttermilk.

34 To complete the side of the box, use the ½-inch (12mm) flat and slip-slap thinned Violet Haze + Light Buttermilk over the basecoat, using loose brushstrokes that go in different directions.

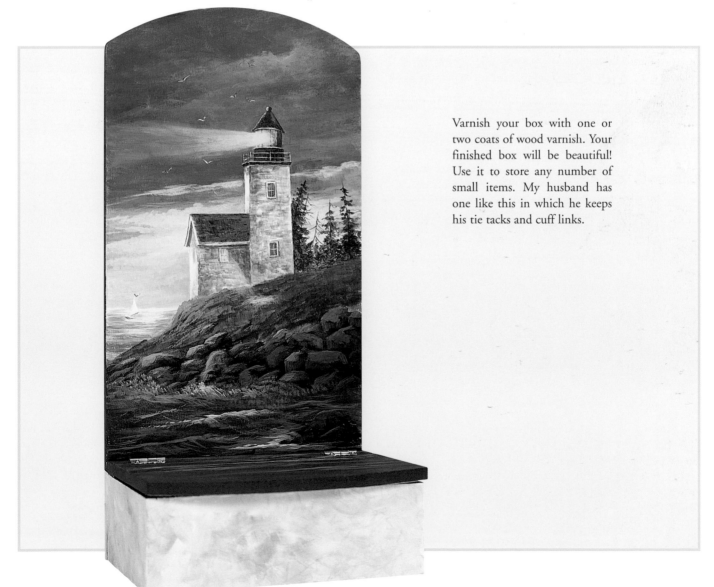

Varnish your box with one or two coats of wood varnish. Your finished box will be beautiful! Use it to store any number of small items. My husband has one like this in which he keeps his tie tacks and cuff links.

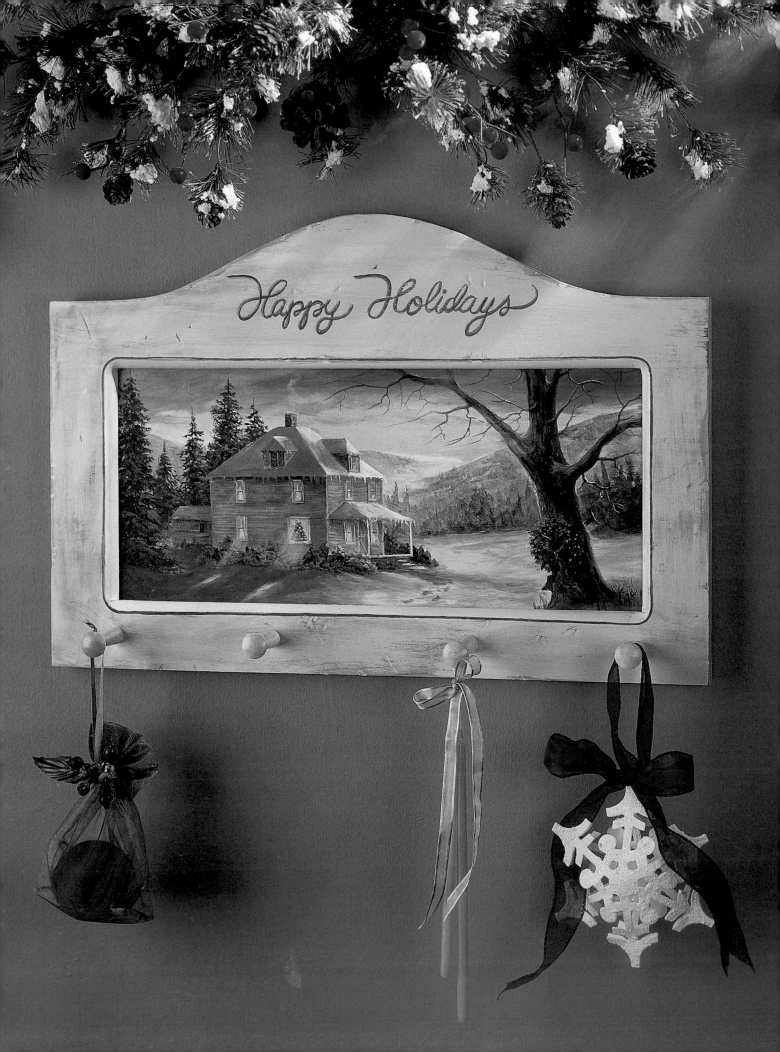

PROJECT FIVE

Country Christmas

This old farmhouse is ready for the holidays. It's fun to paint a special piece for Christmas each year and date the back. Your collection will grow over the years and bring back memories as you decorate your home.

You will learn to paint snow by simply blending the lights and dark together as you follow the slope of the ground. You can work as many layers of paint as you need to achieve the look you want. You will paint trees with snow on them, light from the windows, and build a house with horizontal board lines. There is a lot to do in this one! Enjoy.

MATERIALS

DECOART AMERICANA PAINTS

Black Forest Green	Cadmium Yellow	Deep Midnight Blue	Golden Straw	Light Buttermilk
Mink Tan	Payne's Grey	Peaches 'n Cream	Primary Red (Napthol Crimson)	Russet
Soft Peach	Violet Haze	Glorious Gold (Dazzling Metallics)		

ROYAL SYNTHETIC BRUSHES
no. 2 liner series 595, no. 8 round series 250, no. 8 flat series 150, ½-inch (12mm) flat series 700

ADDITIONAL SUPPLIES
fine sandpaper, tack cloth, 1-inch (25mm) foam brush, stylus, black graphite paper, medium or coarse sandpaper

SURFACE
Pegged board from Stan Brown Arts and Crafts or Painter's Corner, Inc.

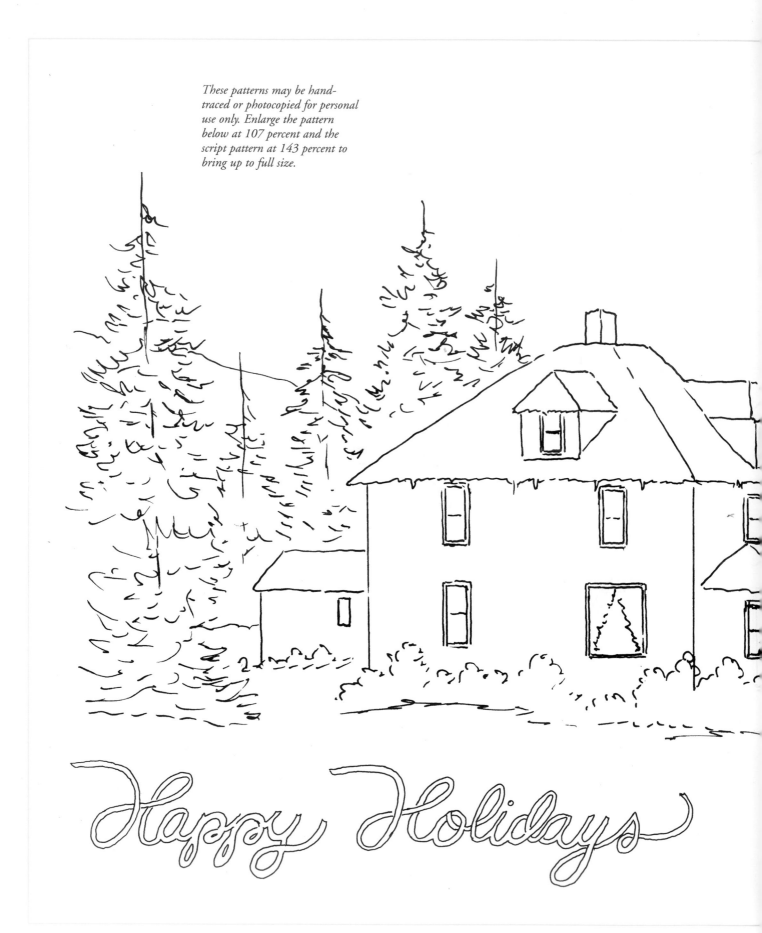

These patterns may be hand-traced or photocopied for personal use only. Enlarge the pattern below at 107 percent and the script pattern at 143 percent to bring up to full size.

D. Dent

1 Sand any rough edges with the fine sandpaper and wipe with a tack cloth to prepare the wood for painting. Remove the wooden panel and paint it with two coats of Light Buttermilk using the 1-inch (25mm) foam. When dry, transfer the pattern using black graphite paper and the stylus.

2 With the 1/2-inch (12mm) flat, brush Soft Peach over the bottom of the sky, working in sweeping, horizontal strokes. Brush between the pine trees and into the edges of the pattern lines to be sure all the sky is covered. Apply two coats of paint for good coverage. Mix Light Buttermilk + Deep Midnight Blue for a soft sky blue. Paint the blue at the middle of the sky using horizontal strokes to create distant clouds. Keep the paint moist with water to work it over the peach. Pick up more Soft Peach to aid in the blending as needed.

3 Paint the sky at the top a darker value of Light Buttermilk + Deep Midnight Blue. Work with slightly thinned paint, building up the darker values with several layers of color. Continue picking up Soft Peach to help blend the blues into the light tones at the middle and bottom of the sky. Paint out the tops of the trees.

4 Pat in the distant hills with short downward strokes, still using the 1/2-inch (12mm) flat. Begin with Light Buttermilk, then pick up a little Payne's Grey + Light Buttermilk, and continue working in the hill. Add touches of thinned Black Forest Green to suggest something growing in the distance. Keep all the values very light. Pat a bit of these colors on the hill to the left, above the pine trees.

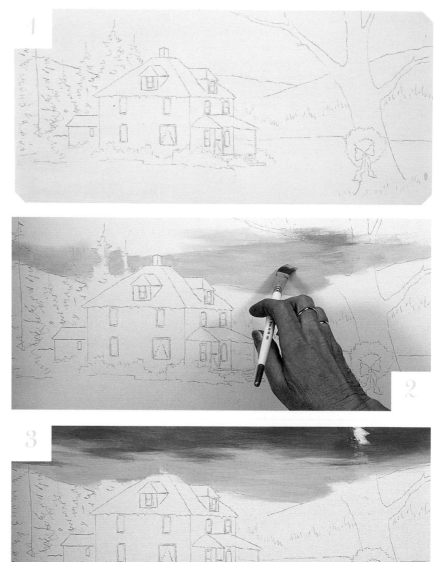

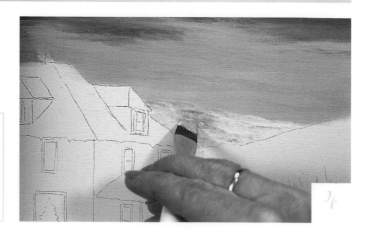

Light Buttermilk + Deep Midnight Blue

Payne's Grey + Light Buttermilk

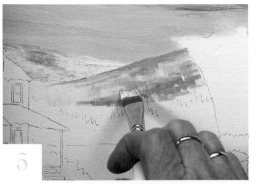

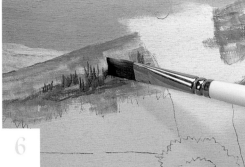

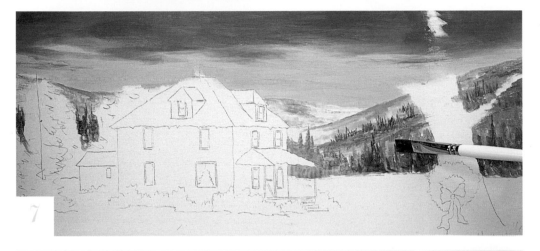

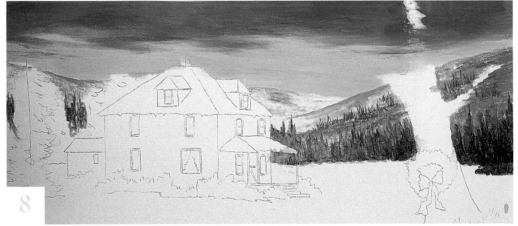

5 Paint the larger hill on the right with a mix of Light Buttermilk + Deep Midnight Blue + Payne's Grey, varying the colors a bit for lights and darks. Continue with the short downward strokes.

6 Mix Payne's Grey + Black Forest Green and thin with water. Pat in a few trees with this light value. Use the bottom corner of the side of the 1/2-inch (12mm) flat for the larger, vertical tree shapes. Pat a little Light Buttermilk and Payne's Grey around the bases of the trees to set them into the ground.

7 Paint the brown trees in the distance with a thinned mix of Russet + Light Buttermilk. Pat them in very loosely using the side of the brush. Work for little more than a wash of color, but add a bit more Russet for a few darker trees. Add some of the color beneath the porch roof and behind the pine trees on the left.

8 Mix Payne's Grey + Black Forest Green and thin with water. Pat this color in front of the Russet trees. Use just the edge of the brush, keeping the handle off to the side. Keep the values very light for distance. If the trees look too dark, let them dry, then brush with a thin glaze of Soft Peach.

Payne's Grey + Black Forest Green

Russet + Light Buttermilk

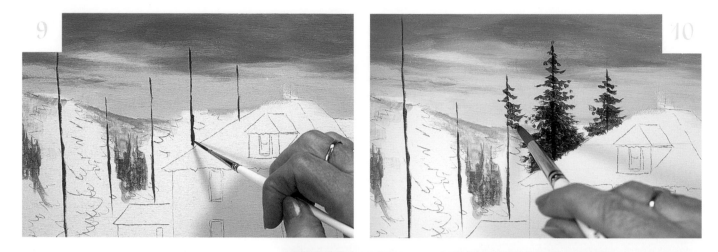

9 Begin the large pines by loading a dark green mix of Payne's Grey + Russet + Black Forest Green on the no. 2 liner. Draw a centerline for each tree.

10 Use the same mix on the tip of the no. 8 round to build the branches. Stand the brush straight up on the tip, and bend the bristles over slightly to release the paint. Work back and forth across the tree, beginning at the top and working down. Stagger the branches a little, keeping the branches close enough together to keep the fullness of the tree. To make the tree dark enough you may need to go over the branches with a second coat.

11 Add the snow on the trees with a little Light Buttermilk, using the same technique as in step 10. Add touches of Deep Midnight Blue and Violet Haze to the Light Buttermilk for shadows in the snow. Keep the right side of the trees a little lighter, as the light is hitting there.

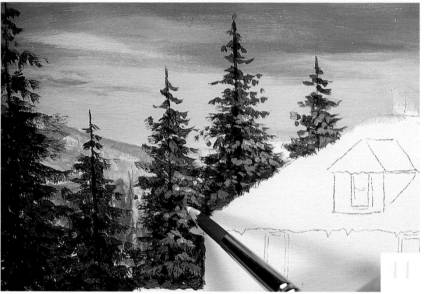

Payne's Grey + Russet
+ Black Forest Green

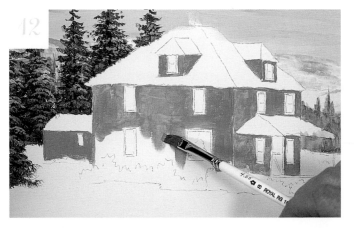

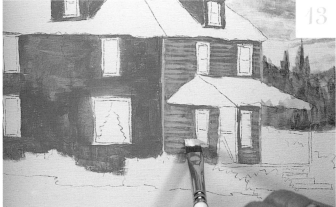

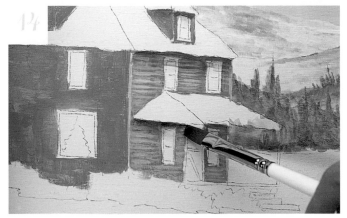

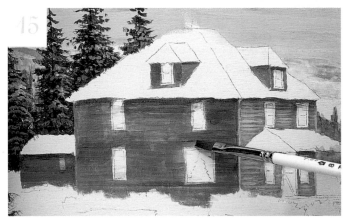

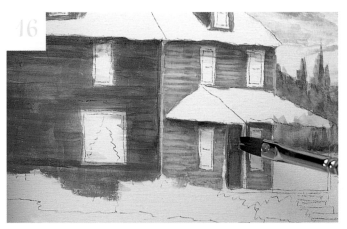

14 Shade beneath the roof edge and under the porch with thinned Payne's Grey.

15 Stroke in a few board lines on the left side of the house with thinned Payne's Grey. Paint them darker in some areas and lighter in other areas. Don't make them too perfect—just suggest that they are there. Add more shading beneath the roof edge with thinned Payne's Grey. Paint the dormers the same as the lower walls. Work for a light side and dark side on each one.

16 Paint the door with a basecoat of Mink Tan. Add shading with thinned Payne's Grey, stroking vertically.

12 Basecoat the house walls with Mink Tan using the no. 8 flat. Work around the windows.

13 Paint the boards on the right side of the house with the chisel edge of the no. 8 flat. Use a mix of Light Buttermilk + Golden Straw. Paint the horizontal boards, then the vertical corner boards. Note that the horizontal boards follow the angle of that part of the roof edge. They don't have to be perfect, just a suggestion of boards is fine.

Light Buttermilk + Golden Straw

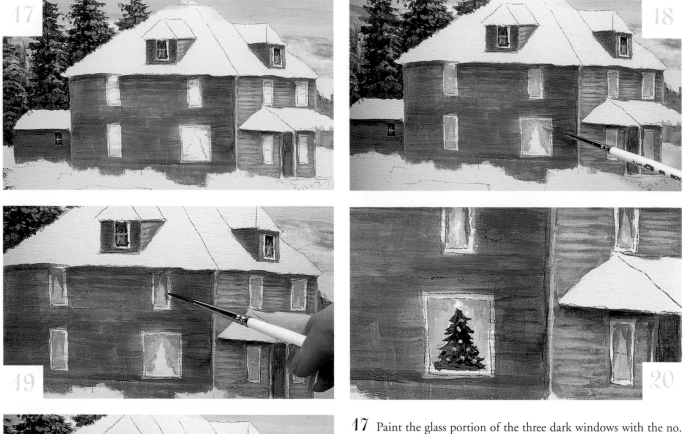

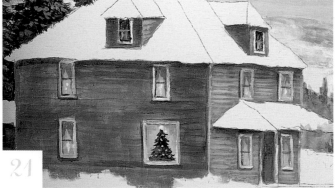

17 Paint the glass portion of the three dark windows with the no. 2 liner and a dark mix of Payne's Grey + Russet. Highlight the glass with a touch of Light Buttermilk, making the right windows a little lighter. Draw a horizontal line through the middle of the windows with Light Buttermilk + Mink Tan to indicate the pane line.

18 Fill in the lit windows with Cadmium Yellow, using the no. 2 liner. Mix a lovely orange with Peaches 'n Cream + Cadmium Yellow and work this in at the top of each window. You can paint around the Christmas tree or paint it out.

19 Suggest curtains with a touch of thinned Russet. Begin at the top of the windows and pull down while creating the loose shape of curtains.

20 Paint the Christmas tree with Black Forest Green + Russet on the liner brush, flicking out the edges to create branches. With the tip of the liner, dot on a few balls with Cadmium Yellow, then a few with Primary Red. Mix Cadmium Yellow + Light Buttermilk for the star at the top.

21 Brush mix Light Buttermilk + Mink Tan, and paint the frames with the no. 2 liner. Shade around the outside of the frames with thinned Payne's Grey to pull the frames away from the wall. With this same mix, add one pane line through the middle of each window except the picture window. Add touches of thinned Payne's Grey to the inside of the frames here and there.

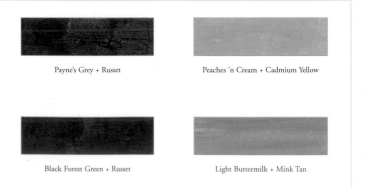

Payne's Grey + Russet	Peaches 'n Cream + Cadmium Yellow
Black Forest Green + Russet	Light Buttermilk + Mink Tan

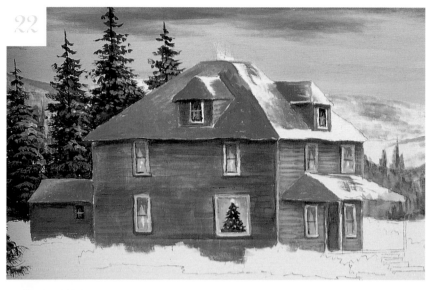

22 Paint the shadow areas of the snow-covered roof with the no. 8 flat and a mix of Light Buttermilk + Deep Midnight Blue. Use short patting strokes, and vary the color value.

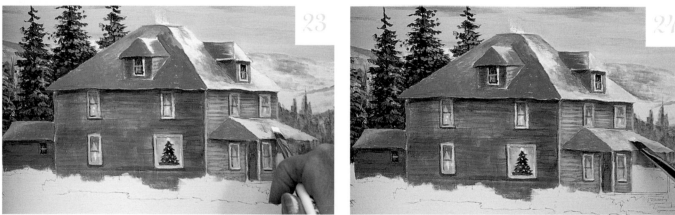

23 Using Light Buttermilk, fill in the light areas with the short patting strokes. Where the light meets the shading, add a little Deep Midnight Blue to blend the colors.

24 Pat a glow of Soft Peach onto the bottom of the distant hill, then add touches to some of the white areas on the roof.

25 Pull down icicles from the roof edge with the no. 2 liner using the same color as the snow on the roof just above the icicle. Vary the length and spacing of the icicles.

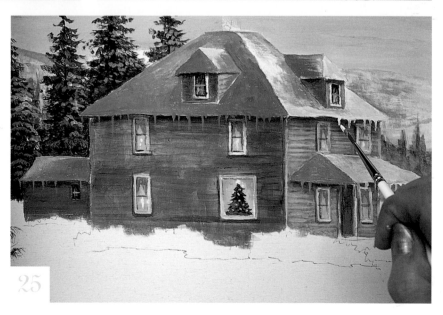

Chimney and Porch

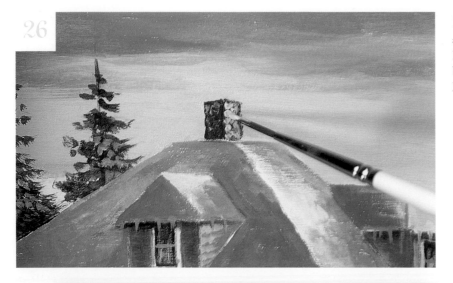

26 Basecoat the chimney with the no. 2 liner and Russet. Highlight the right side with Soft Peach, tapping the color in to suggest rocks or bricks. Add a little to the left side, but leave the left side darker.

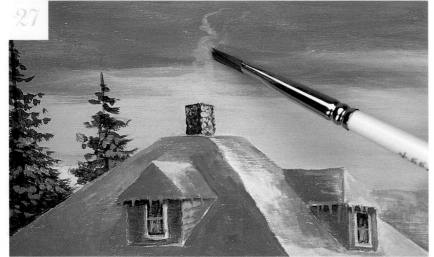

27 For the smoke, thin Light Buttermilk with water. Load a small amount on the no. 8 flat. Begin at the top of the board, and work with small circular strokes, using the bottom corner of the brush. Work down toward the chimney. If you get too much paint, blot it off with a damp clean brush before it dries.

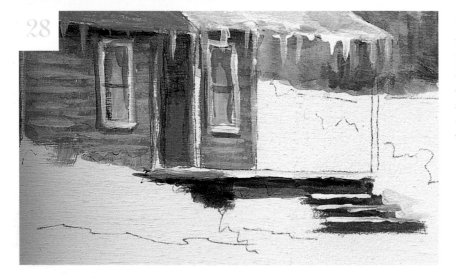

28 Brush mix Payne's Grey + Russet, and fill in the steps of the porch using the no. 2 liner. Leave the top board of the porch unpainted as well as a little line between the steps so you can see the divisions. With Light Buttermilk, paint a line of snow on top of each step and across the top step of the porch. Shade the left side of the top step with thinned Deep Midnight Blue.

29 With the ½-inch (12mm) flat, stroke in the light snow using Light Buttermilk + a touch of Soft Peach. For the shading, pick up a bit of Deep Midnight Blue with the Light Buttermilk, and sweep the snow following the contours of the ground and shadows. Add more Light Buttermilk to the Deep Midnight Blue where the light and dark values meet to aid in gradating the values. Add water to the mix to make the blending easier.

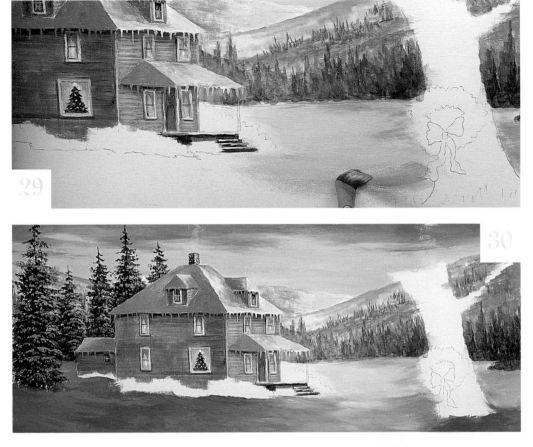

30 Pick up more Deep Midnight Blue in the darkest areas on the left side, adding a little Payne's Grey to the Deep Midnight Blue for the deepest shadows. Add Light Buttermilk to lighten the shadow mix as you brush the light and dark values together. You will not need to blend the colors together too smoothly as the texture adds interest and detail to the snow.

31 Suggest a path coming from the porch with a thin wash of Deep Midnight Blue + a touch of Light Buttermilk. For contrast, paint the path somewhat darker than the snow on the sides. Stroke a few more drifts in the shadow areas of the snow with Light Buttermilk on the top of the brush. Work with short choppy strokes that scoot to the side.

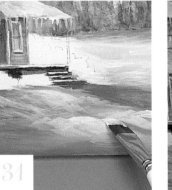

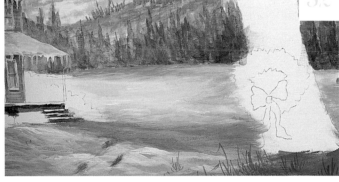

32 With the no. 8 round, add footprints leading toward the path with the shadow color of Deep Midnight Blue + Light Buttermilk in the brush. Add touches of Light Buttermilk along their edges to set them into the ground. With the no. 2 liner, flick up a few weeds around the tree with thinned Payne's Grey.

Light Buttermilk + Soft Peach

Deep Midnight Blue + Payne's Grey + Light Buttermilk

Bushes

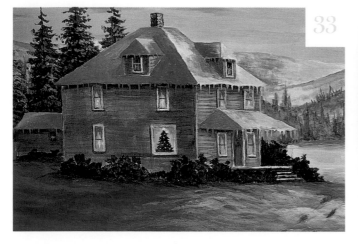

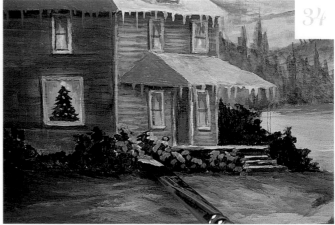

33 Using the bottom corner of the ½-inch (12mm) flat, tap in the bushes with a mix of Black Forest Green + Payne's Grey + Russet. At the base of each bush, pull a few horizontal lines into the snow to soften the hard edge of the bush. Also, pat a little snow around the base of the bush. Use Deep Midnight Blue + Light Buttermilk for the snow for the areas in shadow and Light Buttermilk for the highlights. Pat a little of the bush color into the snow directly beneath it for a reflection.

34 Tap in a little snow on the bushes with Light Buttermilk + a touch of Deep Midnight Blue. Don't cover the bushes too heavily. In the shadow areas, use a little more of the Deep Midnight Blue. Where the light is hitting the bushes, make the snow clumps lighter.

Final Touches on the House

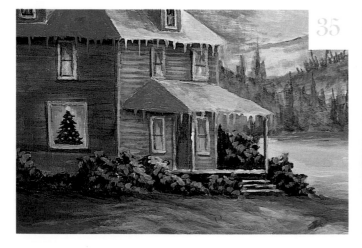

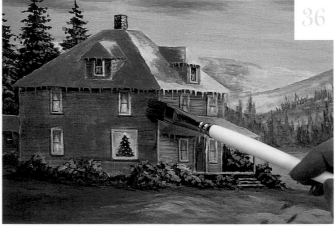

35 Paint the porch posts with the no. 2 liner and thinned Payne's Grey. Highlight the right side with Light Buttermilk. Brush mix Light Buttermilk + Cadmium Yellow and paint some reflected light on the window frames, the left porch post, and on the porch floor.

36 Mix a thin wash of Violet Haze on the ½-inch (12mm) flat, and brush it over some of the shaded snow areas on the roof (see step 22). Add a little on the siding in the shadows and some on the shadowed snow on the ground.

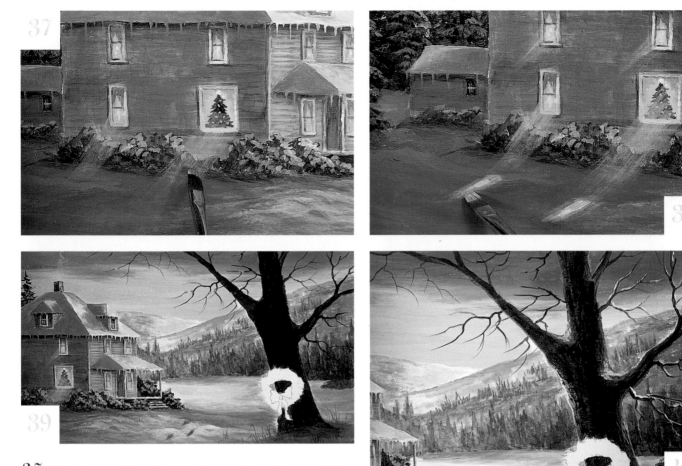

37 With the no. 8 flat, thin Light Buttermilk + Cadmium Yellow for the light rays. Set the brush flat on the surface of each lighted window and pull out. With a damp brush, fade out the end of the light so it doesn't stop abruptly.

38 Apply a second layer if you want the light brighter. Where the light hits the ground, paint a long area of light with a mix of Light Buttermilk + Cadmium Yellow that is not quite as thin as the one used for the rays.

39 Base in the big tree with the no. 8 flat and a mix of Payne's Grey + Russet. Use short, choppy vertical strokes with the side of the brush to suggest bark texture. You may need two or more coats. At the base of the tree, pull out shadow color to the right with thinned Payne's Grey. Pat a little snow color into the base of the tree to help set it into the ground using Light Buttermilk + Payne's Grey and Light Buttermilk. Use the liner brush to paint the tree branches.

40 For the snowy bark on the edges of the trunk and in the crotch of the tree limbs, load one side of the chisel edge of the no. 8 flat with Light Buttermilk + Deep Midnight Blue. Hold the brush so that the paint is facing out from the tree. Use short, choppy strokes to work the paint and texture from the outside edge into the tree a bit. Begin just beyond the edge of the tree rather than inside the dark basecoat. With the liner add a line of Light Buttermilk to the top of the small limbs.

Light Buttermilk + Cadmium Yellow

Wreath

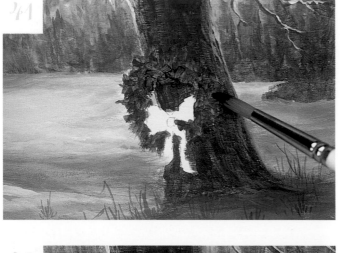

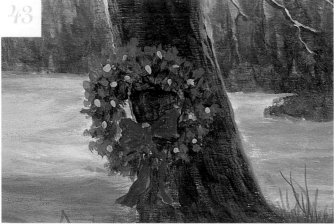

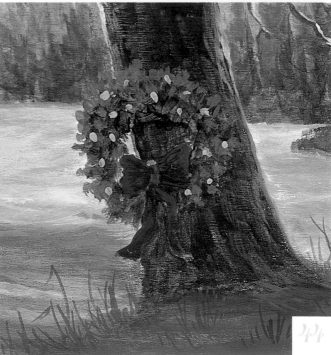

41 Using the no. 8 round and a dark green mix of Black Forest Green + Payne's Grey, basecoat the wreath. Put on two coats for good coverage, making the outside edges a bit uneven.

42 Stroke in highlights with Black Forest Green + Light Buttermilk, working more of this color to the outside edges.

43 Tap on the ornaments with Golden Straw using the tip of the no. 8 round brush. Basecoat the ribbon with Primary Red.

44 Shade the ribbon with thinned Payne's Grey, and Payne's Grey + Primary Red. Add a few highlights with Primary Red + Light Buttermilk on the top edges of the ribbon.

Black Forest Green + Light Buttermilk

Payne's Grey + Primary Red

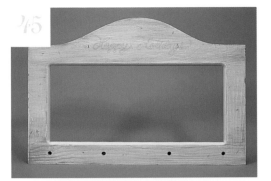

45 Remove the pegs from the frame. If you would like to distress the wood, pound on it a bit with a hammer or screwdriver to add interesting texture and dents. Then basecoat using the 1-inch (25mm) foam brush and two coats of Light Buttermilk. When dry, lightly brush on thinned Deep Midnight Blue + Light Buttermilk mixed approximately half and half. When dry, sand with a medium or course grain sandpaper. Sand some of the blue down to the basecoat and even into the raw wood. Sand off as much of the paint as you like for an old look. Do the same for the four pegs. Transfer the lettering with black graphite paper using the stylus.

46 Load the no. 2 liner with Deep Midnight Blue + a touch of Light Buttermilk, thinning the paint with water. Fill in the letters on the frame. Use this same mix for the line work around the inside of the frame. When dry, load the liner with Glorious Gold. Lay this color to the left side of the blue writing. Glue the pegs into the holes on the frame.

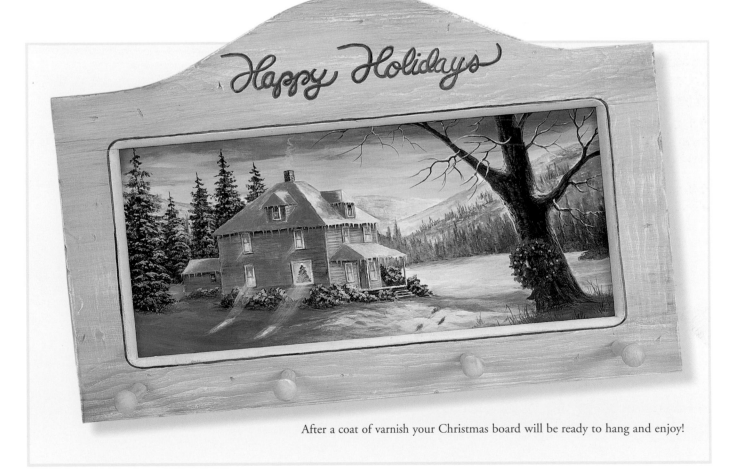

After a coat of varnish your Christmas board will be ready to hang and enjoy!

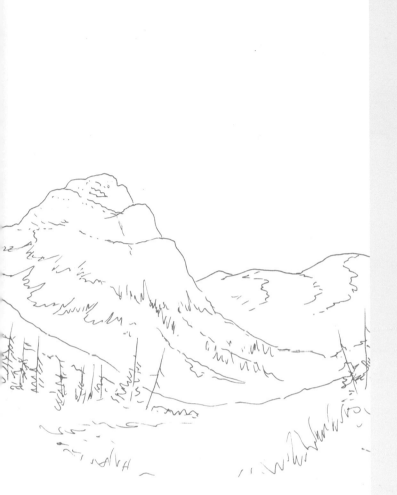

Highland Meadow

A few years ago I had the opportunity to do some on-location painting in Colorado. It is so wonderful to sit out in the open and paint the beautiful scenery before you. Unfortunately my busy schedule doesn't allow for that very often, so I rely on photographs to remind me of what I saw. I hope you enjoy this little mountain scene that came from that Colorado trip. I love the bright colors and can almost smell the mountain air.

Mountains are the focus of this small painting. You will learn to build up light on one slope and shadow on the other slope to shape them. You will see that using touches of Light Buttermilk here and there will add the look of snow. Create distance by working with blues as well as less detail. As you add stronger color and more detail to the foreground, it will appear closer to you.

MATERIALS

DecoArt Americana Paints

Baby Blue Black Forest Green Blue Mist Cadmium Yellow Dusty Rose

Golden Straw Hauser Light Green Light Buttermilk Payne's Grey Pineapple

Primary Red (Napthol Crimson) Russet Ultra Blue Deep Violet Haze

Royal Synthetic Brushes

no. 2 liner series 595, no. 4 filbert series 170, no. 8 flat series 150, ½-inch (12mm) flat series 700, ¾-inch (19mm) flat series 700

Additional Supplies

white gesso, 1-inch (25mm) foam brush, black graphite paper, stylus

Surface

9 X 12-inch (23cm X 30cm) canvas from any craft or art supply store

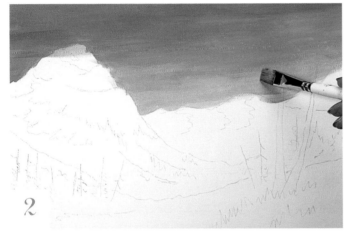

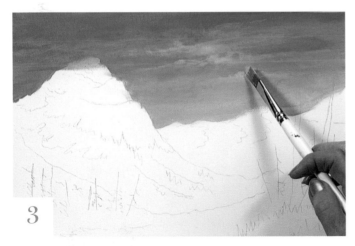

1 Brush three coats white gesso on the canvas using the foam brush. Allow the gesso to dry between coats. When all is dry, transfer the pattern using black graphite paper and the stylus.

2 Paint the sky with the ½-inch (12mm) flat beginning just above the mountains. Brush in horizontal strokes using Baby Blue + Light Buttermilk. Working toward the top, pick up an approximately 1:1 mix of Ultra Blue Deep + Baby Blue, thinning the mix with water. A streaky look is fine, as you will be working clouds into the sky anyway.

3 Add clouds with Light Buttermilk + a touch of Primary Red on the brush. Work for variations in the pink values, picking up more or less Primary Red with the Light Buttermilk. For soft colors, blend over the blue with a damp brush. You may need to pick up a bit of the Baby Blue in the brush to help set the colors together. Scrubbing the brush loosely back and forth and keeping the paint a bit wet helps give a natural look to the clouds. Avoid making stiffly painted clouds with hard edges.

Baby Blue + Light Buttermilk

Ultra Blue Deep + Baby Blue

Light Buttermilk + Primary Red

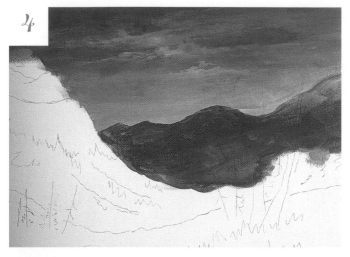

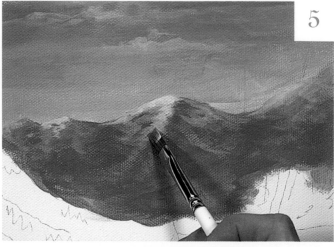

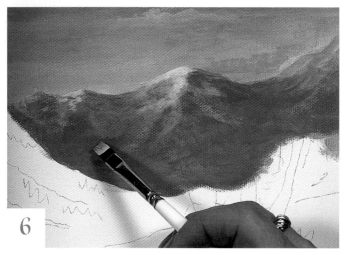

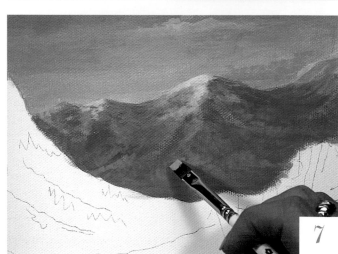

4 Base in the distant mountains with the no. 8 flat. Use a mix of Light Buttermilk + Ultra Blue Deep + Primary Red. Variations in the colors will give texture and depth to the mountains.

5 Brush in highlights on the mountaintops with a mix of Light Buttermilk + Primary Red mixed to a soft pink. Lay the pink in the light areas of the mountains, following the general contour of the slopes. Allow a bit of the blue basecoat to show through here and there. Working with a dry brush of paint will be better than using a lot of wet paint. Loosely blend over the blues where the pink stops. Add more Light Buttermilk for highlights and snow on the peaks, especially on the left sides.

6 Pat in a little Baby Blue + Ultra Blue Deep to intensify the deep areas of the valleys and on the shadowed sides of the mountains. You may add a touch of Light Buttermilk to the mix if the blues seem too strong.

7 Using little patting-down strokes and a touch of Blue Mist, suggest trees at the base of the mountain. Don't try to shape trees—just pat or scoot the brush slightly to suggest something growing in the distance.

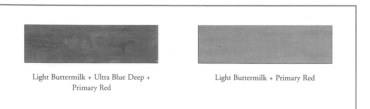

Light Buttermilk + Ultra Blue Deep + Primary Red

Light Buttermilk + Primary Red

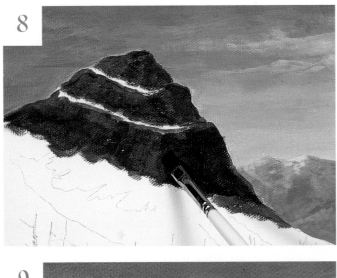

8 Using the no. 8 flat, basecoat the mountain with an approximately 1:1 mix of Primary Red + Ultra Blue Deep. Paint down to the tree line. Leave a little edge unpainted where each section steps down. The strokes can be choppy with some variation of light and dark values.

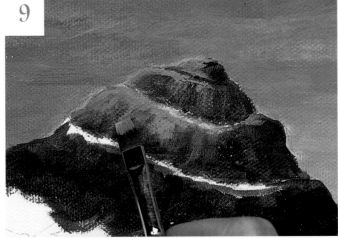

9 Begin the light value with Dusty Rose, laying the color in the ridges you left unpainted. With a small amount of paint on the brush, pull strokes from the ridge downward. Some of the basecoat should show through. Build up more light value on the left, as this is where the light is hitting the mountain.

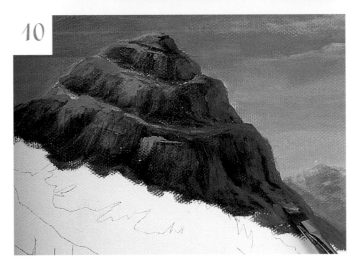

10 Let the Dusty Rose fade out on the right side of the mountain. Add cool highlights on this shadowed side with Baby Blue + Ultra Blue Deep. Add highlights just beyond the outside edge of the mountain to soften the outside line.

Primary Red + Ultra Blue Deep

Distant Trees

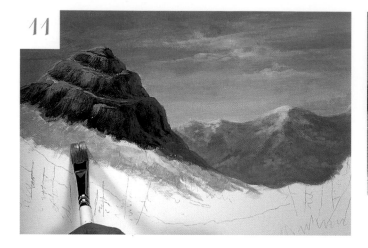

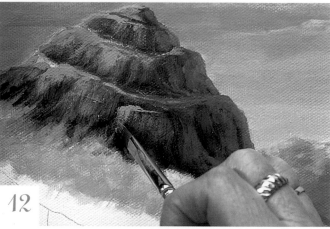

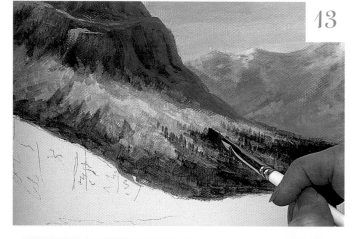

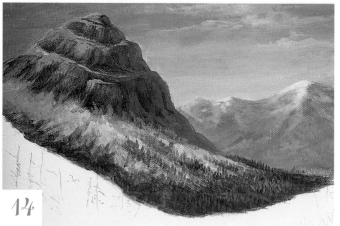

11 With the no. 8 flat, pat in the light greens on the left side with Hauser Light Green + Light Buttermilk + Blue Mist. Use a little more Blue Mist as you move to the left edge of the canvas. Loosely overlap the base of the mountain with the greens.

12 Brush mix Black Forest Green + Russet for a dark green. With the no. 8 flat, pat a few dark trees at the base of the mountain, above the light green area. Add a bit of Hauser Light Green for highlights. Tap a little Blue Mist here and there in the light tree area below for contrast.

13 With Black Forest Green + Russet and the no. 8 flat, pat dark trees below the light area, bringing them down into the valley. Work with short, patting-down strokes to only suggest the distant trees—don't try to paint definite trees. Pat two coats in the darkest areas.

14 Highlight some of the trees in the valley with touches of Hauser Light Green or Blue Mist.

Hauser Light Green + Light Buttermilk +
Blue Mist

Black Forest Green + Russet

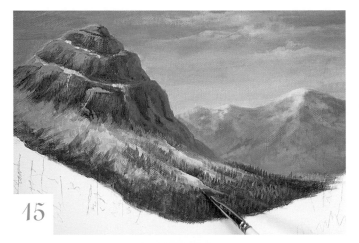

15 With Light Buttermilk on the no. 8 flat, pat in a few drifts of snow over the trees. Brush a bit of Ultra Blue Deep + Baby Blue at the base of the snow for shading. To set the snowdrifts below the trees, tap a few green trees in front of the drifts. Tap a little Light Buttermilk for snow on the ledges of the mountain here and there. Again, add touches of the blue mix for shading.

16 Using the no. 8 flat, brush two coats of Russet + Ultra Blue Deep on the large rock. The strokes can look choppy and the color can vary a bit.

17 Lay a highlight of Dusty Rose on the top of the rock, then drag a dry brush of the color down to form the sides.

18 Finish the highlights on the rock, allowing some of the basecoat to show through. With a mix of Blue Mist + Hauser Light Green, pat some grass at the base of the rock, covering up the pine tree pattern lines. Paint this color about halfway down to the bottom of the canvas. Highlight the top of the grass with Golden Straw.

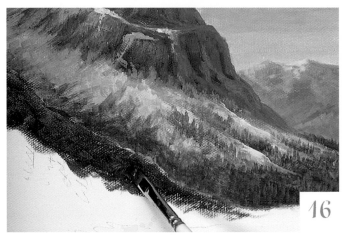

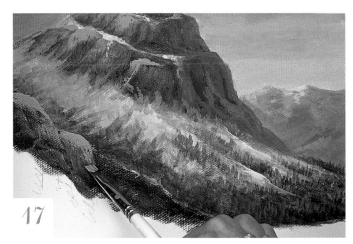

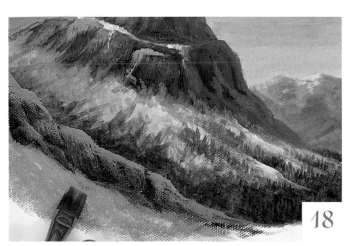

Russet + Ultra Blue Deep Blue Mist + Hauser Light Green

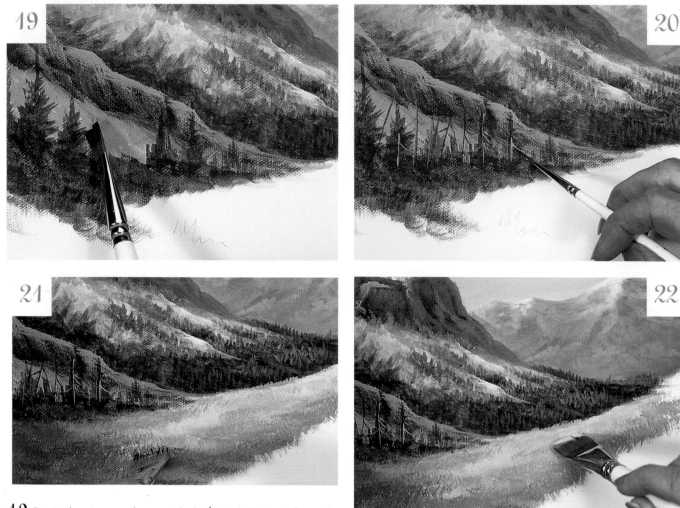

19 Pat in the pine tree shapes with the ½-inch (12mm) flat and a dark mix of Black Forest Green + Russet. Hold the brush with the handle to the side and pat in the centerline of the trees. Turn the brush to horizontal to pat in the branches with more pressure on the inside half of the brush.

20 Using the no. 2 liner, paint in a few bare branches with thinned Russet + Black Forest Green. Add a few lighter ones with Dusty Rose.

21 Paint the grass with the ¾-inch (19mm) flat, working with the paint on the top of the brush. Pick up Hauser Light Green + a touch of Pineapple for the lightest area. Work with short, downward strokes. Pick up a little Blue Mist toward the bottom and left, adding Black Forest Green + Russet in the darkest areas. Overlap the colors where they meet.

22 Highlight the top right portion of the grass with Cadmium Yellow + Pineapple.

Cadmium Yellow + Pineapple

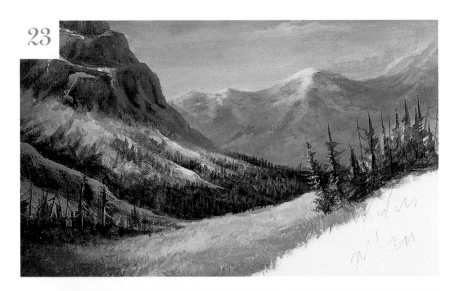

23 Paint the pine trees on the right side of the painting with a dark green mix of Black Forest Green + Russet. Use the same general techniques used in steps 19 and 20. Highlight the outside edges of some trees with Hauser Light Green + Cadmium Yellow.

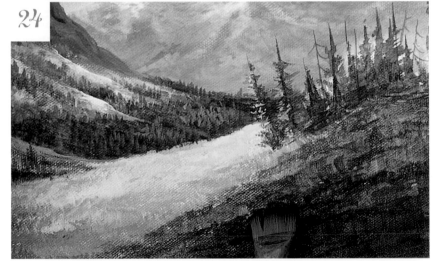

24 Base in the dark grass in the right corner with the ¾-inch (19mm) flat using a mix of Black Forest Green + Russet. Vary the mix by picking up more green sometimes and more Russet another time. Work with short downward strokes following the slope of the ground.

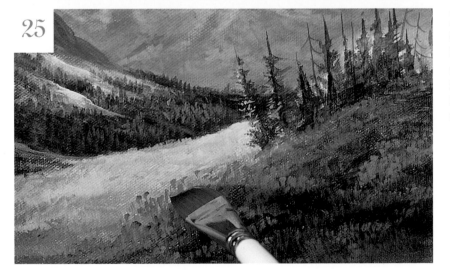

25 Highlight the grass with Hauser Light Green, adding touches of Blue Mist and Black Forest Green from time to time. Work with the color on the top of the bristles of the brush, and flick the color off with a light downward stroke. Don't cover the ground completely, as you want the dark basecoat to show through the highlights.

Foreground Trees

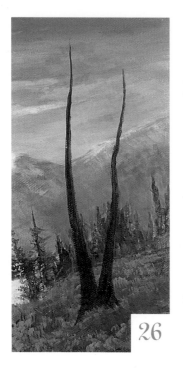

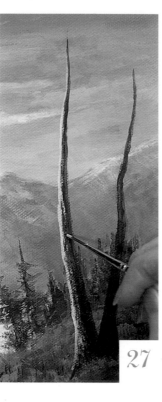

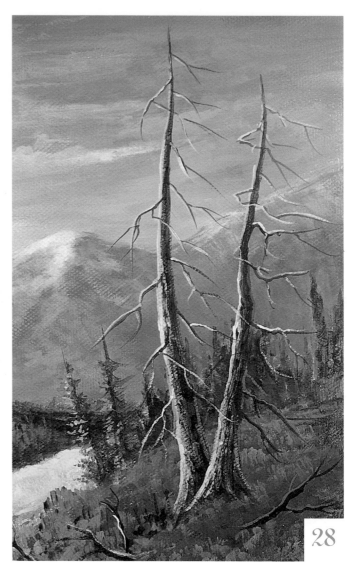

26 Paint the trunks of the tall trees with the side of the no. 4 filbert using a mix of Payne's Grey + Russet.

27 Highlight the left side of the trunks with Golden Straw + Light Buttermilk. Use the no. 2 liner and short, choppy downward strokes. Begin just to the outside edge of the dark trunk, so you are actually painting on the background rather than the tree to make the left edge. Chop a little of the mix into the dark trunk to soften the right edge of the highlight. Pick up a little Russet with the light mix to blend the highlights into the trunk. Add touches of Dusty Rose here and there in the highlights.

28 Add the limbs with the no. 2 liner and Payne's Grey + Russet. Thin the paint for some of the lighter limbs, and use it full strength for the darker limbs. Add a few light and dark limbs on the ground also. Highlight some of the limbs with Light Buttermilk in the sunlight and touches of Violet Haze in the shadows. Lay highlights above or next to the dark limbs so as not to cover up the entire limb.

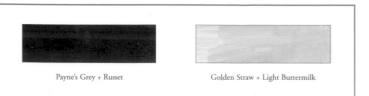

Payne's Grey + Russet Golden Straw + Light Buttermilk

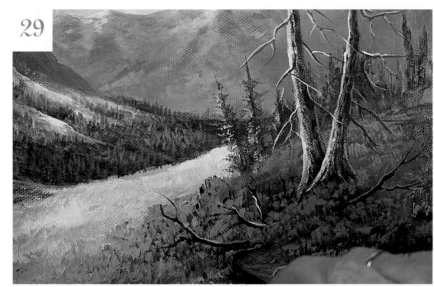

29

29 Tap in a few loosely placed wildflowers with Violet Haze and Violet Haze + Ultra Blue Deep. Pick up the color on the top corner of the ¾-inch (19mm) flat. Touch just a few of the hairs on the canvas and flick downward.

Violet Haze + Ultra Blue Deep

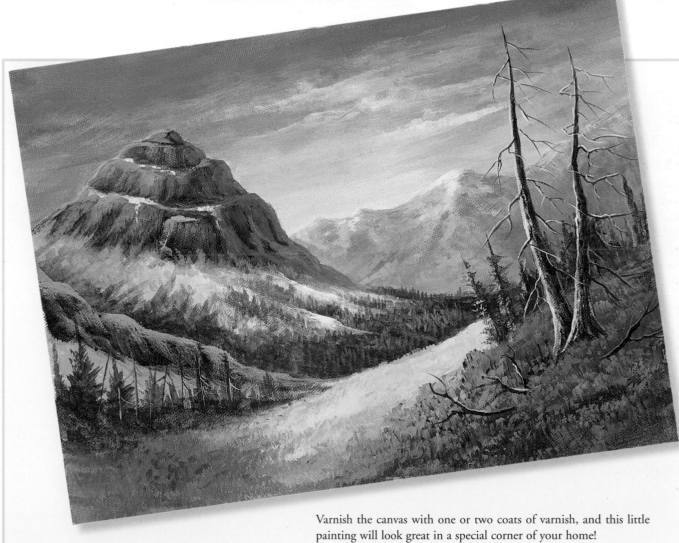

Varnish the canvas with one or two coats of varnish, and this little painting will look great in a special corner of your home!

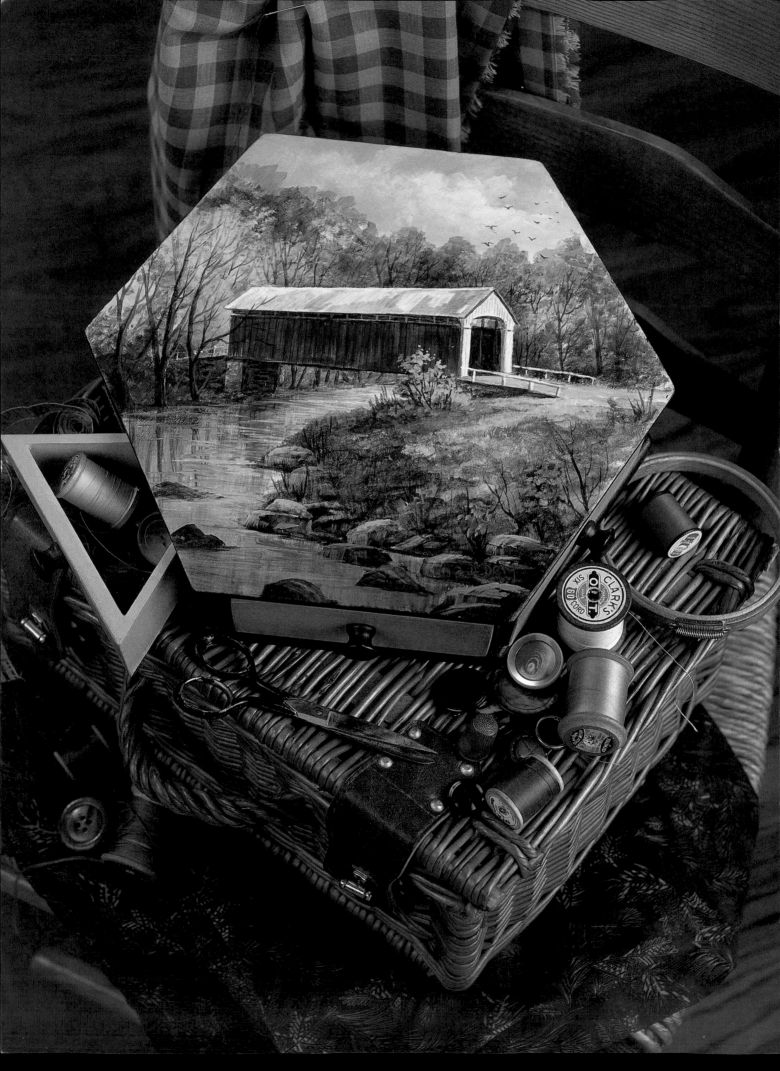

Covered Bridge

Covered bridges are found mostly in the eastern part of the United States, and there are many in Indiana, where they have a Covered Bridge Festival each year. Take a tour of a few of these nostalgic structures if you get a chance. Why were they built? To keep the wooden bridge floor from rotting out so quickly is what I have read.

The trees in this painting are done differently than in any of the other projects. You will learn that thin layers of paint will build up the various colors, and that by adding trunks and limbs you will pull the foliage together for trees. The structure of the bridge is a bit different, and you will paint a stream of water with reflections and movement.

MATERIALS

DecoArt Americana Paints

Antique Rose	Black Forest Green	Burnt Sienna	Burnt Umber	Golden Straw
Light Buttermilk	Payne's Grey	Russet	Violet Haze	Warm Neutral
Wisteria				

Royal Synthetic Brushes
no. 2 liner series 595, no. 8 round series 250, no. 4 filbert series 170, no. 8 flat series 150, ½-inch (12mm) flat series 700

Additional Supplies
fine sandpaper, tack cloth, gesso, 1-inch (25mm) foam brush, stylus, black graphite paper

Surface
Hexagonal multi-drawer box from Sechtem's Wood Products

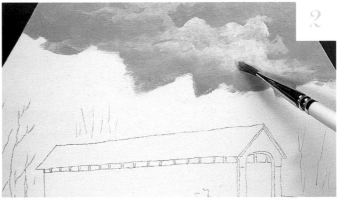

1 Sand the wood and wipe with a tack cloth, then basecoat the top with two coats of gesso using the foam brush. When dry, transfer the pattern using black graphite paper and the stylus.

2 Basecoat the sky with two coats of Wisteria using the ½-inch (12mm) flat. Paint down just slightly past the pattern line of the background trees. With Light Buttermilk, pat in some clouds with the bottom corner of the ½-inch (12mm) flat. Work for a wispy, irregular look. Pick up a little Wisteria to help blend the bottom of the clouds into the sky.

Distant Trees

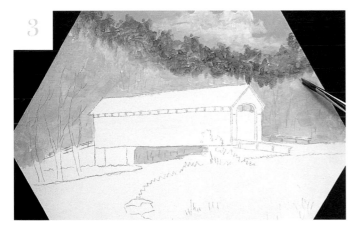

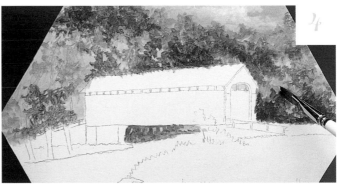

3 Using the ½-inch (12mm) flat, base in Golden Straw over the background tree area, adding a little water to dampen the brush. Leave an area of 1 to 1½ inches (2.5cm to 3.8cm) at the top for green trees. Add blue-green trees at the top by loading thin Black Forest Green + Russet on the bottom corner of the brush and patting in the foliage very loosely. Add a little thinned Wisteria over the greens here and there to soften the color. Pat a little Golden Straw over the bottom of the green trees to soften them into the basecoat.

4 Tap in more trees over the Golden Straw basecoat using thinned Black Forest Green + Russet, sometimes picking up more of one color than the other for variation. Let a lot of the Golden Straw show through the foliage. The foliage will look messy now, but will come together when you add the limbs and trunks.

Black Forest Green + Russet

104

Bridge Supports and Trees

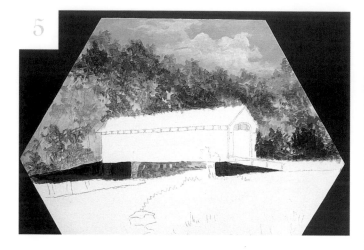

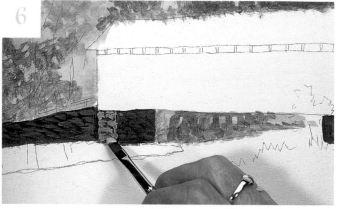

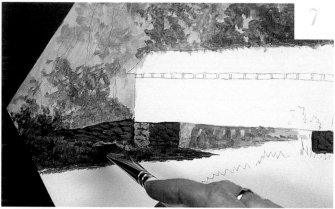

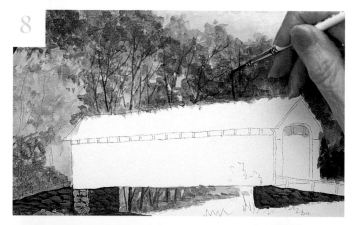

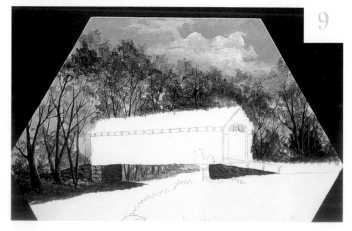

5 Brush mix Antique Rose + Golden Straw and tap this into the orange foliage areas. Vary the proportions of the two colors for variety. Paint the two stone supports of the bridge with two coats of Payne's Grey.

6 Build the rock shapes on the supports with the no. 4 filbert. In the shadows use a mix of Payne's Grey + Wisteria; in the lighter areas use Wisteria. Work for good contrast at the corners where the light and dark values meet.

7 With the ½-inch (12mm) flat, base in the ground around the bridge support with Russet + a touch of Black Forest Green. Paint the ground down to the water. Tap in the bush at the left with a dark mix of Black Forest Green + Russet. Add a little Antique Rose to suggest flowers in the grass. Highlight the grass with Golden Straw on the top of the brush, working with short, downward strokes.

8 Paint in the trunks with the no. 2 liner using a mix of Payne's Grey + Russet. Thin the paint with additional water for the branches and distant trunks to create a lighter value, especially in the tree-tops. Remember to paint branches under the bridge.

9 Continue to paint the trunks and branches, placing them wherever you feel is good for a balanced look. Tap a little of the foliage colors over the trunks in a few places. Highlight the right side of the larger trees with Violet Haze using the no. 2 liner.

Antique Rose + Golden Straw

Payne's Grey + Wisteria

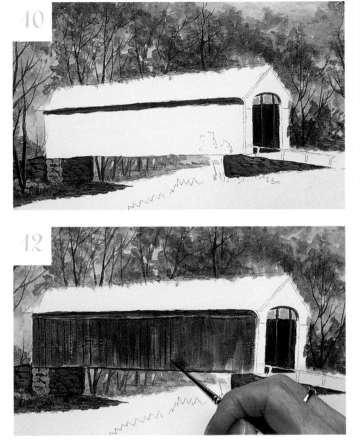

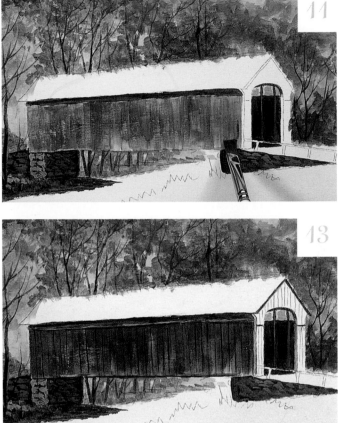

10 With the no. 4 filbert, paint the inside of the bridge wall with two coats of Payne's Grey + Russet. Add the dark mix to the inside of the bridge seen above the wall and at the top of the arched entrance. Paint the posts holding up the roof on the far side with Payne's Grey + Antique Rose, pulling the bracing down the dark wall as shown.

11 Paint the siding with the no. 8 flat and a thin wash of Burnt Sienna. Use downward strokes that follow the direction of the boards. A streaky, uneven look is fine.

12 Streak in some darker values with thinned Russet. Let some of the basecoat boards show through. Draw a horizontal line just below the top edge of the wall and at the very bottom of the wall with thinned Payne's Grey on the no. 2 liner. Highlight above the top line with a little Light Buttermilk. Add linework for cracks between the boards with thinned Payne's Grey.

13 Using the no. 2 liner, paint the front of the bridge with Light Buttermilk to clean up the edges. Indicate board lines with thinned Payne's Grey on the same brush. Paint the underside of the roof with Payne's Grey. Note the small side section to the front, on the left. Show the turn of the wall there with a little thinned Payne's Grey on the left side of the corner. Show the thickness of this wall and the wall on the right side of the door opening by drawing down a line of thinned Payne's Grey + Light Buttermilk.

Payne's Grey + Russet Payne's Grey + Light Buttermilk

Roof and Road

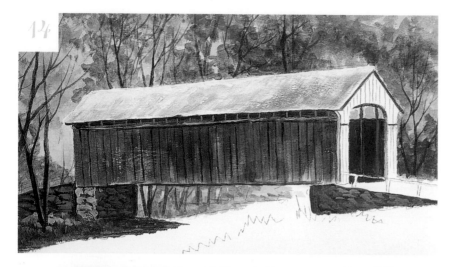

14 Clean up the roof edges with Light Buttermilk if needed. Brush in the roof with the no. 8 flat using thinned Payne's Grey + a touch of Wisteria. Highlight with Light Buttermilk. You want a patchy look. Add more Payne's Grey to sharpen or clean up the bottom roof edge. Paint in the little support posts with Violet Haze on the liner.

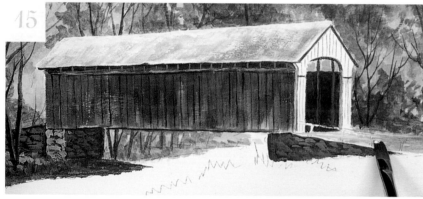

15 Paint the road with a thin wash of Russet using the no. 8 flat. Vary the values for a textured look. Toward the opening, pick up highlights of Golden Straw + Light Buttermilk.

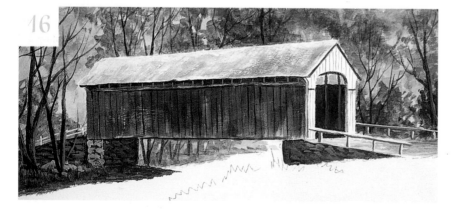

16 With the no. 2 liner and a mix of Payne's Grey + Light Buttermilk, stroke in the railings at both ends of the bridge. Add a highlight of Light Buttermilk to the right of the posts and at the top of the rails.

Golden Straw + Light Buttermilk

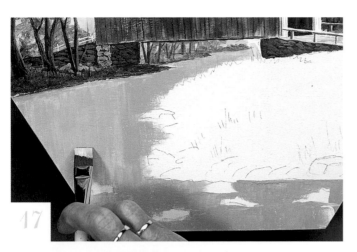

17 Basecoat the water with Wisteria using the ½-inch (12mm) flat. With slightly moist Golden Straw + Light Buttermilk, quickly brush in the yellow reflections with downward strokes using the flat of the brush. Overlap the Wisteria where the colors meet.

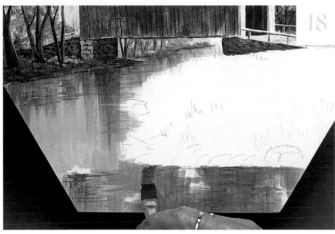

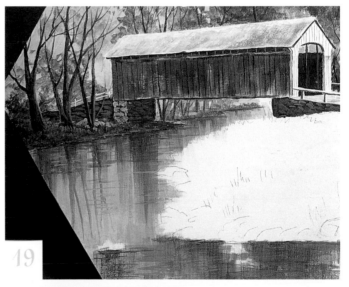

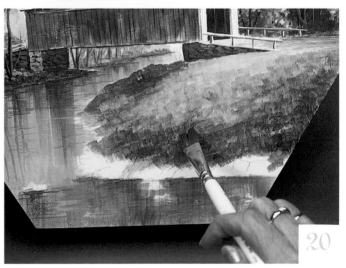

18 Pull down reflections beneath the banks with thinned Payne's Grey + Russet, touches of Black Forest Green, or other colors used in the trees. Stroke all reflection colors in with the flat of the brush and thinned paint. Before they dry, quickly and lightly brush across just enough to distort the downward strokes and create a shiny look. Cut a few narrow movement lines in with the chisel edge of the brush (the movement lines are created by paint lifting off). Add more layers of shading as desired, drying between layers. Reflect the bridge support with a little thinned Payne's Grey.

19 With thinned Payne's Grey on the no. 8 flat, pull reflections down for the tree trunks. Again, brush lightly across while they are wet to distort the lines. Add a few strokes of thinned Russet to suggest the reflections of the bridge.

20 Paint the grass with the ½-inch (12mm) flat using short, downward strokes that follow the slope of the ground. Begin at the top with a mix of Golden Straw + Light Buttermilk, picking up Black Forest Green and Black Forest Green + Russet in the darker areas at the bottom. Vary the colors as you go, sometimes picking up more of the previously used color to help in the blending.

Bush, Rocks and Final Touches

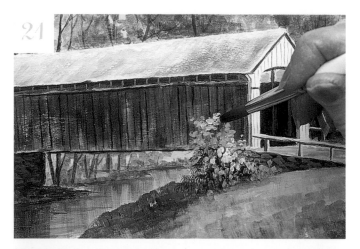

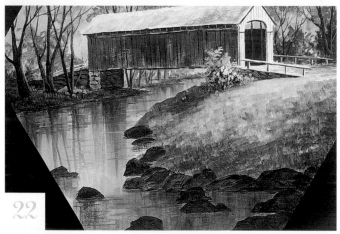

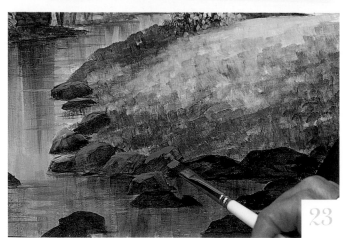

Burnt Sienna + Light Buttermilk

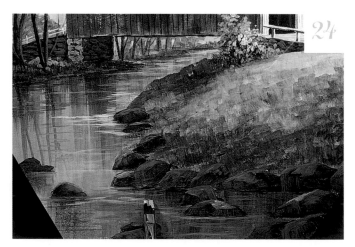

21 With Black Forest Green + Russet, tap in the bush near the base of the bridge using the no. 8 round. Highlight with Golden Straw and Golden Straw + Light Buttermilk, working for a light, airy look at the top of the bush.

22 Base in the rock shapes with Payne's Grey + Russet, using the no. 8 flat. Place the rocks on the bank and in the water, wherever you choose. Add a little reflection of the rocks in the water with thinned Payne's Grey + Russet on the brush. Paint quick, downward strokes beneath the rocks with the flat of the brush. Brush lightly across with horizontal strokes before they dry to distort the downward strokes.

23 With the no. 8 flat, highlight the rock tops with Burnt Sienna + Light Buttermilk, mixed to a pink-tan. Establish a top to one rock at a time with a few strokes, then pull down with a lighter touch and less paint to create the side of that rock. If you lose too much of the dark value on the side, you will lose the shape of the rock. If this happens, glaze in a bit more Payne's Grey + Russet. Add a little Violet Haze to the rocks in the shadows.

24 After finishing the rocks, add movement lines in the water with the chisel edge of the no. 8 flat. Keep the strokes parallel to the bottom of the box. Begin in the distance with Light Buttermilk. As you work into the foreground, add Violet Haze to the Light Buttermilk.

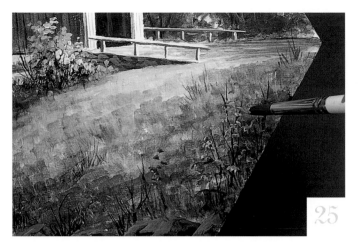

25 Using the no. 2 liner, paint some tall grass and small twigs in the foreground with thinned Payne's Grey + Russet. Tap in a few leaves with Burnt Sienna and touches of Golden Straw using the no. 8 round.

26 Finish the box by basing the drawers inside and out with two coats of Warm Neutral using the ½-inch (12mm) or ¾-inch (19mm) flat. Remove the knobs and antique the front of the drawers with Burnt Umber thinned with water or an antiquing medium. Brush it on very lightly with either of the large flat brushes. If you get too much, wipe it off with a soft rag.

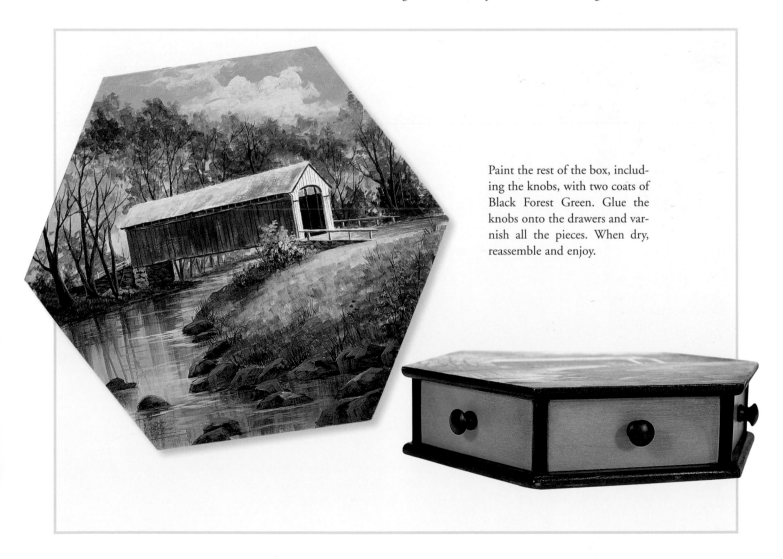

Paint the rest of the box, including the knobs, with two coats of Black Forest Green. Glue the knobs onto the drawers and varnish all the pieces. When dry, reassemble and enjoy.

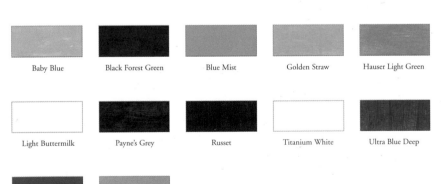

Country Church

The architecture of churches varies widely across the land, but most of us are familiar with the small white churches that are dotted around the countryside, many with beautiful steeples peeking above the treetops, pointing the way to heaven. I love the peaked design above the windows on this little country church.

You will learn to paint beautiful, billowy clouds in this painting by using a flat brush and layering the paint. You will use the liner to add detail to the church and a filbert brush to add thin layers of shading to create light and dark values. As you paint the grass you will see how working paints lighter in the distance and darker in the foreground will show depth. When you add a few flowers, you will feel as if you have created a nice summer day!

MATERIALS

DecoArt Americana Paints

Baby Blue	Black Forest Green	Blue Mist	Golden Straw	Hauser Light Green
Light Buttermilk	Payne's Grey	Russet	Titanium White	Ultra Blue Deep
Violet Haze	Wisteria			

Royal Synthetic Brushes
no. 2 liner series 595, no. 4 filbert series 170, no. 8 flat series 150, ½-inch (12mm) flat series 700, ¾-inch (19mm) flat series 700

Additional Supplies
sandpaper, tack cloth, gesso, 1-inch (25mm) foam brush, black graphite paper, stylus, ¾-inch (1.9cm) masking tape, sea sponge or wadded-up paper towel

Surface
Bible box from Sechtem's Wood Products

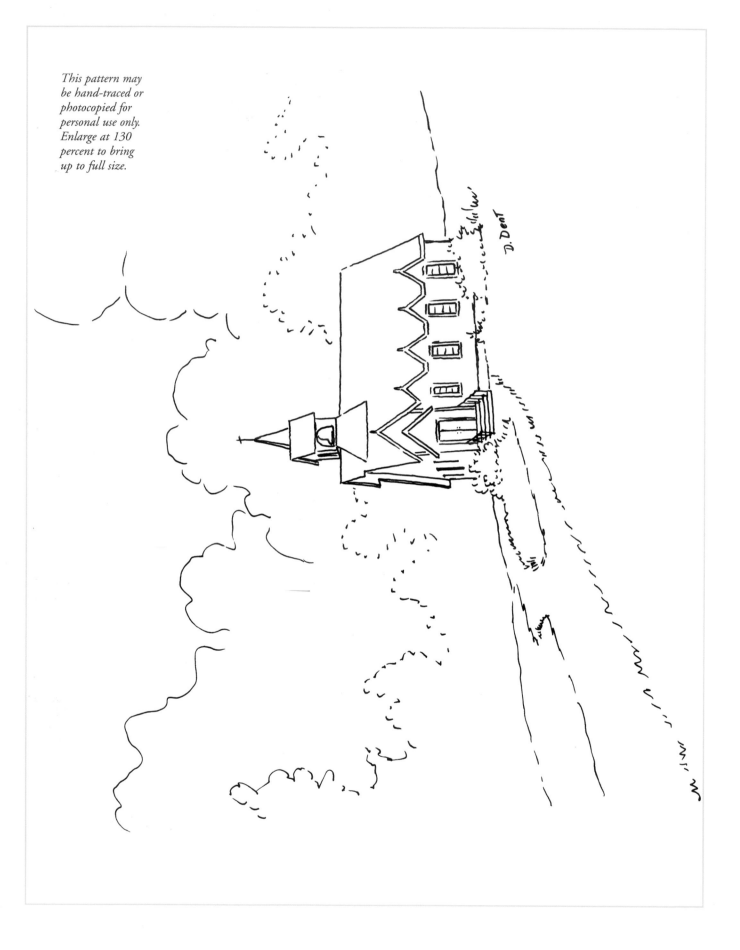

This pattern may be hand-traced or photocopied for personal use only. Enlarge at 130 percent to bring up to full size.

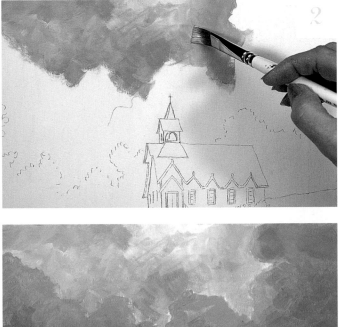

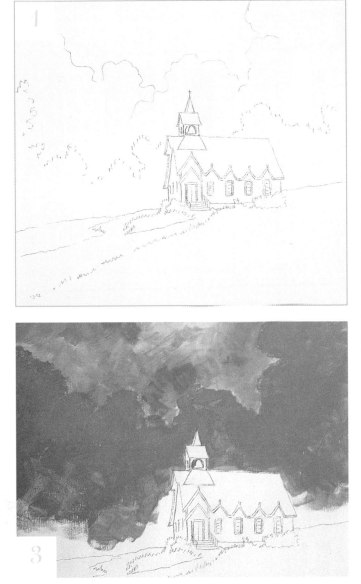

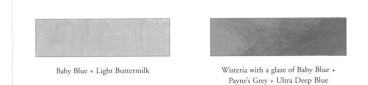

1 After sanding the wood and wiping it with a tack cloth, basecoat the top of the box with two coats of gesso using the foam brush. When dry, transfer the pattern using black graphite paper and the stylus. Place the pattern so that the tip of the steeple is 3 inches (7.6cm) down from the top of the box and 4¾ inches (12.1cm) from the right edge of the box.

2 With the ½-inch (12mm) flat, brush mix Baby Blue + Light Buttermilk and base in the blue area of the sky. Vary the color by picking up more Light Buttermilk sometimes and more Baby Blue sometimes. The variation of color will give the look of clouds.

3 Base in the rest of the sky with two coats of Wisteria, using the ½-inch (12mm) flat. Work down into the trees, painting them at least halfway out. Paint the tiny bit of sky showing just to the left of the bell in the tower.

4 Thin Baby Blue + Payne's Grey + a touch of Ultra Deep Blue with water and apply a glaze of blue over the Wisteria. Allow some of the Wisteria to show through here and there, especially toward the top. Pick up a bit of thin Wisteria to aid in blending the colors together where they meet.

Baby Blue + Light Buttermilk

Wisteria with a glaze of Baby Blue + Payne's Grey + Ultra Deep Blue

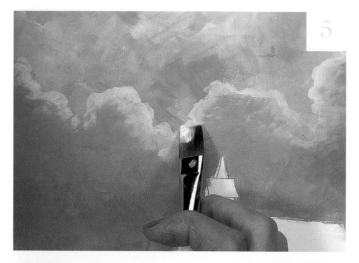

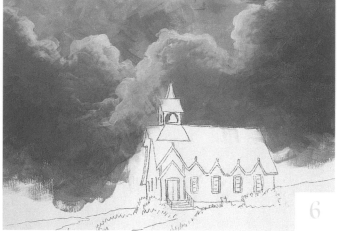

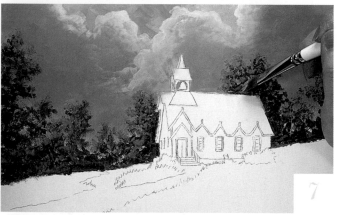

5 Lay in the edges of the clouds by side loading the ½-inch (12mm) flat with a very thin mix of Light Buttermilk + Golden Straw. Place the loaded edge of the brush just beyond the edge of the clouds. Use short C-shaped strokes to highlight the edge of the front clouds. Pick up more water on the brush as needed to blend the highlight into the base color. You can go over the clouds as many times as necessary to build up the color and blending.

6 Continue to add light glazes until you are happy with the result. Pull a few light rays toward the steeple with the flat of the brush.

7 Load the ½-inch (12mm) flat with a mix of Black Forest Green + Payne's Grey. Using the bottom corner of the brush, pat in the dark value of the background trees. Allow some of the sky to show through the clusters of foliage at the tops of the trees.

Tap in highlights with Black Forest Green + Light Buttermilk, mixed to a light green. Add touches of Hauser Light Green for a brighter highlight, especially on the left side of the clusters of foliage. Be careful not to over-highlight, as you want some of the dark value to show through.

8 Using the no. 2 liner and thinned Payne's Grey, stroke in a few trunks and limbs. Weave them in and out of the foliage. With Violet Haze on the corner of the ½-inch (12mm) flat, tap in a few lavender flowers toward the bottom of the trees to create bushes in bloom.

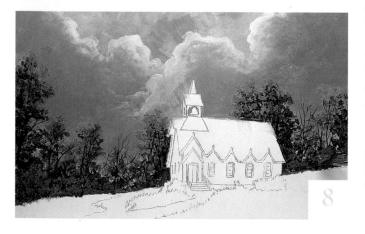

Black Forest Green + Payne's Grey

Black Forest Green + Light Buttermilk

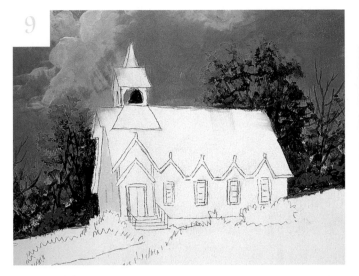

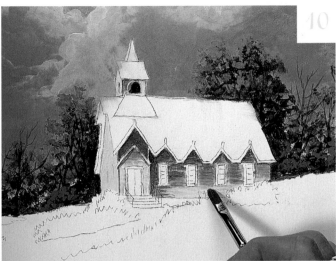

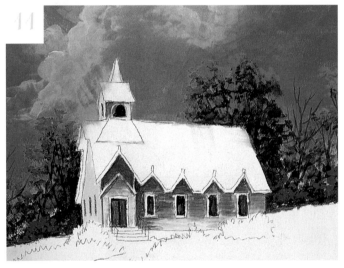

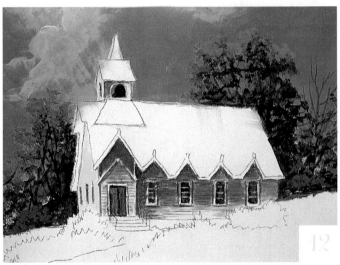

9 With Light Buttermilk, basecoat the left wall of the church using the no. 4 filbert and the left wall of the steeple with the no. 2 liner. Use the liner and a bit of Payne's Grey to paint the bell in the tower.

10 Basecoat the front wall with Light Buttermilk. With the no. 4 filbert, work a thin glaze of Payne's Grey + Violet Haze on the front wall. Use a slightly darker value of the mix at the top, beneath the roof edge. Leave some of the Light Buttermilk showing toward the bottom. If the shading looks too dark, add a bit of Light Buttermilk over it to tone it down. Paint the section with the door just a bit lighter, and deepen the shading behind this section so it will stand out. Paint some of the shading on the front wall of the steeple also using the liner. Indicate horizontal board lines with thin Payne's Grey on the chisel edge of the brush.

11 With Payne's Grey on the no. 2 liner, basecoat the windows and the door. Highlight the door with Wisteria, and add a bit inside the front-facing windows also.

12 Paint the frames with a touch of Light Buttermilk to straighten them up if needed, using the tip of the no. 2 liner. Paint in the pane lines on the windows with Light Buttermilk. Shade outside the frames with thinned Payne's Grey + Violet Haze. Add some of the shading color to the frames that are in shadow. Add horizontal board lines to the wall with thinned Payne's Grey + Violet Haze.

Payne's Grey + Violet Haze

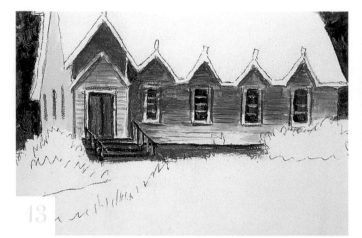

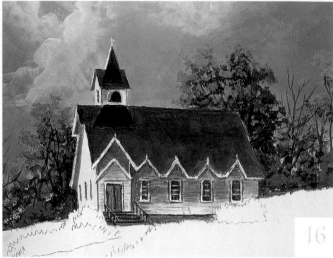

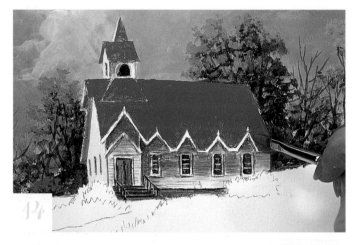

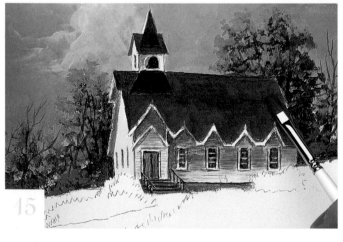

13 Brush mix Russet + Light Buttermilk + a touch of Payne's Grey on the no. 4 filbert and base in the foundation of the building. Draw a line of Payne's Grey between the foundation and the wall with the no. 2 liner. Base in the steps with the foundation mix, then paint the top pattern line of each step with Payne's Grey. Paint the railings Payne's Grey and highlight them with Titanium White.

14 Add a lavender-gray basecoat under the left overhangs of the roof and on the steeple with Violet Haze + a touch of Payne's Grey + Light Buttermilk, using the no. 2 liner. With the no. 4 filbert, basecoat the roof Violet Haze. Leave a hint of a line below the base of the steeple so as not to lose the placement.

15 Wash over this basecoat with a thin mix of Payne's Grey + Russet, adding more Payne's Grey to the mix for the top and base of the steeple. Create texture on the roof with the direction of the strokes and by varying the color values.

16 Using the no. 2 liner and Light Buttermilk + Titanium White, tidy up the white edges of the roof. Add the light board edges on the far left of the roof and the steeple roof. Add a tiny cross on top of the steeple. Brush a little shading on the front roof edges with a wash of thin Violet Haze + Payne's Grey.

Russet + Light Buttermilk + Payne's Grey	Violet Haze + Payne's Grey + Light Buttermilk	Payne's Grey + Russet

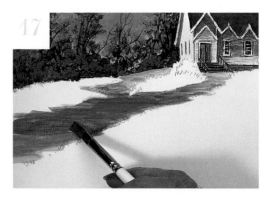

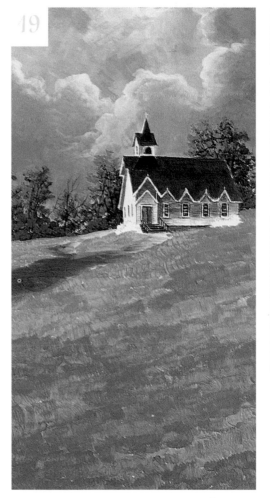

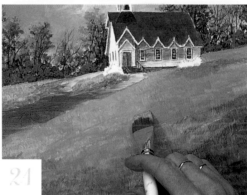

17 Brush in the path with horizontal strokes of thinned Light Buttermilk + Russet using the no. 8 flat. Add more Light Buttermilk at the top, close to the church, and more Russet toward the bottom. The path should have a rough, streaky look.

18 When the path is dry, streak in a thin wash of Violet Haze, especially near the end of the path. Pick up a little thinned Payne's Grey in an old stiff-bristle brush. First flick out a spray of paint on a test piece of paper. When the specks of paint are the way you'd like, hold the brush close to the surface and add a few to the path.

19 Brush mix Hauser Light Green + Light Buttermilk on the ¾-inch (19mm) flat. Begin in the upper left corner of the grass and pat in the grass with short downward strokes. Add Blue Mist toward the edge of the box. Paint the right side of the grass, adding more Blue Mist. Closer to the path use a lighter value of the Hauser Light Green + Light Buttermilk mix.

20 Add thinned Payne's Grey to the foreground grass. Occasionally pick up touches of Black Forest Green. Keep the paint thin. Add some of the darker values below and to the side of the bushes around the church to create shadows.

21 Highlight some of the grass with a brush mix of Hauser Light Green + Light Buttermilk + Golden Straw. Tap this color on the top of the bank, fading it out into the middle ground.

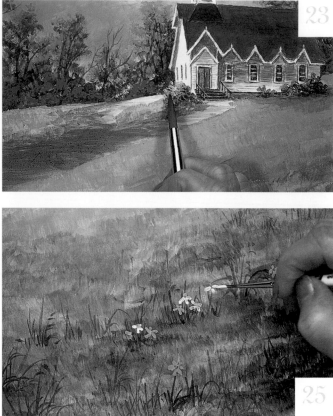

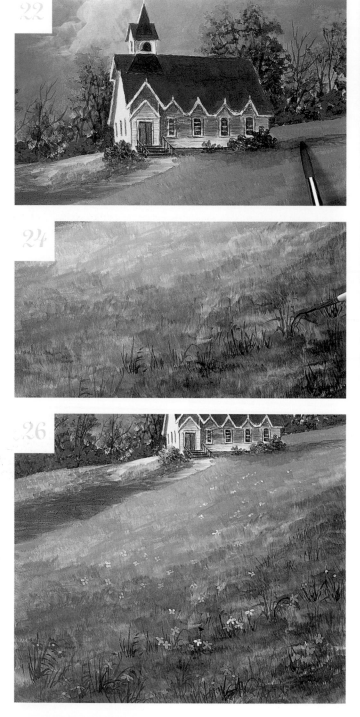

Black Forest Green + Russet

22 Base in the bushes with Black Forest Green + Russet, tapping in the color with the bottom of the no. 8 flat. Add water to the mix and soften the bottom of the bush, pulling more shadows out from the bottom of the bushes.

23 Highlight the top and left side of the left bush with a touch of Golden Straw + Titanium White. Tap it in using the very bottom corner of the no. 8 flat. Add a touch of Hauser Light Green on the tops and left sides of the bushes to the right. Highlight the path where it is closest to the church with additional Light Buttermilk.

24 Stroke in a few groupings of weeds or grasses in the foreground with Black Forest Green + Payne's Grey, using the no. 2 liner. Bend a few blades of grass in different directions.

25 Paint the foreground flowers with tiny pressure strokes using the no. 2 liner. Press down with the tip and pull toward the center of the flower. Use a variety of colors such as Violet Haze + Light Buttermilk; Baby Blue + Light Buttermilk; and Violet Haze + Baby Blue. Add a dot of Golden Straw for the centers.

26 As the flowers fade into the distance, paint them smaller and with less detail. Dab in touches of the Light Buttermilk and Baby Blue to indicate these distant blossoms.

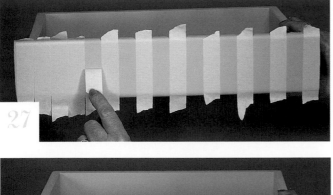

27 Basecoat the rest of the box with Light Buttermilk + Baby Blue mixed to a light blue. Paint the edges slightly darker with Baby Blue + Payne's Grey. When dry, lay 3/4-inch (1.9cm) wide strips of masking tape side by side, with the edges touching, all the way around the box. Pull off every other strip of tape.

28 Moisten the sea sponge or a small wadded-up paper towel with water, then dip it into Light Buttermilk. Tap it a few times on the palette to soften and distribute the paint. Tap the sponge across the blue stripes on the side of the box. Allow some of the blue basecoat to show through.

29 Gently pull off the remaining tape, and your stripes will appear.

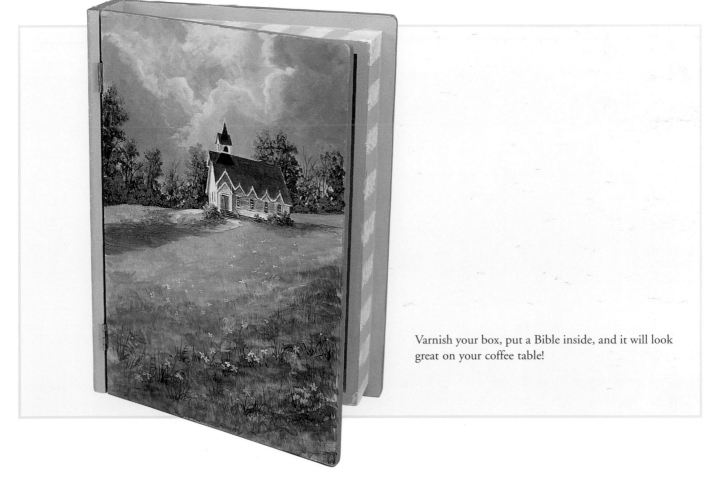

Varnish your box, put a Bible inside, and it will look great on your coffee table!

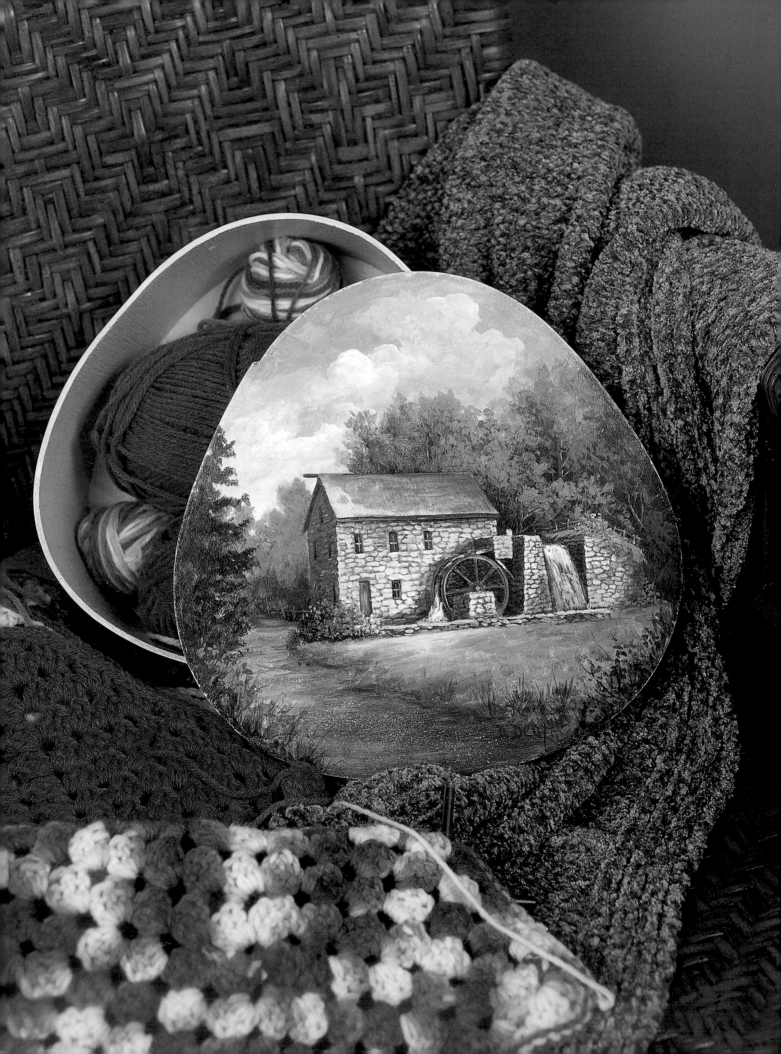

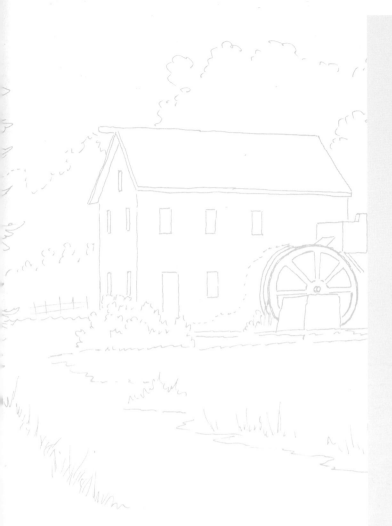

Old Rock Mill

Old mills are one of my favorite subjects to paint. We no longer need a local mill to grind our grain as in days gone by, and many of our mills from the last century are no more. However, in the spirit of restoration, some of our great mills are being repaired and are grinding grain as they once did. A friend gave me a photo of this rock mill located in Sudbury, Massachusetts, near Boston. I hope you will enjoy painting it.

In this project, you will learn to paint tree foliage by working with groupings of leaves. You will gain experience in painting rocks on a wall and glazing in shadows where needed. You will paint the road with horizontal strokes so it will appear to lie flat. Since grass is in most landscape paintings, you will get more experience creating the texture and color values to make it look real.

MATERIALS

DecoArt Americana Paints

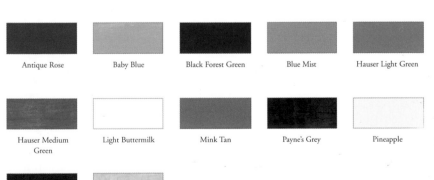

Antique Rose	Baby Blue	Black Forest Green	Blue Mist	Hauser Light Green
Hauser Medium Green	Light Buttermilk	Mink Tan	Payne's Grey	Pineapple
Russet	Soft Peach			

Royal Synthetic Brushes
no. 2 liner series 595, no. 8 round series 250, no. 4 filbert series 170, no. 8 flat series 150, ½-inch (12mm) flat series 700

Additional Supplies
tack cloth, fine sandpaper, 1-inch (25mm) foam brush, stylus, black graphite paper, sea sponge or wadded-up paper towel

Surface
Bentwood box from Viking Woodcrafts, Inc.

This pattern may be hand-traced or photocopied for personal use only. Enlarge at 115 percent to bring up to full size.

D. Dent

1 After sanding the raw wood and wiping with a tack cloth, basecoat the box lid where the painting will be with two coats of Light Buttermilk using the foam brush. Transfer the pattern with black graphite paper and the stylus.

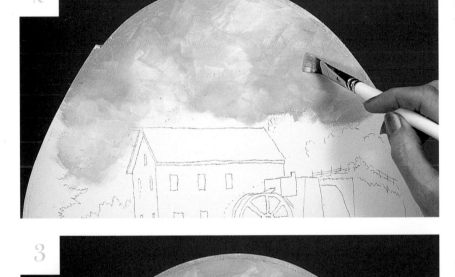

2 Base in the sky with a mix of Baby Blue + Light Buttermilk using the ½-inch (12mm) flat. Vary the colors a bit for a cloudy look.

3 Brush in the larger clouds using Light Buttermilk on the ½-inch (12mm) flat. Pick up a little water with the paint to thin it in the areas where you want the blue to show through. Build up more Light Buttermilk in the whiter areas. Work with several thin layers rather than one or two heavier layers of paint.

Baby Blue + Light Buttermilk

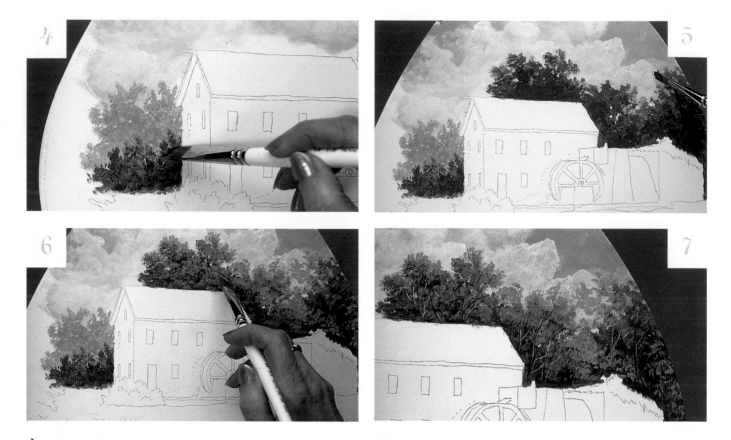

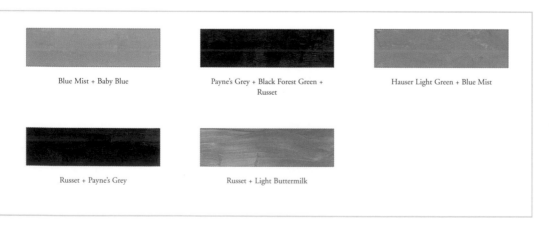

4 Paint the trees to the left of the mill using the bottom corner of the ½-inch (12mm) flat and a mix of Blue Mist + a touch of Baby Blue. Work for a loose, airy look at the tops. Pat in the bushes at the bottom with a dark mix of Payne's Grey + Black Forest Green + a touch of Russet. Highlight the bushes with a touch of Blue Mist.

5 Paint the trees behind the mill with the same dark mix, working on the bottom corner of the ½-inch (12mm) flat. Brush mix the colors to get some variation as you go.

6 Using the same brush, highlight the foliage with Hauser Light Green + Blue Mist. Pick up the paint on the top corner of the brush and tap in groupings of foliage. Build up more light leaves on the right sides of the clusters of foliage, but be careful not to cover up all of the dark. Work for a loose look at the tops, extending light leaves beyond the dark basecoat.

7 With Russet + a little Payne's Grey, paint the branches and trunks of the trees using the no. 2 liner. Highlight to the right of the branches with Russet + Light Buttermilk.

Blue Mist + Baby Blue

Payne's Grey + Black Forest Green + Russet

Hauser Light Green + Blue Mist

Russet + Payne's Grey

Russet + Light Buttermilk

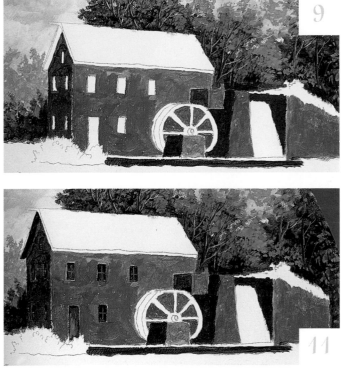

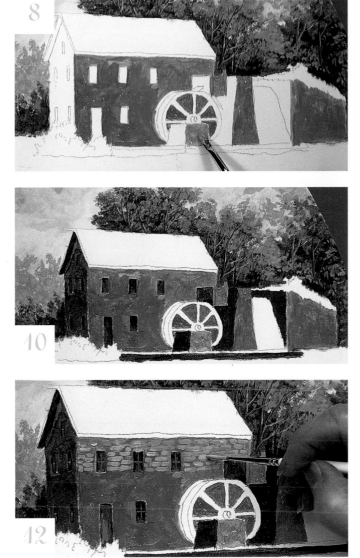

8 Basecoat the light areas of the mill with a mix of Payne's Grey + Light Buttermilk + Russet using the no. 4 filbert. The color does not need to be smooth, as you will be painting rocks over it.

9 Basecoat the dark sides of the mill with two coats of Payne's Grey + Russet. Paint the rock retaining wall also.

10 Using the no. 2 liner, basecoat the windows and door with a brush mix of Payne's Grey + Russet. Also, fill in the area underneath the overhang of the roof.

11 Paint the pane lines in the windows with a mix of Russet + Mink Tan. Paint the door with downward strokes of Russet + Mink Tan, leaving an edge of the dark basecoat showing at the top and on the right side.

12 Paint the stones on the light section of the mill with the tip of the no. 2 liner and Light Buttermilk + Mink Tan, adding touches of Payne's Grey to the mix now and then. Lay the stones in rows, staggering them in the next row, just as bricks are laid. Work for a little variation of color, but keep them light so they will show up against the basecoat.

Payne's Grey + Light Buttermilk + Russet

Russet + Mink Tan

Light Buttermilk + Mink Tan with touches of Payne's Grey

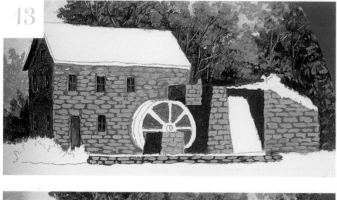

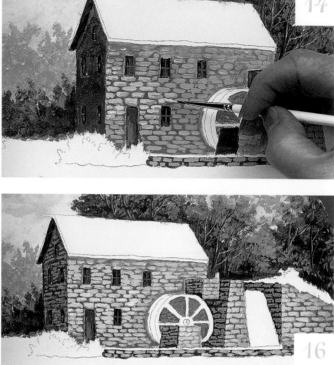

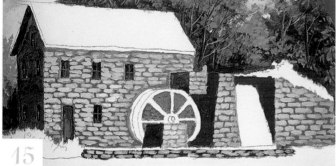

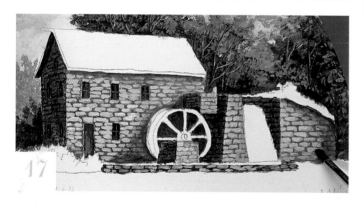

15 Continue to add highlights, working in several layers of color to build up the light. Add touches of Light Buttermilk to the Soft Peach + Pineapple in the lightest area. Be sure to bring the light all the way to the corners of the building and to the edge of the windows. Inside the wheel, paint the stones Mink Tan.

16 Only suggest the stones on the left side of the mill, using Baby Blue + Mink Tan. Follow the angles of the top and bottom of the windows to get the perspective correct. Paint the stones in the rest of the dark areas in the same way.

17 Glaze in shadows on the dark areas of all the structures with moist Payne's Grey, using the no. 4 filbert. Add more than one coat if needed for darker values.

13 Continue to establish the placement of the stones. Additional color and shading will be added on later. Paint the stones on the retaining wall as well.

14 On the sunny front side of the building, build up light warm values on the stones with touches of Soft Peach + Pineapple on the tip of the no. 2 liner.

Soft Peach + Pineapple

Baby Blue + Mink Tan

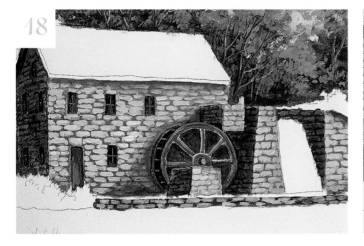

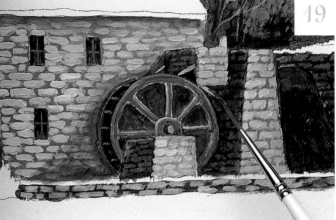

18 Paint the inside of the wheel, where the water will be running, with two coats of Payne's Grey using the no. 2 liner. Base in the rim and spokes of the wheel with Russet, picking up a bit of Payne's Grey for shading. Add touches of Light Buttermilk with the Russet for highlights. With this same mix, paint the lines for the edges of the buckets where the water will run.

19 Base in the waterfall with two coats of Payne's Grey, using the no. 4 filbert. With Soft Peach on the liner, paint in the three support posts above and to the right of the wheel. Add Payne's Grey shading beneath them.

Waterfall

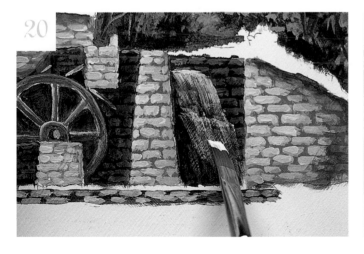

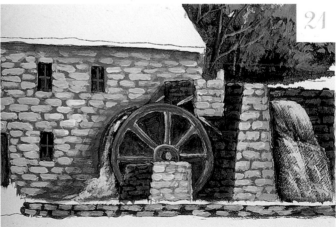

20 With Light Buttermilk on the top of the no. 8 flat, place the brush at the top of the falls and lightly pull down for the water. Lift the brush up and set it down again, continuing to pull down to complete the falling water.

21 Add more strokes as needed to lighten some areas of the water. Brush a little water from the top of the wheel around on the left. Tap lightly with more Light Buttermilk on the brush for the foamy look at the bottom.

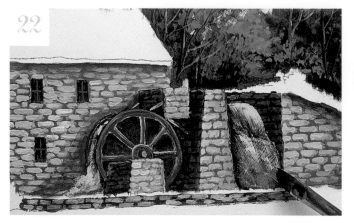

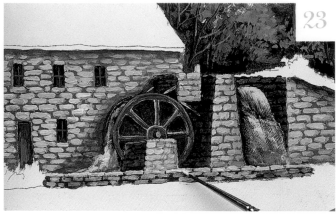

22 Glaze over the water with thinned Baby Blue to add a touch of color toward the bottom of the falls. On the wheel, shade the water close to the wheel (see completed shading in photo for step 23).

23 Paint the retaining wall in front of the wheel the same as the other rock walls (see step 12). Add a light edge on top with more Light Buttermilk + Soft Peach + Pineapple.

Roof

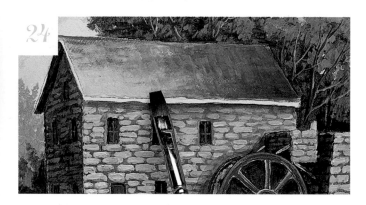

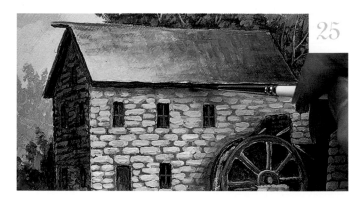

24 Basecoat the roof with Light Buttermilk + Payne's Grey, using the no. 8 flat. Use more Payne's Grey on the right side of the roof, and add Light Buttermilk + Soft Peach to the lower left. Paint the roof with short, downward strokes following the slope of the roof. Add a little variation of color and texture to suggest shingles. Paint down to the board line around the roof.

25 Fill in the board line under the roof with two coats of Payne's Grey using the no. 2 liner. Add a thin line of Russet + Mink Tan on top of the Payne's Grey.

Light Buttermilk + Soft Peach + Pineapple

Light Buttermilk + Payne's Grey

Light Buttermilk + Soft Peach

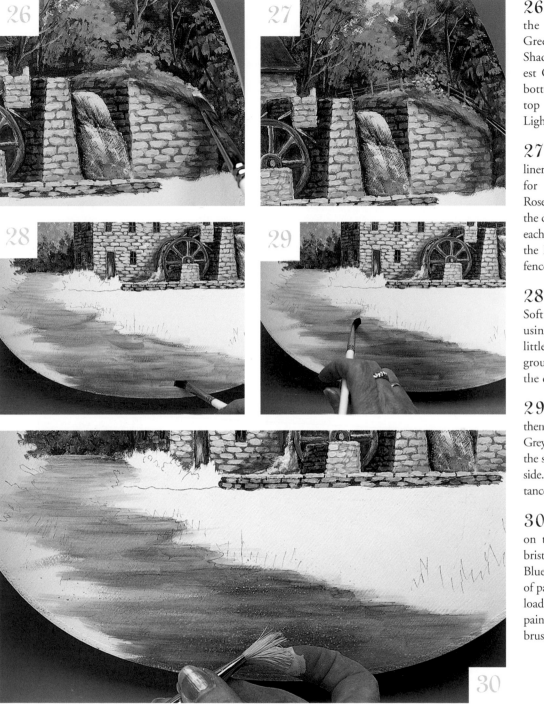

26 Base in the grass on top of the wall with Hauser Light Green using the no. 8 flat. Shade the grass with Black Forest Green + Russet toward the bottom. Tap in highlights at the top of the grass with Hauser Light Green + Pineapple.

27 Using the tip of the no. 2 liner, paint dots and dabs of color for the flowers with Antique Rose + Light Buttermilk. Vary the colors, adding more or less of each. With a bit of Baby Blue on the liner, paint the posts of the fence, then the rails.

28 With a mix of Russet + Soft Peach, basecoat the road using the no. 8 flat. Pick up a little more Russet in the foreground and more Soft Peach in the distance.

29 Allow the basecoat to dry, then brush in thinned Payne's Grey with the no. 8 flat, pulling the shadows across from the right side. Use less shading in the distance and more in the foreground.

30 To give the look of gravel on the road, load an old stiff-bristle brush with thinned Baby Blue. Flick the color on a piece of paper first to see if the paint is loaded correctly. Then flick the paint onto the road, holding the brush fairly close to the surface.

Black Forest Green + Russet

Hauser Light Green + Pineapple

Russet + Soft Peach

Fence and Bush

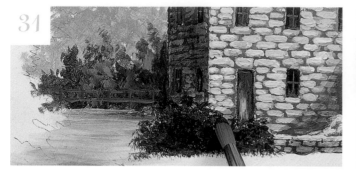

31 Using the no. 2 liner, paint the fence in the distance with Russet + Mink Tan. Tap in the basecoat on the bush by the mill with Black Forest Green + Payne's Grey + a touch of Russet using the no. 8 round.

32 Tap in green highlights with touches of Hauser Light Green and Hauser Light Green + Pineapple. Place most of the highlights toward the top of the bush, leaving it darker at the bottom. Tap in flowers with the tip of the no. 8 round using Antique Rose, Light Buttermilk, and Pineapple.

Pine Tree and Front Grass

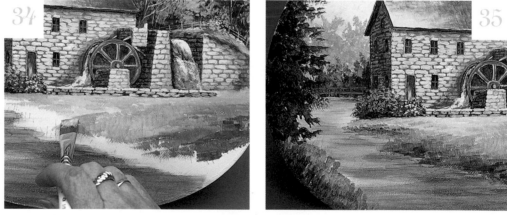

Hauser Medium Green + Russet

33 With the no. 8 round, paint the pine tree on the left with a mix of Black Forest Green + Russet. Paint two coats for a good dark value. Work for uneven edges on the tree.

34 Using the 1/2-inch (12mm) flat, paint the grass with short downward strokes. Begin in the light areas with Hauser Light Green + Pineapple. Pick up Hauser Light Green + Blue Mist as you move to the right. As you work toward the middle of the grass, pick up a little Hauser Medium Green + Russet with the Hauser Light Green + Blue Mist mix to give you a mid-tone value. Overlap and vary the colors for nice grass texture. Keep the strokes short and choppy. Build up more light toward the wheel with additional Pineapple patted over the basecoats.

35 Near the path pick up Black Forest Green + Russet + a touch of Payne's Grey for darker values. Soften the colors into the lighter grass where they meet. Pick up more of the lighter colors to help in the blending. Pull a little of the thinned green mix of Hauser Medium Green + Russet into the edge of the road.

36 Brush mix Russet + Black Forest Green on the no. 8 round and tap in foreground bushes, and add the distant dark bush beneath the wall on the right side. With the same color thinned, flick up a few tall grasses in the foreground with the no. 2 liner. Add flowers on the bushes with Antique Rose + Light Buttermilk on the no. 8 round.

37 Paint the sides of the lid and sides of the box with two coats of Light Buttermilk. Dip a wet sea sponge or wadded-up paper towel in Soft Peach, tap it on the palette a few times, then tap it onto the sides of the lid and sides of the box.

38 Tap a little Baby Blue over the Soft Peach. Add just a little of the blue so that you can see both colors. Touches of Pineapple or Light Buttermilk may be tapped on as well, if desired.

Varnish the box and use it to store a few special treasures!

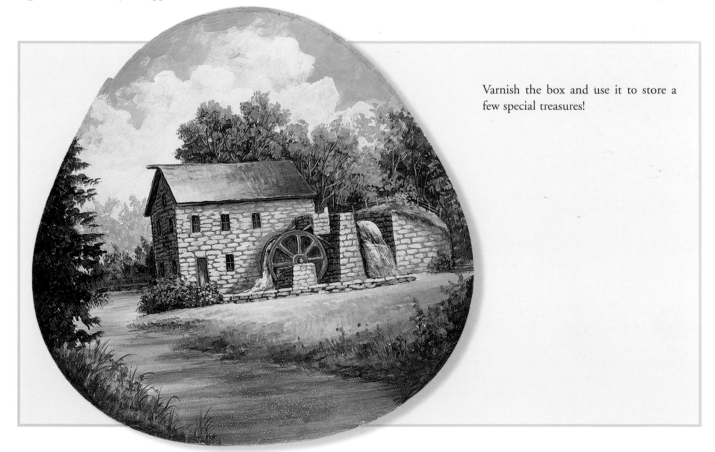

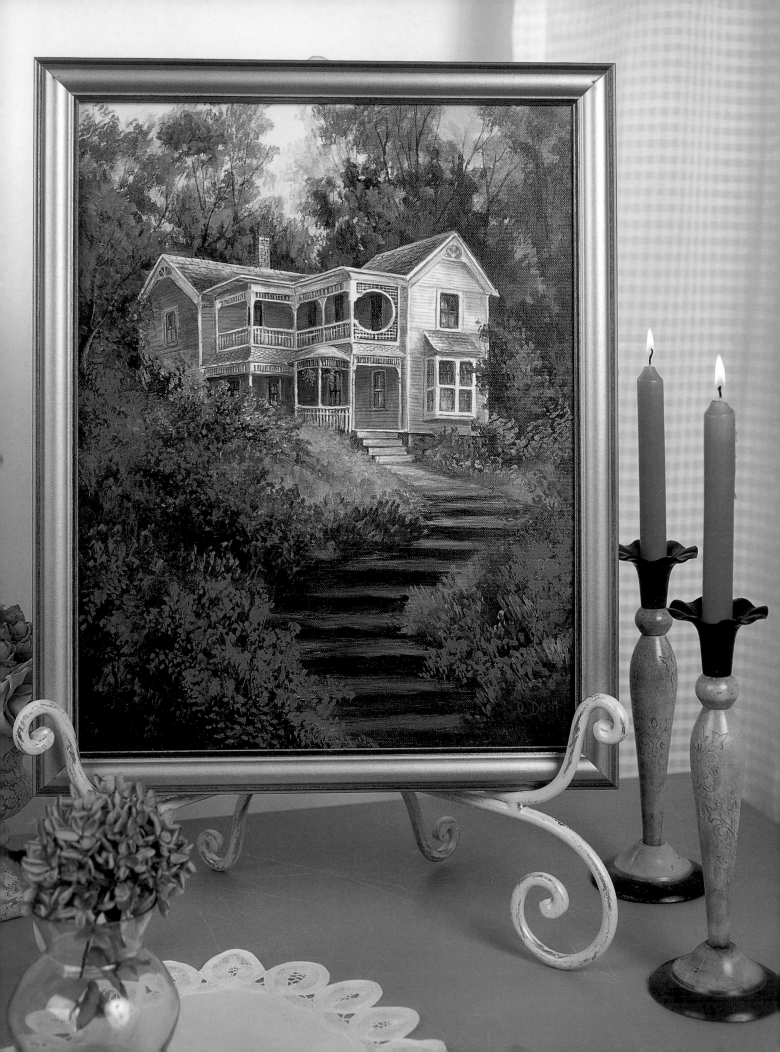

Victorian Summer

Eureka Springs, Arkansas, is a quaint little town built on very hilly terrain. It is called the "Little Switzerland of the Ozarks," as no two streets are on the same level. It also has many neat little shops, bed and breakfasts galore and beautiful Victorian homes. It is only about an hour and a half or so from me, so it's a favorite "get-away-for-a-day" spot. Here is a sample of one of the homes you may find there. If you like detail, this is the painting for you.

You will be learning more about foliage in this painting. Remember the direction the light is coming from when you add the highlights, and keep darker values in the shadows. You will work with glazes for deep shadows, and add more highlights to create the contrasts in color and value. Working one section at a time makes this painting less difficult. When you add all the dabbed-in flowers, the painting will come alive!

MATERIALS

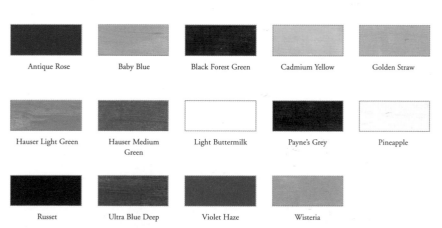

DecoArt Americana Paints

Antique Rose	Baby Blue	Black Forest Green	Cadmium Yellow	Golden Straw
Hauser Light Green	Hauser Medium Green	Light Buttermilk	Payne's Grey	Pineapple
Russet	Ultra Blue Deep	Violet Haze	Wisteria	

Royal Synthetic Brushes
no. 1 liner series 595, no. 2 liner series 595, no. 4 filbert series 170, no. 8 flat series 150, ½-inch (12mm) flat series 700, ¾-inch (19mm) flat series 700

Additional Supplies
gesso, 1-inch (25mm) foam brush, black graphite paper, stylus

Surface
14 × 18-inch (36cm × 46cm) canvas from any craft or art supply store

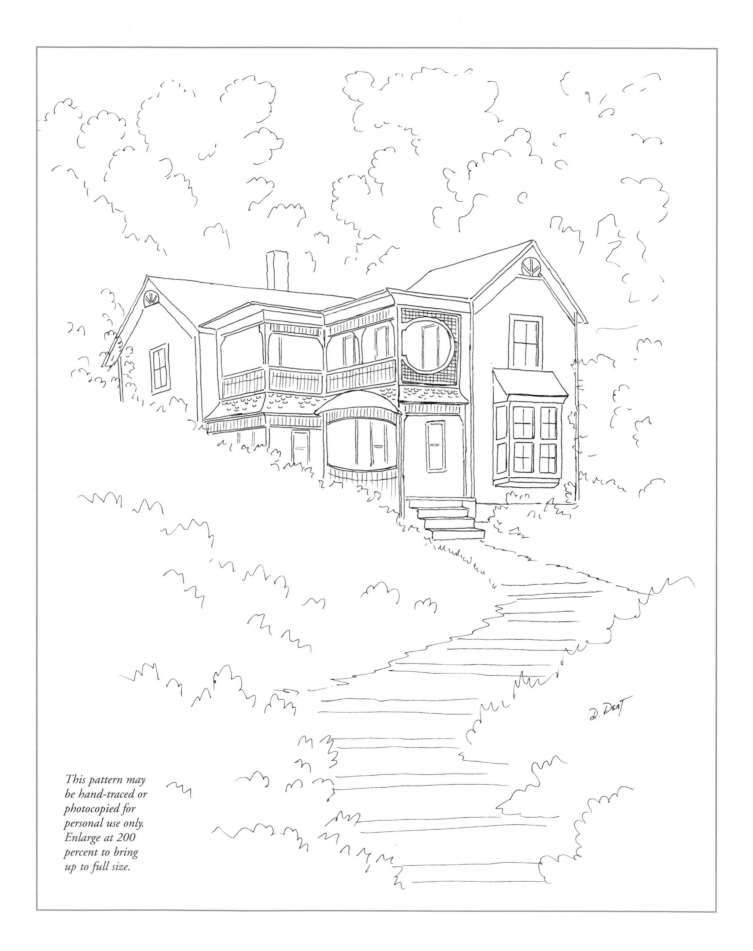

This pattern may be hand-traced or photocopied for personal use only. Enlarge at 200 percent to bring up to full size.

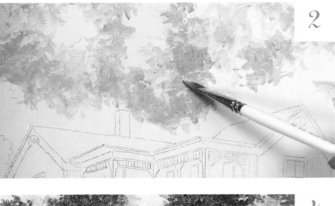

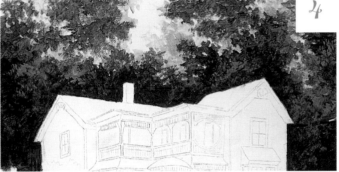

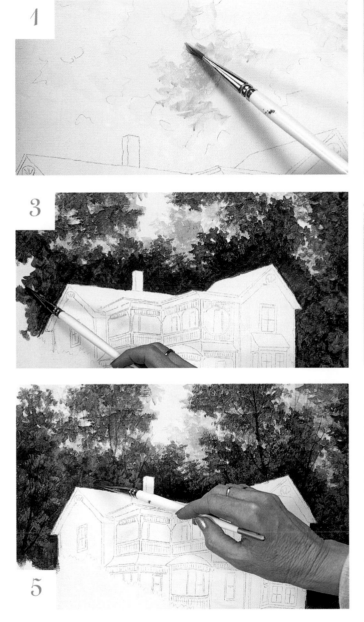

3 Add the dark foliage, working with the same brush and a mix of Black Forest Green + Russet. In the darkest areas apply two layers of paint to build up the darks.

4 Highlight the trees with Hauser Light Green, adding a touch of Pineapple for lighter greens. Break up dark areas that look too solid with the light greens, but do not lose too much of the dark values.

5 Add trunks and limbs with the no. 2 liner and thinned Payne's Grey + Russet. Keep the closer trunks quite dark and those in the distance lighter. Thread the branches in and out of the foliage. Add a very thin glaze of Ultra Blue Deep + water sparingly over some of the foliage.

1 Using the foam brush, basecoat the canvas with three coats of white gesso, allowing drying time between coats. When dry, transfer the pattern using black graphite paper and the stylus. Basecoat the sky with two coats of Pineapple + a touch of Light Buttermilk using the ½-inch (12mm) flat. Paint a bit past the tree lines so some of the sky will show through the foliage. Pat in Wisteria using the bottom corner of the brush and working for the airy look of distant foliage.

2 Add light green foliage that will show around the outside edges of the trees using Hauser Light Green and Hauser Light Green + Pineapple. Continue with the bottom corner of the ½-inch (12mm) flat and work the greens loosely over the sky for a soft, irregular look.

Pineapple + Light Buttermilk	Hauser Light Green + Pineapple
Black Forest Green + Russet	Payne's Grey + Russet

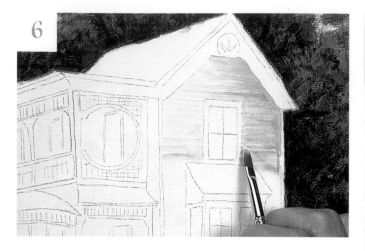

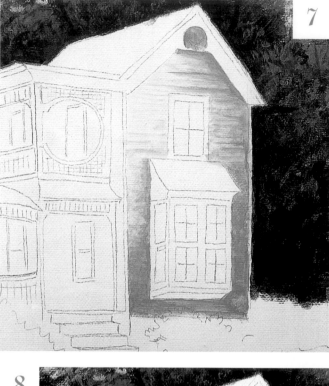

6 Base in the light areas on the gable end of the house with Light Buttermilk using the no. 4 filbert. With a thin wash of Baby Blue + Light Buttermilk, shade around the light areas. Keep the paint fairly thin and stroke in the horizontal direction of the boards. Don't try to paint actual board lines at this time, just establish the general lights and darks.

7 In the bluer areas, base in the walls with Baby Blue. Where light and dark meet, soften the edges with thinned Baby Blue, stretching out the paint over the Light Buttermilk.

8 Using the side of the no. 4 filbert, paint the board lines with thinned Payne's Grey + Baby Blue. Use the top and bottom pattern lines on the windows as a guide to help you keep the linework going in the right direction.

9 As you turn the corner to paint the walls under the porch roof, add more Payne's Grey to the Baby Blue. Paint the deepest shadows to the far left and toward the top with straight Payne's Grey. Paint around the posts so as not to lose their placement. Paint out the spindles at the top, but go around the top and bottom horizontal boards to keep the placement. The sharp edge of the no. 4 filbert works well for this detail.

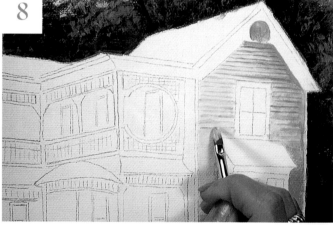

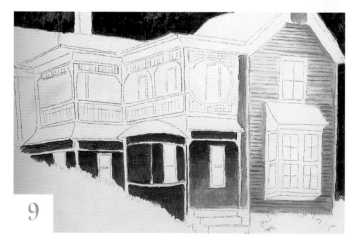

Payne's Grey + Baby Blue

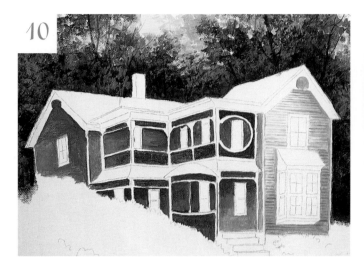

10 Paint the walls under the porch roof on the second floor in the same general way. Use straight Payne's Grey on the walls behind the latticework. Add Baby Blue to the Payne's Grey in the lighter areas of the walls.

Use a mix of Payne's Grey + Baby Blue for the far left wall, adding more Payne's Grey under the eaves and toward the right corner. Be sure there is contrast in color value at the corner.

11 With the no. 4 filbert, paint the board lines with Payne's Grey + Baby Blue and straight Payne's Grey in the darker areas. Work for just a value or two darker than the wall they are on, so they will show up but not look too harsh. Be sure your lines are going in the direction shown to keep the perspective correct.

Windows

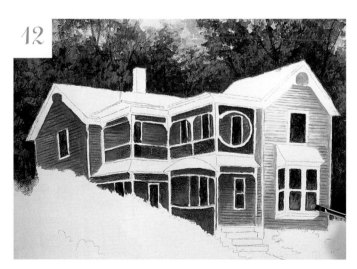

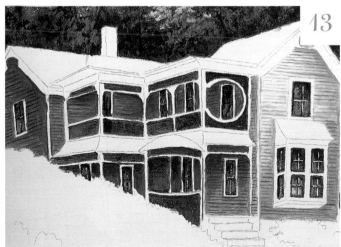

12 With the no. 4 filbert or the no. 2 liner, basecoat all the windows with Payne's Grey, adding a touch of Russet now and then. Begin to highlight the windows with a little Baby Blue on a dry brush. More highlights can be added where the windows are in the sunlight. Let some of the dark basecoat show through on all the windows.

13 After all the windows have been highlighted, use the no. 1 liner to base in the pane lines with Payne's Grey. Highlight the panes with Light Buttermilk, making those in the sunlight a little brighter. Add a touch of Light Buttermilk to the windowpanes in the sunlight to brighten them a little more.

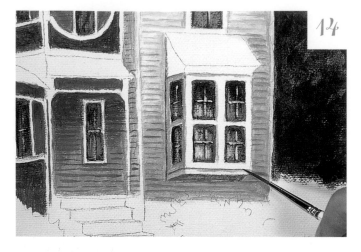

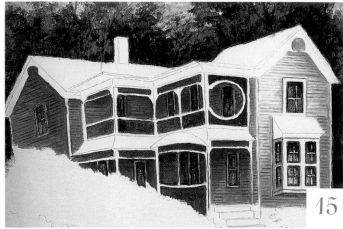

14 Using the no. 2 liner, paint the frames on the bay window with Light Buttermilk. Add a little Baby Blue shading to help straighten the frames from the outside. Add shading under the bay window with thinned Payne's Grey. Add a thin glaze of Baby Blue + Payne's Grey to shade the frames on the left side of the bay window.

15 Paint the rest of the frames with Light Buttermilk. When they are dry, add a glaze of thinned Payne's Grey and touches of Russet to push them into the shadows.

Posts and Spindles

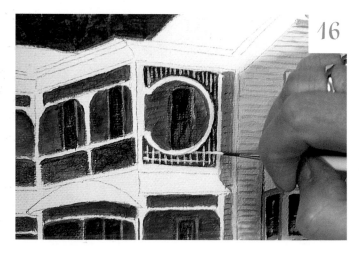

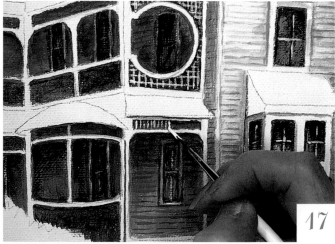

16 With Light Buttermilk on the no. 1 liner, straighten and redefine the posts. Use the colors of the house to straighten them from the outside. Do the best you can, and remember that this is a painting, not a photograph. They don't have to be perfect. Paint the latticework with thin lines of Light Buttermilk.

17 For the tiny spindles, pull downward strokes with the tip of the no. 1 liner, spacing them out freehand. They don't have to be perfect, and they will look better if they aren't.

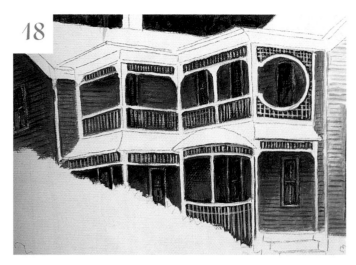

18 Finish all the spindles as shown above.

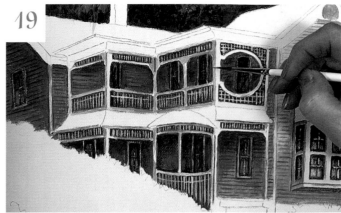

19 Shade the spindles in the shadows with a thin wash of Baby Blue. Pay particular attention to where the corners of the posts come together. Work Baby Blue on the left side and Light Buttermilk on the right for good contrast.

Fascia Board and Roof

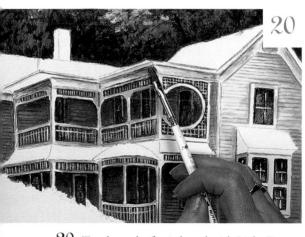

20 Touch up the fascia board with Light Buttermilk as needed to straighten it. With thinned Payne's Grey on the no. 4 filbert, paint the deepest shadows under the roof. Soften the lines by pulling the Payne's Grey down onto the board before the paint dries. Add shadows at the corners, painting darker values on the left side. Anywhere you see a pattern line beneath the roof, emphasize it with a softened line of Payne's Grey. Wash a few hints of thinned Russet on the boards here as well. Add more Light Buttermilk in the light areas if needed for better contrast.

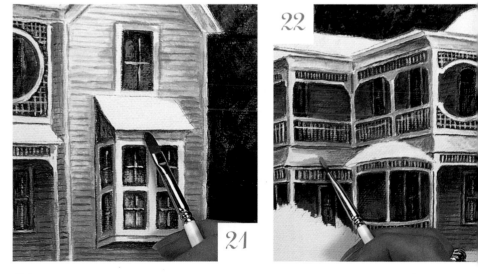

21 Shade in the fascia board over the bay window with the same technique. Work with slightly darker values on the left side.

22 Basecoat the lower porch roof with Light Buttermilk, using the no. 4 filbert. Include the rounded section. Define the bottom edge with a line of Payne's Grey between the latticework and the bottom of the roof. Wash in shadows with thinned Baby Blue + a touch of Payne's Grey on all but the rounded part of the lower roof. Be sure to show definition between light and dark at the corners.

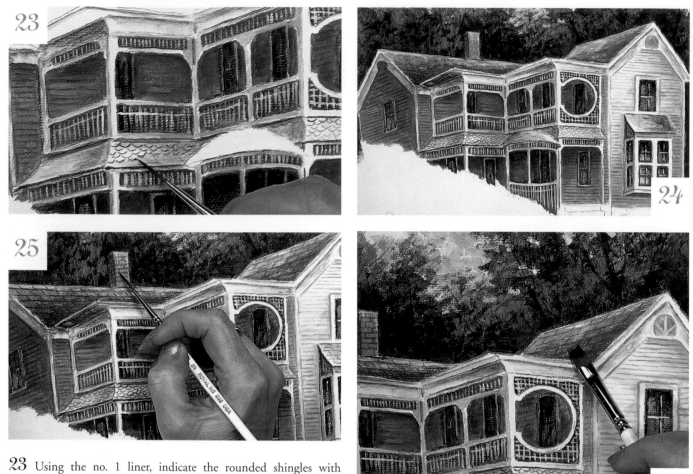

23 Using the no. 1 liner, indicate the rounded shingles with thinned Payne's Grey + a touch of Russet. Work a row at a time, staggering the strokes on the next row. Don't worry if they are not perfect.

24 Touch up the main roofline with Light Buttermilk to remove any stray foliage. Paint the roof with the no. 8 flat, working with short, choppy downward strokes that overlap each other. Use a mix of Russet + a touch of Light Buttermilk + a touch of Payne's Grey. Vary the colors in the mix, working more Light Buttermilk in the mix toward the top of the roof and darker values toward the bottom. Lay in a light edge on the top porch roof just so it will show up against the back roof. Paint the roof over the bay window and the rounded one in the middle. Base in the chimney also, using Russet + Light Buttermilk. Work for contrast, making the left side a bit darker.

25 With the no. 4 filbert, brush a wash of Russet at the edge of the upper porch roof. Load the no. 1 liner with thinned Payne's Grey and paint the horizontal shingle lines, following the top roof line. Pull downward shingle lines, following the slope of the roof. Add the brick lines on the chimney also.

26 Finish the designs in the peaks of the roof using Light Buttermilk for the one on the right and Baby Blue + Payne's Grey + Light Buttermilk for the one on the left. Add very thin washes of Hauser Medium Green here and there on the roof to reflect the trees.

Russet + Light Buttermilk + Payne's Grey

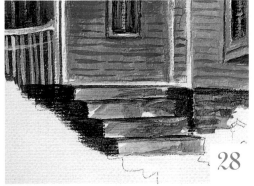

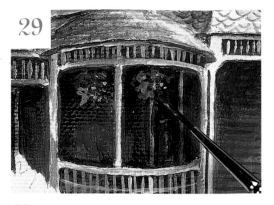

27 Base in the foundation and step sides with Payne's Grey + a touch of Russet, using the no. 8 flat. Add a little more Payne's Grey on the left sides. Paint the top of each step with the dark mix, painting right on the pattern line with the chisel edge of the brush.

28 Paint the risers with thinned Russet + a touch of Payne's Grey. With Light Buttermilk, paint the edge of the porch, above the top step.

29 Using the no. 2 liner, pull tiny strokes of Hauser Light Green and Hauser Medium Green to make the leaves of the hanging flower baskets. Be sure some of the strokes connect to show form. Paint dots of Antique Rose and Light Buttermilk for the flowers.

Sidewalk and Steps

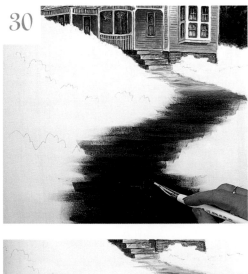

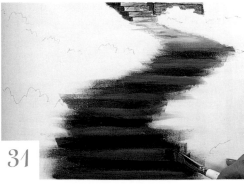

30 Basecoat the sidewalk and lower steps with the ½-inch (12mm) flat. Brush in Russet + Light Buttermilk at the top, keeping the strokes horizontal. As you move down, add more Russet, then begin to add Payne's Grey to the mix. Paint out the step lines.

31 To define the top of the lower steps, brush a horizontal streak with a little thinned Baby Blue + Ultra Blue Deep + a touch of Payne's Grey mixed to a gray blue. Skip an area for the riser, and brush in another step top. Continue until all the steps are in. Add more highlights to the step tops or more shading to the risers if needed for contrast.

Russet + Light Buttermilk

Baby Blue + Ultra Blue Deep + Payne's Grey

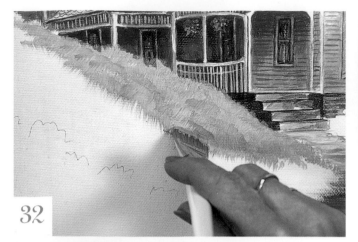

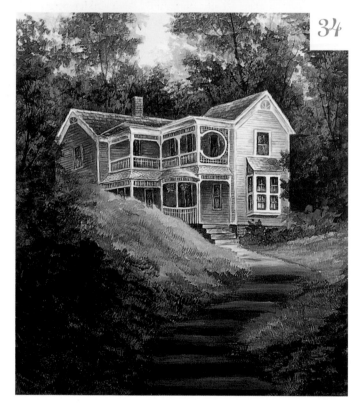

32 Basecoat the lightest part of the grass with Hauser Light Green + Pineapple using the ¾-inch (19mm) flat. Use short downward strokes, following the slope of the ground. Hold the brush perpendicular to the canvas and use the tips of the bristles to paint.

33 As you work down, pick up Black Forest Green + a touch of Russet, occasionally picking up a little Hauser Light Green to soften the transition of color. Overlap the lights and darks as you go to set the colors together in a natural way. The variation of colors will make the grass realistic and interesting.

34 Continue basing in the grass and foliage. Work for darker values at the edge of the steps, in the dark bushes around the house, and in the foreground.

35 Highlight the bushes around the house with Hauser Light Green, working on the top of the ¾-inch (19mm) flat. Use the corner hairs of the brush and bouncy strokes that occasionally pull down a bit to set the foliage into the dark basecoat.

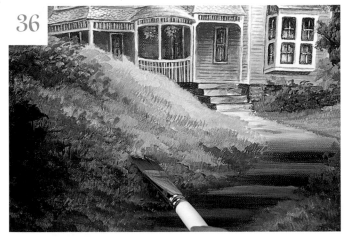

36

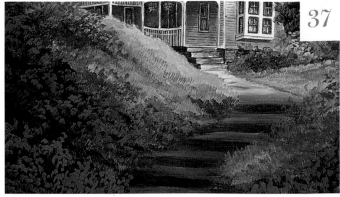

37

36 Using the same light tapping technique with a slight downward pull, add the flowers. Paint the pink flowers with Antique Rose + Light Buttermilk. Tap in clusters of blossoms, working for a loose, natural look.

37 Add lavender flowers with Violet Haze; Violet Haze + Antique Rose; and Violet Haze + Light Buttermilk. With Golden Straw and Cadmium Yellow, add a few bright yellow flowers in the grass by the house to draw the viewer's eye toward the building. Add more flowers of pinks and lavenders where you feel they need to be for color and balance. Avoid covering up all of the dark beneath them. Tap in Ultra Deep Blue + Light Buttermilk flowers at each side of the canvas in the lower portion of the background trees.

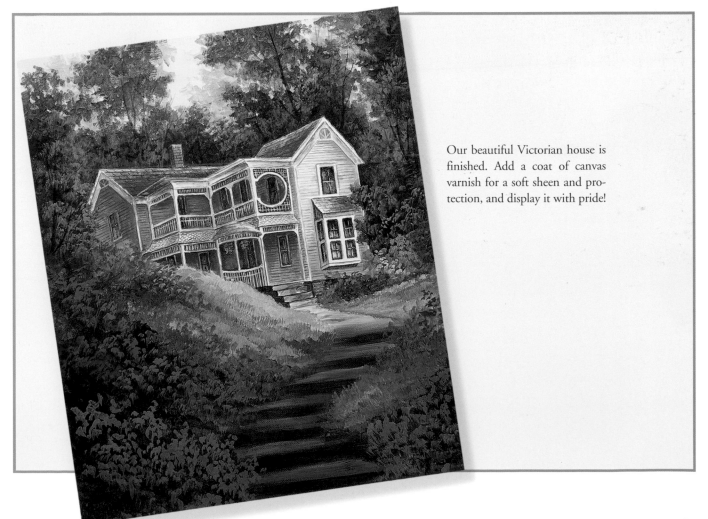

Our beautiful Victorian house is finished. Add a coat of canvas varnish for a soft sheen and protection, and display it with pride!

Resources

ALL SUPPLIES AND SOME SURFACES

Painter's Corner, Inc.
108 W. Hwy 174
Republic, MO 65738
(417) 732-2076
www.ddent.com
e-mail: ddent94587@aol.com

PAINTS

DecoArt
P.O. Box 327
Stanford, KY 40484
(800) 367-3047
www.decoart.com

BRUSHES

Royal & Langnickel Brush Mfg., Inc.
6707 Broadway
Merrillville, IN 46410
(800) 247-2211

SURFACES

Sechtem's Wood Products
533 Margaret St.
Russell, KS 67665
(800) 255-4285
www.tolemine.com

Stan Brown Arts & Crafts
13435 N. E. Whitaker Way
Portland, OR. 97230
(800) 547-5531
www.stanbrownartsandcrafts.com

Sunbelt Mfg., Inc.
103 Nikki Dr.
Longview, TX 75604
(800) 333-8412

Viking Woodcrafts, Inc.
1317 Eighth St. S.E.
Waseca, MN 56093
(800) 328-0116
www.vikingwoodcrafts.com

RETAILERS IN CANADA

Crafts Canada
2745 Twenty-ninth St. NE
Calgary, Alberta T1Y 7B5

Folk Art Enterprises
P.O. Box 1088
Ridgetown, Ontario N0P 2C0
(888) 214-0062

MacPherson Craft Wholesale
83 Queen St. E.
P.O. Box 1870
St. Mary's, Ontario N4X 1C2
(519) 284-1741

Maureen McNaughton Enterprises
RR #2
Belwood, Ontario N0B 1J0
(519) 843-5648

Mercury Art & Craft Supershop
332 Wellington St.
London, Ontario N6C 4P7
(519) 434-1636

Town & Country Folk Art Supplies
93 Green Lane
Thornhill, Ontario L3T 6K6
(905) 882-0199

RETAILERS IN THE UNITED KINGDOM

Art Express
Index House
70 Burley Road
Leeds LS3 1JX
Tel: 0800 731 4185
www.artexpress.co.uk

Crafts World
No. 8 North Street
Guildford
Surrey GU1 4AF
Tel: 07000 757070

Chroma Colour Products
Unit 5 Pilton Estate
Pitlake
Croydon CR0 3RA
Tel: 020 8688 1991
www.chromacolour.com

Green & Stone
259 King's Road
London SW3 5EL
Tel: 020 7352 0837
greenandstone@enterprise.net

Hobbycrafts
River Court
Southern Sector
Bournemouth International Airport
Christchurch
Dorset BH23 6SE
Tel: 0800 272387

Homecrafts Direct
P.O. Box 38
Leicester LE1 9BU
Tel: 0116 251 3139

Explore the wonder of decorative painting
with North Light Books!

Decorative Mini-Murals You Can Paint

Add drama to any room in your home with one of these eleven delightful mini-murals! They're perfect for when you don't have the time or the experience to tackle a whole wall. You'll learn exactly which colors and brushes to use, plus tips and mini-demos on how to get that realistic "wow" effect mural painters love. Detailed templates, photos and instructions assure your success at every step.

ISBN 1-58180-145-9, paperback, 144 pages, #31891-K

Painting Romantic Landscapes

Sharon Buononato, CDA, shows you how to paint landscapes that evoke feelings of nostalgia, hearth and home. Inside you'll find six easy-to-follow projects, including start-to-finish instructions, detailed drawings, traceable patterns, helpful hints and invaluable advice for painting trees, flowers, water, skies, birds, barns, mills, stonework and more!

ISBN 1-58180-160-2, paperback, 144 pages, #31909-K

Decorative Artist's Guide to Realistic Painting

Take your decorative painting to an exciting new level of depth and dimension by creating the illusion of reality—one that transforms your work from good to extraordinary! Patti DeRenzo, CDA, shows you how to master the building blocks of realism—value, temperature, intensity and form—to render three-dimensional images with height, depth and width.

ISBN 0-89134-995-2, paperback, 128 pages, #31661-K

Trompe L'Oeil Murals Using Stencils

Learn how to create stunning illusions on walls, floors, and ceilings. Here's all the instruction you need to use inexpensive, laser-cut plastic stencils with skill and confidence. Author Melanie Royals shows you how to combine stencils, shields, and tape with simple paint techniques, buy the proper equipment, prepare surfaces, manipulate stencils, and apply paint. The final section provides more advanced instruction for large-scale projects.

ISBN 1-58180-028-2, paperback, 128 pages, #31668-K

These books and other fine North Light decorative painting titles are available from your local art & craft retailer, bookstore, online supplier or by calling 1-800-289-0963.